American Vanguards

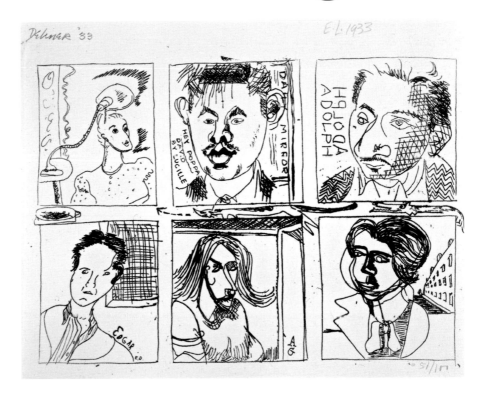

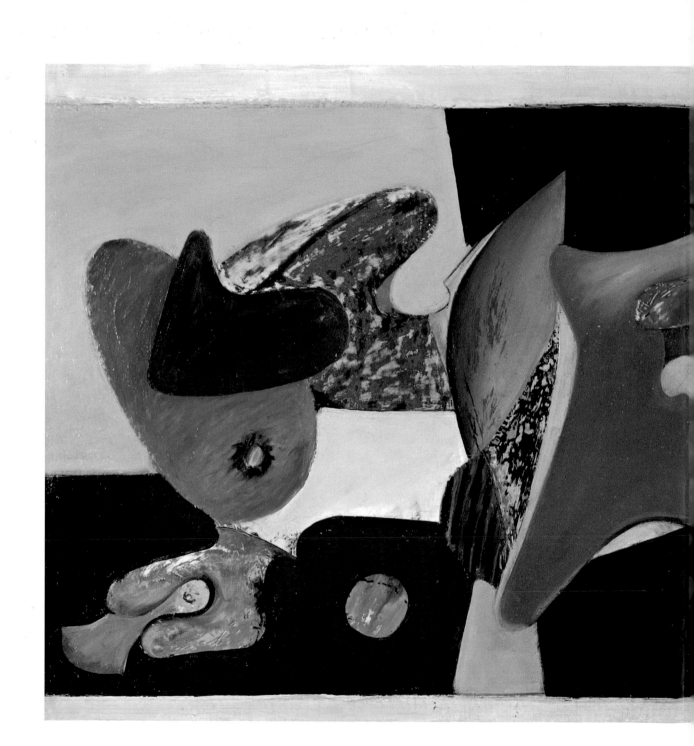

American Vanguards

Graham, Davis, Gorky, de Kooning, and Their Circle, 1927–1942

William C. Agee, Irving Sandler, and Karen Wilkin

Chronologies by
Alicia Longwell and Emily Schuchardt Navratil

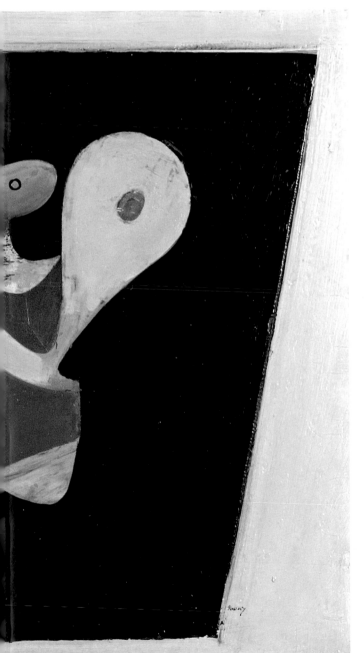

Addison Gallery of American Art

Phillips Academy, Andover, Massachusetts

Yale University Press

New Haven and London

American Vanguards: Graham, Davis, Gorky, de Kooning, and Their Circle, 1927–1942
Organized by the Addison Gallery of American Art
Phillips Academy, Andover, Massachusetts

Generous support for this exhibition and publication was provided by the Henry Luce Foundation and The Dedalus Foundation, Inc., and by an indemnity from the Federal Council on the Arts and Humanities.

Neuberger Museum of Art
Purchase College
State University of New York
Purchase, New York
January 29–April 28, 2012

Amon Carter Museum of American Art
Fort Worth, Texas
June 9–August 19, 2012

Addison Gallery of American Art
Phillips Academy
Andover, Massachusetts
September 21–December 31, 2012

Published by Addison Gallery of American Art
Phillips Academy, in association with Yale University Press

© 2011 Addison Gallery of American Art
Phillips Academy, Andover, Massachusetts

Addison Gallery of American Art
Phillips Academy
180 Main Street
Andover, Massachusetts 01810
www.addisongallery.org

Yale University Press
302 Temple Street
P.O. Box 209040
New Haven, Connecticut 06520–9040
www.yalebooks.com/art

A catalog record for this book is available from the Library of Congress.
Library of Congress Cataloging-in-Publication number 2011020689
ISBN 978-0-300-12167-4

Jacket illustrations: (front) Stuart Davis, *American Painting,* 1932 and 1942–54, oil on canvas, 40 × 50¼ in., on permanent deposit to the Joslyn Art Museum from the University of Nebraska at Omaha Art Collection, © The Estate of Stuart Davis / Licensed by VAGA, New York; (back) Alexander Calder, *Portrait of John Graham,* plate 81
p. i: Dorothy Dehner, Adolph Gottlieb, Esther Dick Gottlieb, Edgar Levy, Lucille Corcos Levy, and David Smith, *Six Artist Etching,* plate 82
pp. ii–iii: Arshile Gorky, *Organization (Nighttime, Enigma, and Nostalgia),* plate 40

Content Editor: Patricia Fidler
Indexer: Kay Banning
Designer: Laura Lindgren
Printed and bound in Italy by Mondadori

10 9 8 7 6 5 4 3 2 1

CONTENTS

LENDERS TO THE EXHIBITION

Addison Gallery of American Art, Phillips Academy, Andover,
 Massachusetts
Albright-Knox Art Gallery, Buffalo, New York
Allan Stone Collection, Courtesy of the Allan Stone Gallery, New York
Amon Carter Museum of American Art, Fort Worth, Texas
Bunty and Tom Armstrong
The Art Students League of New York, New York
Babcock Galleries, New York
Peter Blum, New York
Brooklyn Museum, New York
Anthony F. Bultman IV and Ellis J. Bultman
The Honorable and Mrs. Joseph P. Carroll, New York
Chrysler Museum of Art, Norfolk, Virginia
Des Moines Art Center, Iowa
Barry Friedman, Ltd., New York
The Adolph and Esther Gottlieb Foundation, New York
Grey Art Gallery, New York University Art Collection
Hirshhorn Museum and Sculpture Garden, Smithsonian Institution,
 Washington, D.C.
Basha and Perry Lewis
Tommy and Gill LiPuma, New York
The Metropolitan Museum of Art, New York
The Modern Art Museum of Fort Worth, Texas
Montclair Art Museum, New Jersey
Museum of Fine Arts, Boston, Massachusetts
The Museum of Fine Arts, Houston, Texas
The Museum of Modern Art, New York
National Gallery of Art, Washington, D.C.
Neuberger Museum of Art, Purchase College, State University of New York
New Orleans Museum of Art, Louisiana
Philadelphia Museum of Art, Pennsylvania
The Phillips Collection, Washington, D.C.
Private collection

Private collection, Brooklyn, New York

Private collection, courtesy National Gallery of Art, Washington, D.C.

Private collection, courtesy Eykyn Maclean

Rose Art Museum of Brandeis University, Waltham, Massachusetts

Fayez Sarofim Collection

Seattle Art Museum, Washington

Sheldon Museum of Art, University of Nebraska, Lincoln

The Estate of David Smith, New York

The Estate of David Smith, courtesy Joan Washburn Gallery, New York

The Estate of David Smith, courtesy Gagosian Gallery, New York

Smithsonian American Art Museum, Washington, D.C.

University of Arizona Museum of Art, Tucson

Weatherspoon Art Museum, The University of North Carolina
 at Greensboro

Whitney Museum of American Art, New York

Jane Voorhees Zimmerli Art Museum, Rutgers, The State University
 of New Jersey

FOREWORD

The Addison Gallery of American Art has a long history of collecting
and exhibiting early modernist art. Stuart Davis's *Red Cart* and David
Smith's *Structure of Arches* have held places of pride in our galleries for
many years. Our exhibition program has been enriched by presentations
of early abstraction of some of America's early- and mid-twentieth-century
masters, exhibitions both drawn from our own collection and on loan. Thus
when our close colleague Karen Wilkin and her co-curators William C.
Agee and Irving Sandler approached our curatorial team with the idea
of a show of the work of John Graham, Stuart Davis, Arshile Gorky, and
Willem de Kooning, we were immediately enthusiastic. Built on Wilkin and
Agee's work together on the Stuart Davis catalogue raisonné, informed by
Sandler's close connections with these artists, and bolstered by a similar
exhibition concept that Wilkin had pondered some years before, the
proposal laid out a thoughtful and engaging thesis, which promised a long-
overdue examination of an important and little-studied period in American
art. As this project unfolded over the past several years, our enthusiasm
and commitment to it were rewarded manyfold.

As Wilkin's exhibition précis so aptly argued, the late 1920s to the
early 1940s were formative years for some of America's most inventive
painters and sculptors. During this period, innovators such as Stuart
Davis, Arshile Gorky, Willem de Kooning, Jackson Pollock, David Smith,
and many more now legendary figures forged their identities as artists and,
as they did so, dramatically transformed conceptions of what a painting or
sculpture could be.

Among the most significant groups was the circle of artists associated
with John Graham, an enigmatic figure who played a pivotal role during
this period. By 1930, Graham, Gorky, and Davis were constantly in one
another's company. They were joined by the young de Kooning, who met the
trio not long after his arrival in New York in 1929. As de Kooning reported to
Harold Rosenberg, "I was lucky enough when I came to this country to meet
the smartest guys on the scene: Gorky, Stuart Davis, and John Graham."
Around these four were gathered many more, a remarkably varied cross-
section of some of the most remarkable American artists of the period.

Much has been written and many exhibitions organized about the most significant artists in Graham's circle, yet surprisingly, despite Graham's close links with so many of these artists in the evolution of American abstraction, he remains little known. This long-overdue exhibition rediscovers Graham and puts his art and charismatic influence in the context of his time. By bringing together works by the New York artists of Graham's circle, made during the years of their association with him, the curators provide visible testimony to dialogue and cross-fertilization as well as common sources and stimuli between these artists.

This exhibition concentrates on works by Graham, Davis, Gorky, and de Kooning, largely from the years 1927 to 1942, when they were in closest contact, set in a wider context of selected works by other members of the circle. The show also reassembles some works included in the formative exhibition, *French and American Paintings,* that Graham organized in 1942 for McMillen, Inc. This assembly of paintings and sculpture evidences the creative energy of New York painting and sculpture during this crucial period and fosters greater understanding of the associations formed by the leading artists of this formidable generation.

We are honored that our institutional collaborators at the Amon Carter Museum of American Art, Fort Worth, Texas, and the Neuberger Museum of Art, Purchase College, State University of New York, will host the exhibition, thus guaranteeing that this groundbreaking project will reach a wide national audience. We are also grateful to all the lenders, both institutional and individual, who have been willing to share works from their collections for the duration of the tour. Their generosity has made it possible for the exhibition to present the fullest examination of this important period of American art.

A project like this has called on many people and institutions over its formation. The curators express their sincere thanks to Emily Schuchardt Navratil, who has worked tirelessly on behalf of this project, and Alicia Longwell, whose recent dissertation on John Graham has been an essential resource. Their dedicated scholarship has resulted in the chronologies that

enhance our understanding of the artists who were participants in this fertile point in time.

Invaluable help has been offered to the curators by Fred Bancroft, Fernwood Art Investments; Armand Bartos, Armand Bartos Fine Arts; Ani Boyajian; Anthony F. Bultman IV; Krzysztof Ciezkowski of the Tate Library, London; the Honorable Joseph P. Carroll; Lyle Gray Dawson, director, Babcock Galleries; Asher Edelman, Edelman Arts; Sanford Hirsch, director, the Esther and Adolph Gottlieb Foundation; William Edward O'Reilly; Mark Rutkoski; Peter Stevens, director, and Susan Cooke, associate director, the Estate of David Smith; Professor Lucy Freeman Sandler of New York University; and Claudia Stone; with very special thanks to Harry Cooper, curator of modern and contemporary art at the National Gallery of Art, Washington, and Michael R. Taylor, Muriel and Philip Berman Curator of Modern Art at the Philadelphia Museum of Art.

On the Addison's part, special thanks go to Juliann D. McDonough, curatorial coordinator, who has worked far beyond the call of duty to attend to every detail of the project's organization, masterfully squiring this project through from beginning to end. Susan Faxon, our associate director and curator of art before 1950, has overseen the development and implementation of the exhibition with her unusual skill and attention. They and I thank the following for their generous assistance: Rebecca Endres, Albright-Knox Art Gallery; Lacey Imbert, assistant registrar, Amon Carter Museum; Melissa Kerr, managing director, The Arshile Gorky Foundation; Aimee L. Marshall, manager of rights licensing, The Art Institute of Chicago; Jennifer Belt, associate permissions director, Art Resource; Tess Schwab, gallery associate/researcher, Babcock Galleries; Deborah Lenert, visual resources manager, The Barnes Foundation; Yana Balson, Peter Blum Gallery-SoHo; Wendy Zieger, picture researcher, rights executive, and Bridgeman education specialist, Bridgeman Art Library; Elisa Flynn, Brooklyn Museum; Museum Services, Christie's; Jennifer M. Holl, collections registrar, Delaware Art Museum; Mickey Koch, associate registrar/rights and reproductions manager, Des Moines Art Center; Thomas McCormick, representative of the Estate of Jan Matulka (1890–1972), McCormick Gallery; James McKee, Gagosian Gallery; Nancy Litwin, art collection manager, Adolph and Esther Gottlieb Foundation, Inc.; Michèle M. Wong, registrar, gallery manager, Grey Art Gallery, New York University; Kim Bush, manager of licensing, Guggenheim Museum; Amy Densford, photography permissions manager, Hirshhorn Museum and Sculpture Garden, Smithsonian Institution; Mary B. Holt; Matthew Clouse, registrar, Joslyn Art Museum; Leila Saadai, exhibitions director, L&M Arts; Amy Chie, The Menil Collection; Heidi S. Raatz, visual resources librarian, Visual Resources Department, Permissions,

Minneapolis Institute of Arts; Allie Heath, image resources, Modern Art Museum of Fort Worth; Erica Jacob and Andrea Cerbie, Montclair Art Museum; Brigitte Milleron, Musée Zervos; Veronica Keyes, administrative assistant, Photographic and Imaging Services, Museum of Fine Arts, Houston; Cora Rosevear, associate curator, Department of Painting and Sculpture, The Museum of Modern Art; Liam Schaefer, Art Resource Inc.; Lehua Fisher, associate registrar for collections, Alicia B. Thomas, senior loan officer, and Barbara C. G. Wood, images and permissions coordinator, National Gallery of Art, Washington, D.C.; Stacey Sherman, imaging services, rights and reproductions, The Nelson-Atkins Museum of Art; Karol Lurie, curatorial administrator, Norton Museum of Art; Joseph Holbach, chief registrar and director of special initiatives, and Trish Waters, assistant registrar for visual resources and collection, The Phillips Collection; Lauren Tucker, associate registrar, Seattle Art Museum; Leslie Prouty, senior vice president, contemporary art, Sotheby's, New York; Lauren Rabb, curator, and Kristen Schmidt, registrar, University of Arizona Museum of Art and Archive of Visual Arts; Jill Stanley and Kim Tishler Rosen, VAGA (Visual Artists and Galleries Association); Elaine D. Gustafson, curator of collections, and Myra Scott, assistant registrar, Weatherspoon Art Museum, the University of North Carolina at Greensboro; Kiowa Hammons, rights and reproductions assistant, Whitney Museum of American Art; Amy Schichtel, executive director, and Ricki Lynn Moskowitz, archivist, The Willem de Kooning Foundation; and Kiki Michael, assistant registrar, Jane Voorhees Zimmerli Art Museum, Rutgers, the State University of New Jersey.

Once again, the Addison has been fortunate to work with our colleagues at Yale University Press, Patricia Fidler, publisher, art and architecture; Phillip King, manuscript editor; Katherine Boller, editorial assistant; Sarah Henry, production manager; and the talented designer Laura Lindgren, whose careful and graceful attention to the editing, designing, and production, have resulted in this elegant publication.

We are greatly honored to have the generous support of the Henry Luce Foundation and The Dedalus Foundation, Inc. Their acknowledgment of this fine project is gratifying to all of us. Our final appreciation goes to the three distinguished curators, Karen Wilkin, William C. Agee, and Irving Sandler, each among the giants in the interpretation of American modernism and mid-twentieth-century art. They have been delightful and immensely resourceful in putting together this important exhibition project. We offer our sincere gratitude to them all.

<div style="text-align:right">

Brian T. Allen
The Mary Stripp & R. Crosby Kemper Director
Addison Gallery of American Art

</div>

American Vanguards

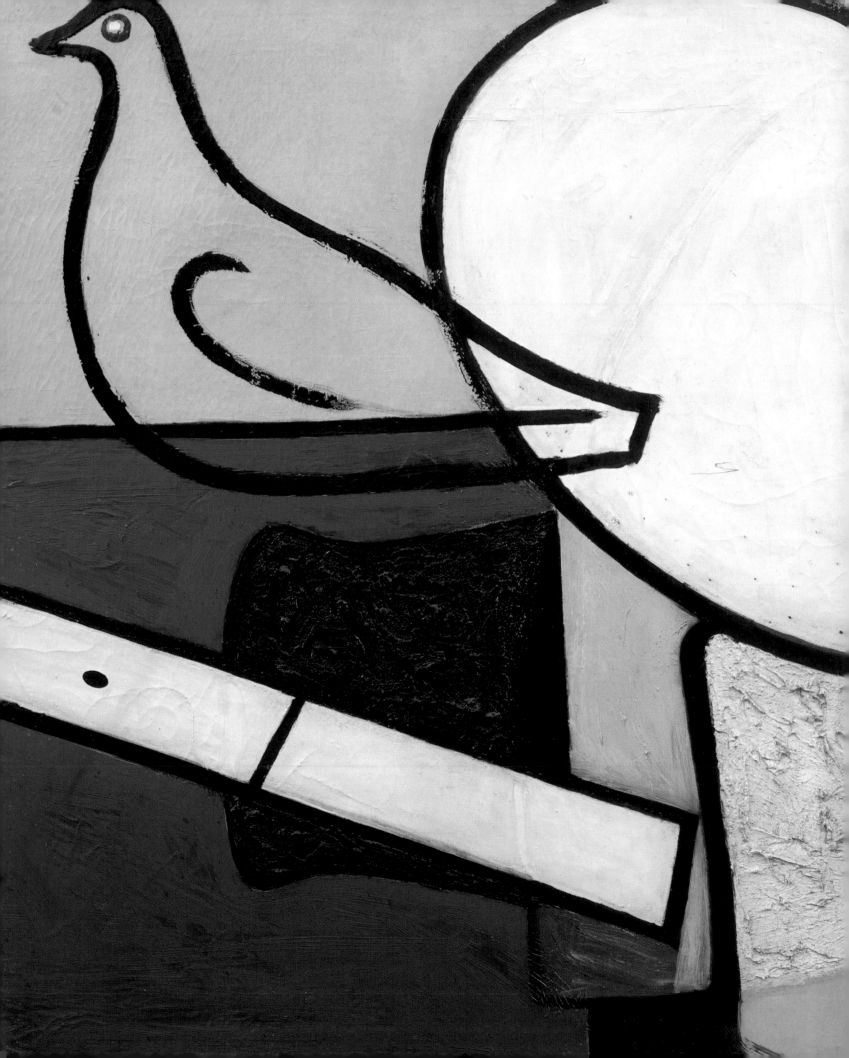

William C. Agee

Introduction

This catalogue and the exhibition it accompanies have been in the making for over forty years, perhaps even longer, all things considered. Each of my two co-curators and I have given much of our careers to the study of modernism and midcentury American art. Historian and art critic Irving Sandler, a friend of many of the artists included in this exhibition, has studied and written numerous publications focused on the painters and sculptors of this period. Art historian Karen Wilkin's comprehensive studies and writings have centered on individual artists represented in this exhibition as well as general examinations of mid-twentieth-century art.

For my part, these issues and these artists have engaged me since early in my career. In the fall of 1968, while a young curator at the Whitney Museum of American Art, I organized a major exhibition titled *The 1930s: Painting and Sculpture in America*. My purpose had been to show that despite the social, political, and economic calamities of the decade, not all the art of the time necessarily or by definition depicted or directly addressed these terrible realities. To be sure, the show did include artists associated with the period, such as Thomas Hart Benton, John Steuart Curry, Ben Shahn, Edward Hopper, and others. But equal representation was given to what I understood to be the continuing and newly emerging modernist currents of the time. These were artists who gave the period such a rich and fertile painting culture, one that had maintained and expanded the development of modernism in America since 1908.

Included were artists of the older, pioneering generation, John Marin, Marsden Hartley, and Arthur Dove among them, who were at the peak of their powers in the 1930s; surrealizing artists such as Man Ray; structural abstractionists such as Josef Albers, Burgoyne Diller, and Ilya Bolotowsky; color and expressionist artists, especially Milton Avery; Cubist artists who had developed in the 1920s and who continued at a high level, including Arthur B. Carles, Hans Hofmann, Stuart Davis, and John Graham. Finally there were artists of a younger generation just then emerging, including Willem de Kooning, Arshile Gorky, and Jackson Pollock, all of whom had earned some considerable recognition by 1940, if only among their peers.

Detail, pl. 3

I anticipated some controversy involving the inclusion of abstract art, but I had no idea of the anger and outrage that the exhibition would generate. It was attacked from all quarters, by critics, artists, and special interest groups, all quick to offer their own condemnation of the show. This included a coalition of black artists and community leaders protesting the absence of any black artists. (I don't arrange art by race, gender, religion, class, or sexual orientation.) At a symposium quickly organized by the museum's directors, one artist, critic, official, administrator, ripped the very idea that modern art had even existed in the 1930s, condemning the exhibition as a distortion and a hideous misreading of history. Only Harry Holtzman, an important abstract artist of the 1930s and later, and I spoke for the exhibition. We were shouting into the wind.

Two critics did have positive things to say. One of them was Lawrence Alloway, but more notable was the supposedly conservative Hilton Kramer, who highly praised the effort, although he faulted the inclusion of some weaker artists. (He was right.) Conversely, however, Harold Rosenberg, the putative champion of advanced art and new ideas, memorably excoriated the exhibition, from every possible point of view, in a lengthy article in the *New Yorker*.

Having developed my point of view for years, I remained confident in my approach. One of the first paintings I had ever seen was Stuart Davis's brilliant *Red Cart* of 1931 in the collection of the Addison Gallery of American Art at Phillips Academy, where I was a student. It is especially fitting and gratifying that the Addison is organizing this show, for the gallery was a bastion of modernism in the 1930s, when it was founded. In the early 1960s, I had directed a study of the government arts programs of the 1930s that convinced me of the period's importance in the development of American modernism. But it was axiomatic that the very mention of "the thirties" automatically brought up intractable images of dust bowl realism, radical politics, economic devastation, social upheaval and, by 1935, oncoming war in the Far East and Europe. Still today, when most people think of the 1930s, a Dorothea Lange photograph of an impoverished and anguished dust bowl migrant likely comes to mind, not a glorious Stuart Davis mural, *Swing Landscape* of 1938, celebrating the vitality and optimism of American life. This is not to disparage or disrespect Lange, or any socially conscious artist; it is only to say that the art of the period was far more diverse.

Clearly, the period needed to be put in a broader context of American art, to get beyond the poisonous label of "the thirties" that tainted our view of its art. By 1977, when I organized an exhibition along these lines at the Museum of Fine Arts, Houston, that helped to place the 1930s as a continuation of art that had started in this country before World War I,

and had pointed to post-1945 developments, the tenor had changed. In 1982, John R. Lane, then director of the Carnegie Museum of Art, and I planned an exhibition, *Abstract Painting in America, 1927–1944,* starting with Stuart Davis's breakthrough and influential paintings, the *Egg Beater* series of 1927–28, and ending in the year Piet Mondrian died in New York, closing a period of precisionist, tightly structured abstraction. The show included a large selection from members of the American Abstract Artists, an important and respected group founded in 1936 to further abstract art, a group that is still going today. This exhibition was a breakthrough in American modernist studies and laid the foundation for subsequent examinations of the period. In addition to these efforts, Michael Fitzgerald's comprehensive study of Pablo Picasso and America, which gave sustained attention to the period and to Graham, Davis, Gorky, and de Kooning, helped American modernism between the wars reclaim its heritage in abstract art.

In 1984, my colleague Karen Wilkin, who had written a book on Stuart Davis, and I began close and sustained study of Davis for the preparation of his catalogue raisonné, which demonstrated that political commitment could, if not always peacefully, at least coexist with an abstract modernist language of the highest order. Davis was more committed to radical politics, artists' rights, and social and artistic justice than any artist of the time, yet with the exception of two or three minor examples, it never showed in his art. He belongs to a tradition of American artists who have insisted on keeping their political, social, and economic beliefs separate from their art. At the same time, his art is rich with content and meaning.

Through our work, Ms. Wilkin and I came to realize that Davis and his long-standing associate Gorky had joined with John Graham to form a group that came to be called the Three Musketeers, with de Kooning making a fourth. The resulting Four Musketeers were among the best artists in New York, and their mutual interaction formed a vital part of the history of American modernism. Graham was an older, European-oriented artist, collector, art adviser, writer, and facilitator, respected and admired by his younger friends and by many artists of the time. Graham and his friends had been included in the original 1968 show, but I was then unaware of their close ties. Indeed, the circle around Graham was not limited to the original four, but touched on and included other artists, including David Smith, Lee Krasner, Edgar Levy, Dorothy Dehner, Jan Matulka, Adolph Gottlieb, and Jackson Pollock. Together, this group formed a genuine avant-garde of the period, of inestimable value to the course of American modernism.

One of Graham's many skills was his fine eye for young emerging talent, and he offered welcome and needed encouragement to many.

Graham first met Davis in 1928, the first encounter of the group, and he acted as a mentor to numerous modernists until 1942, when he organized an important if little-known exhibition, *French and American Paintings,* at McMillen, Inc., in New York, which offered the first public recognition of several of these artists, most notably de Kooning and Pollock. After 1942, Graham apparently renounced Picasso and modernism, although I believe we have misread him in these years in ways I discuss in my essay later in the book.

Scholarship in the field of American art has matured in recent years, and we have benefited from new viewpoints and research that help us to see the 1930s with a more informed and intelligent eye. Still, so deep are the memories or received ideas, it is possible that this exhibition may raise some of the same issues brought up by Harold Rosenberg in his review from 1968. They are worth discussing because they touch on how we understand and write art history. Rosenberg, like many of his generation, remained bitter about the grim realities and economic desperation of the 1930s, and most of all angry at the failed promise of a better society promoted by the leftist causes they supported. For such, the art also had to be grim, and failed; Gorky called this kind of art "poor art for poor people," a harsh sentiment but with much truth to it.

Rosenberg recalled the 1930s as an "interval," in which history set aside art, a "drop out" formally. This was not true, and we can now see the decade as part of an ongoing history of art in America. For Rosenberg and others, the financial plight of artists took precedence over aesthetic problems; but as de Kooning said, "We were all poor and worried only about the work. It used to be all artistic ideas."[1] Rosenberg claimed that only "a tiny minority" of artists continued to work with the teachings of Cubism, Surrealism, and Neo-Plasticism. However, as the *Abstract Painting in America* show demonstrated in 1982, and as we continue to learn, there were many more abstract artists than we had imagined. Remember, too, that tiny minorities, sometimes a single artist, have transformed modern Western art and art history. Think of Caravaggio, who saved European painting from the perversions of late Mannerism with his daring innovations in about 1600; of a small group of Impressionists in the 1870s who completely changed the idea of art; and two solitary artists, Picasso and Georges Braque, who reversed five hundred years of perspective and illusionism by inventing Cubism, a new language for modern art. Art, and art history, are not matters of majority rule.

Critics complained that the 1968 exhibition was based on current taste, that of the 1960s, and that is true, but how else can we read history if not from the present? Indeed it was clear that Cubism had continued in the 1960s in the work of Smith, Hofmann, Davis, George L. K. Morris,

Charles Sheeler, and others, so the 1968 show was discovering patterns perhaps unseen or understood at the time but more clearly visible now in retrospect. Finding and defining these patterns is a primary function of art history. The 1930s was not a backward-looking decade. These artists were progressive, extending what had come before into new and personal visions, in the way that the best art has always done. The best art of the 1930s was in constant motion, changing and developing as it matured, and producing some of the most accomplished works of American modernism. The period was rich and deep, and deserves our full attention and admiration for what it brought to our history. The 1930s and indeed our entire history of art, long diminished, rightly deserve celebration.

Note

1. Irving Sandler, *From Avant-Garde to Pluralism: An On-the-Spot History* (Lenox, Mass.: Hard Press Editions, 2006), 35.

Plates · 1926–1930

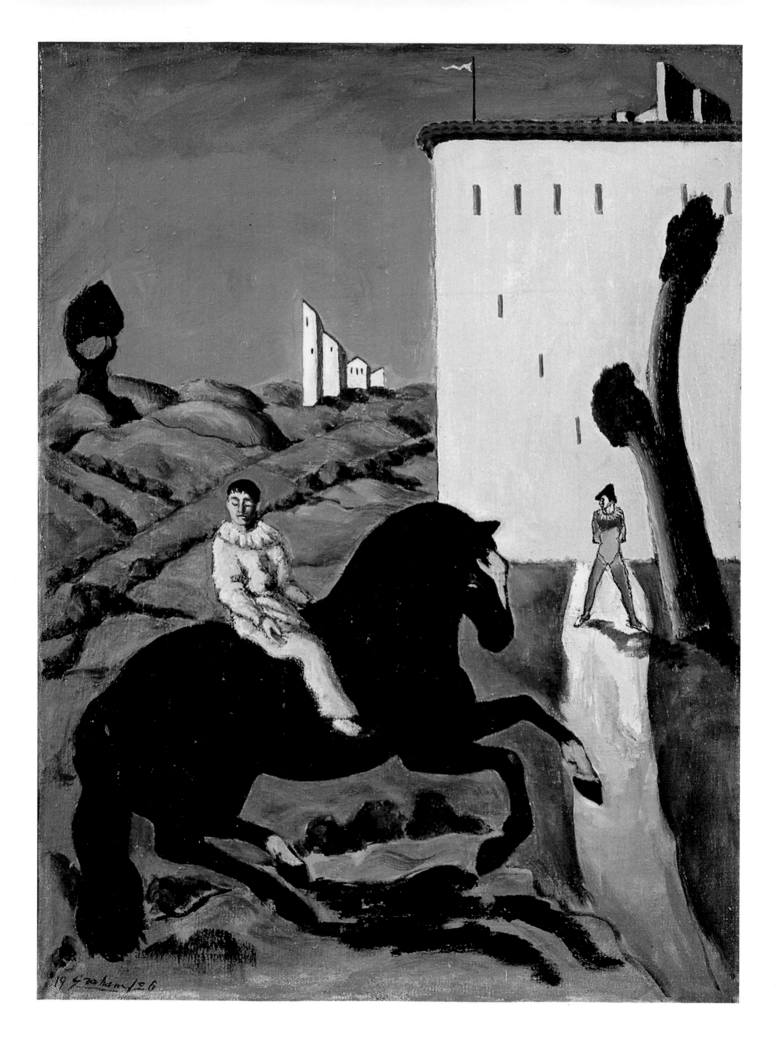

2
John Graham (1887–1961)
Sailboat, 1927
Oil on canvas mounted on cardboard
8⅞ × 15¼ in. (22.5 × 38.7 cm)
The Phillips Collection, Washington, D.C.

1 *(opposite)*
John Graham (1887–1961)
Horse and Rider (recto), *Portrait of a Woman* (verso), 1926
Oil on canvas
22 × 16 in. (55.9 × 40.6 cm)
Collection of The Honorable and Mrs. Joseph P. Carroll, New York

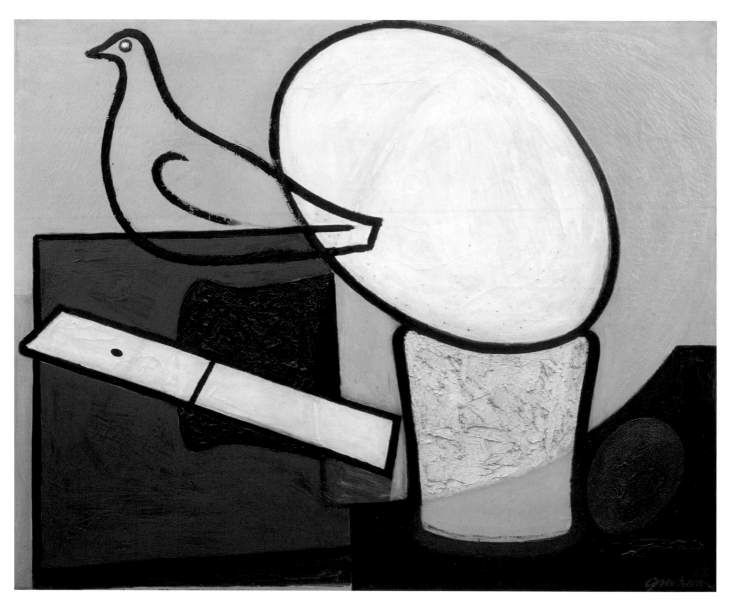

3
John Graham (1887–1961)
Table Top Still Life with Bird, 1929
Oil on canvas
32 × 39 in. (81.3 × 99.1 cm)
Collection of Tommy and Gill LiPuma, New York

4

Willem de Kooning (1904–1997)

Still Life with Eggs and Potato Masher, c. 1928–29

Oil and sand on canvas

18 × 24 in. (45.7 × 61 cm)

Collection of The Honorable and Mrs. Joseph P. Carroll, New York

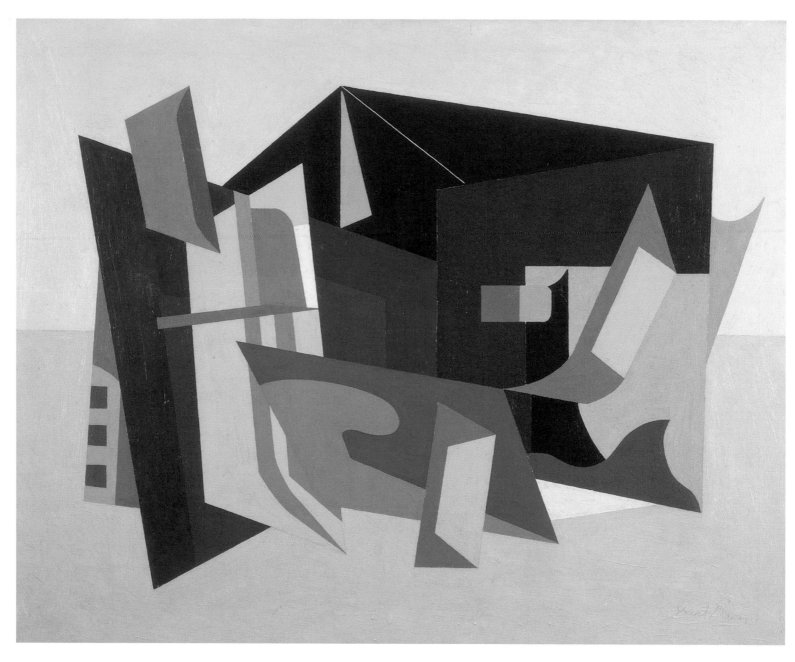

5
Stuart Davis (1892–1964)
Egg Beater No. 1, 1927
Oil on canvas
29⅛ × 36 in. (74 × 91.4 cm)
Whitney Museum of American Art, New York,
Gift of Gertrude Vanderbilt Whitney, 31.169

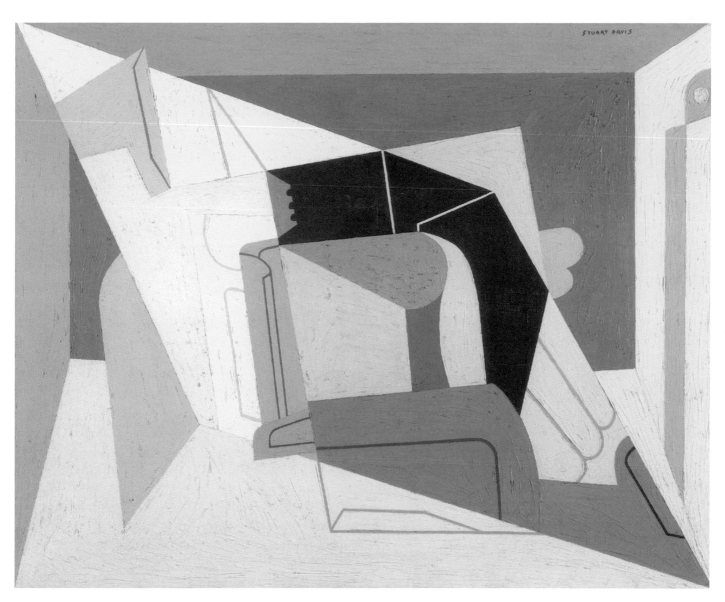

6

Stuart Davis (1892–1964)

Egg Beater No. 2, 1928

Oil on canvas

29¼ × 36¼ in. (74 × 91.4 cm)

Amon Carter Museum of American Art,

Fort Worth, Texas, 1996.9

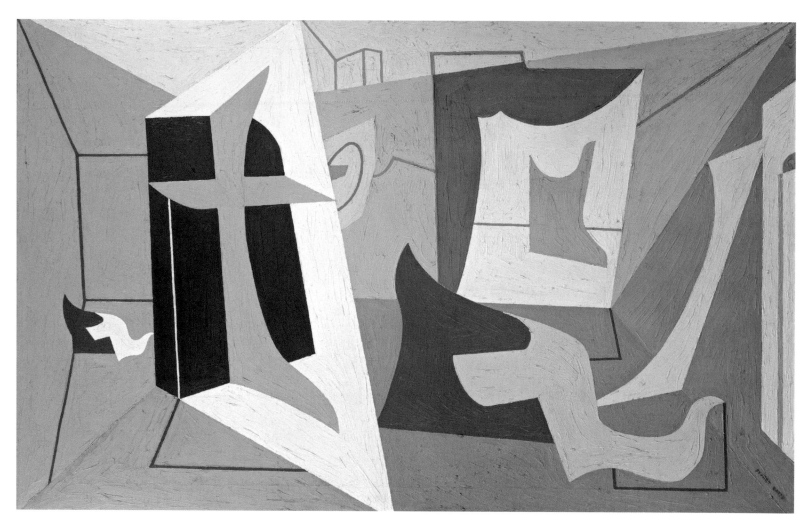

7
Stuart Davis (1892–1964)
Egg Beater No. 3, 1928
Oil on canvas
25⅛ × 39⅛ in. (63.8 × 99.4 cm)
Museum of Fine Arts, Boston, Gift of the
William H. Lane Foundation, 1990.391

8

Stuart Davis (1892–1964)
Rue des Rats, No. 2, 1928
Oil and sand on canvas
20 × 29 in. (50.8 × 73.7 cm)
Hirshhorn Museum and Sculpture Garden,
Smithsonian Institution, Washington, D.C.,
Gift of Joseph H. Hirshhorn, 1972

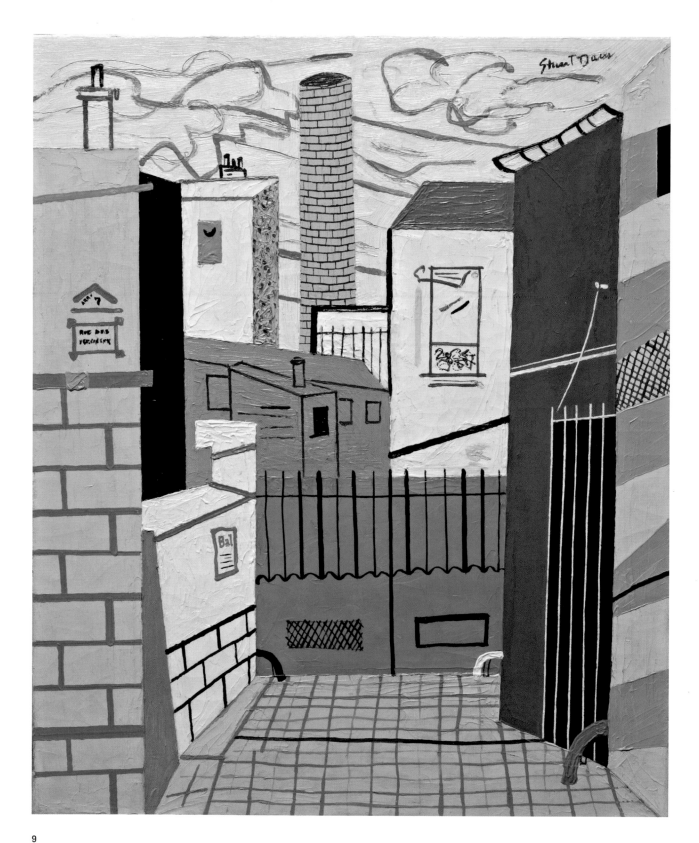

9

Stuart Davis (1892–1964)
Adit No. 1 (Industry), 1928
Oil on canvas mounted on masonite
28½ × 23½ in. (72.4 × 59.7 cm)
University of Arizona Museum of Art, Tucson,
Gift of C. Leonard Pfeiffer

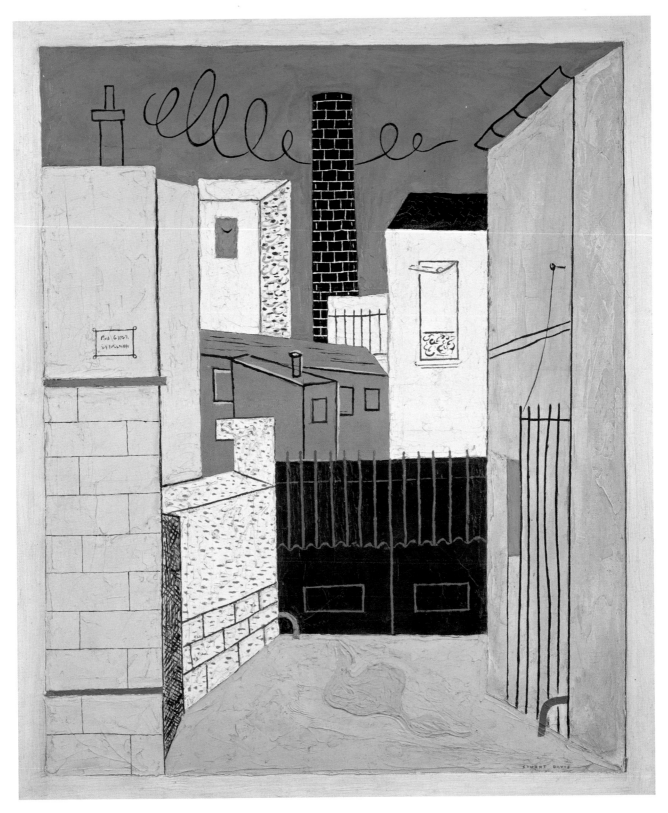

10

Stuart Davis (1892–1964)

Adit No. 2, 1928

Oil on canvas

28⅞ × 23¾ in. (73.3 × 60.3 cm)

Museum of Fine Arts, Boston, Gift of the

William H. Lane Foundation, 1990.394

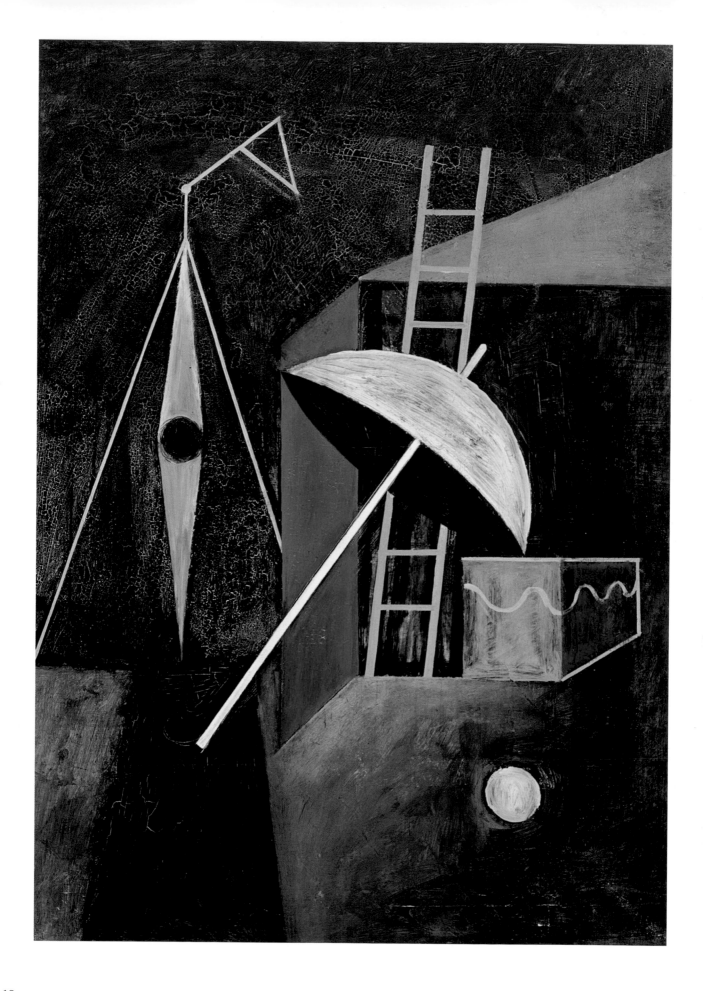

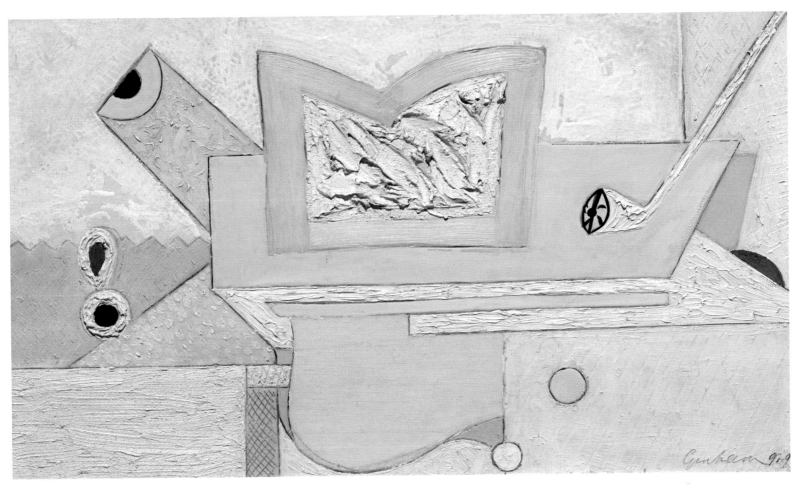

12
John Graham (1887–1961)
Still Life with Pipe, 1929
Oil on canvas
13¼ × 23 in. (33.7 × 58.4 cm)
The Museum of Fine Arts, Houston, Gift of Mr. and
Mrs. George R. Brown and George S. Heyer, Jr.

11 (*opposite*)
Willem de Kooning (1904–1997)
Untitled, c. 1928
Oil on canvas
28 × 20½ in. (71.1 × 52.1 cm)
Private collection

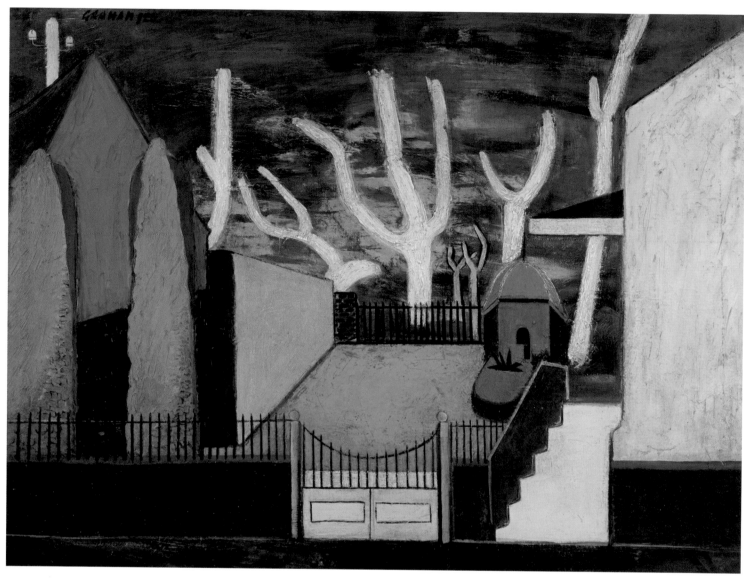

13

John Graham (1887–1961)

Vigneux, 1929

Oil on canvas

19⅝ × 25¼ in. (49.8 × 64.1 cm)

The Phillips Collection, Washington, D.C.

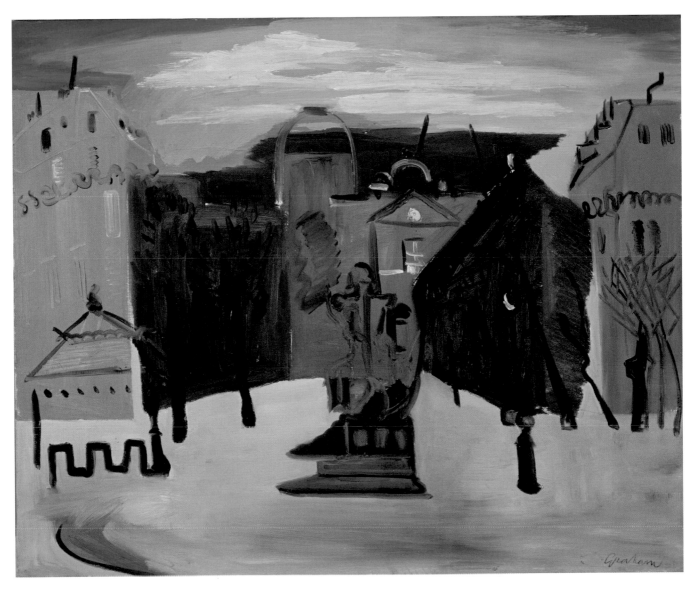

14
John Graham (1887–1961)
Fountain, 1929
Oil on canvas
21¼ × 25¼ in. (54 × 64.1 cm)
The Phillips Collection, Washington, D.C.

15
Stuart Davis (1892–1964)
Arch Hotel, 1929
Oil on canvas
28¾ × 39½ in. (73 × 100.3 cm)
Sheldon Museum of Art, University of
Nebraska–Lincoln, UNL–F. M. Hall Collection

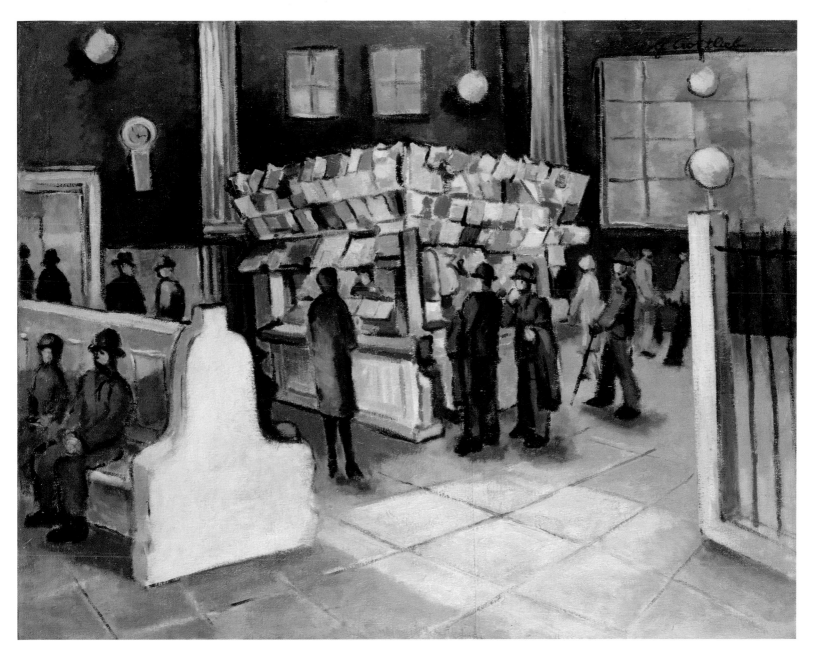

16
Adolph Gottlieb (1903–1974)
South Ferry Waiting Room, c. 1929
Oil on cotton
36 × 45 in. (91.4 × 114.3 cm)
Adolph and Esther Gottlieb Foundation, New York

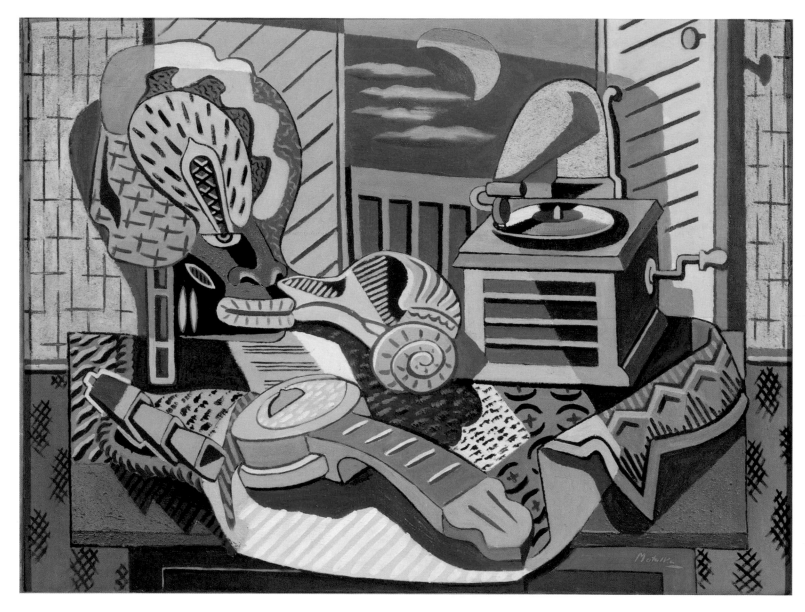

17

Jan Matulka (1890–1972)

Arrangement with Phonograph, 1929

Oil on canvas

30 × 40 in. (76.2 × 101.6 cm)

Whitney Museum of American Art, New York,

Gift of Gertrude Vanderbilt Whitney, 31.298

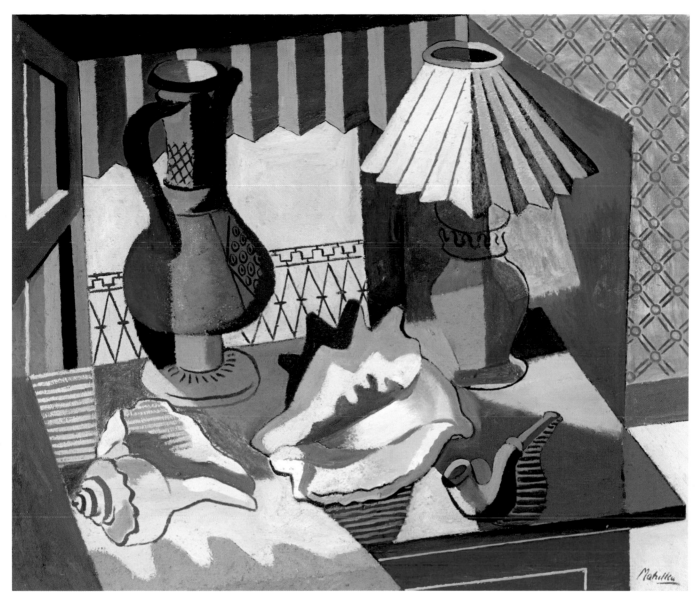

18

Jan Matulka (1890–1972)

Still Life with Lamp, Pitcher, Pipe, and Shells, 1929–30

Oil on canvas

30 × 36 in. (76.2 × 91.4 cm)

The Museum of Fine Arts, Houston, Museum purchase

19

Arshile Gorky (1904–1948)

Enigma (Composition of Forms on Table), 1928–29

Oil on canvas

33 × 44 in. (83.8 × 111.8 cm)

Collection of The Honorable and Mrs. Joseph P. Carroll, New York

20
Arshile Gorky (1904–1948)
Still Life with Palette, c. 1929–30
Oil on canvas
28¼ × 36¼ in. (71.8 × 92.1 cm)
Montclair Art Museum, Museum purchase,
funds provided by the Ball Committee,
1972.18

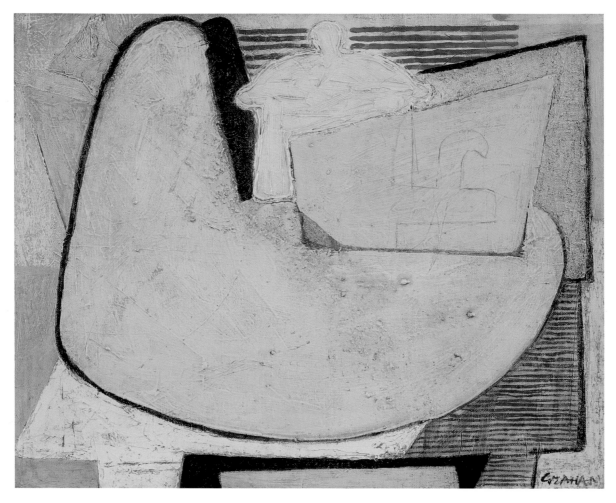

21

John Graham (1887–1961)
The Yellow Bird, c. 1930
Oil on canvas
16⅛ × 20⅛ in. (41 × 51.1 cm)
Weatherspoon Art Museum, The University
of North Carolina at Greensboro, Museum
purchase with funds from the Jefferson-
Pilot Corporation, 1970

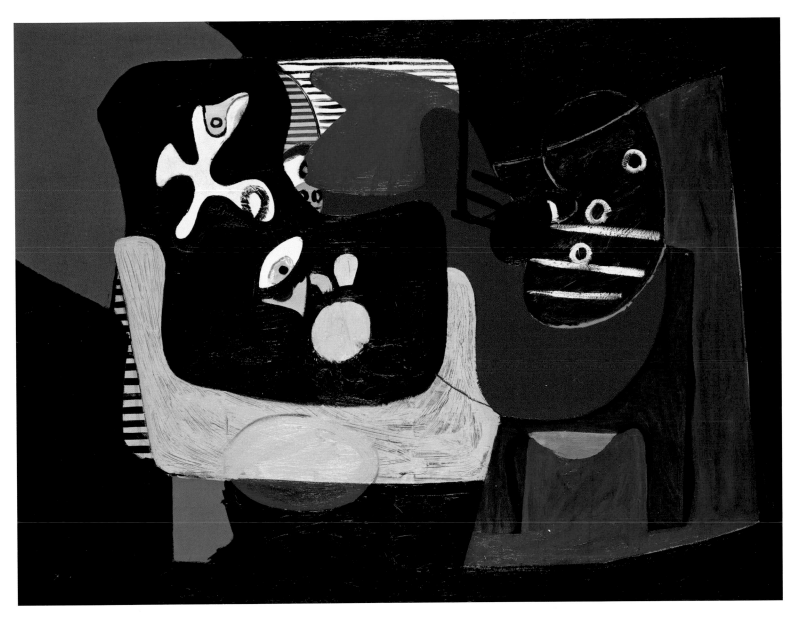

22
Arshile Gorky (1904–1948)
Still Life, c. 1930–31
Oil on canvas
38½ × 50⅜ in. (97.8 × 127.9 cm)
Chrysler Museum of Art, Norfolk, Virginia,
Bequest of Walter P. Chrysler, Jr., 89.51

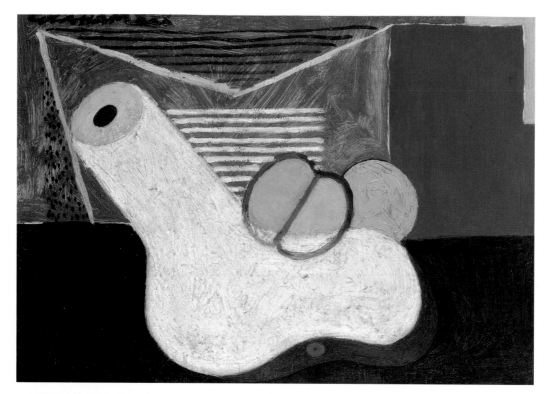

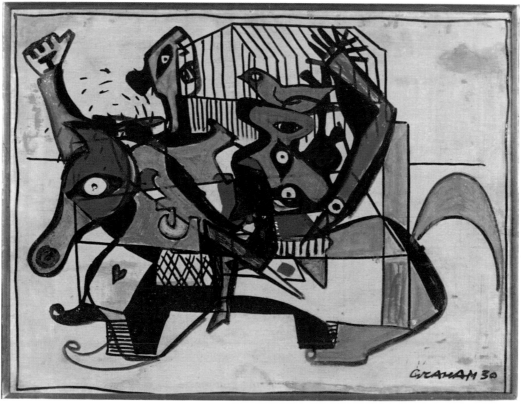

23
John Graham (1887–1961)
The White Pipe, 1930
Oil on canvas mounted on board
12¼ × 17 in. (31.1 × 43.2 cm)
Grey Art Gallery, New York University Art
Collection, Gift of Dorothy Paris, 1961

24
John Graham (1887–1961)
Untitled, 1930
Oil on canvas
16 × 21 in. (40.6 × 53.3 cm)
Collection of Basha and Perry Lewis

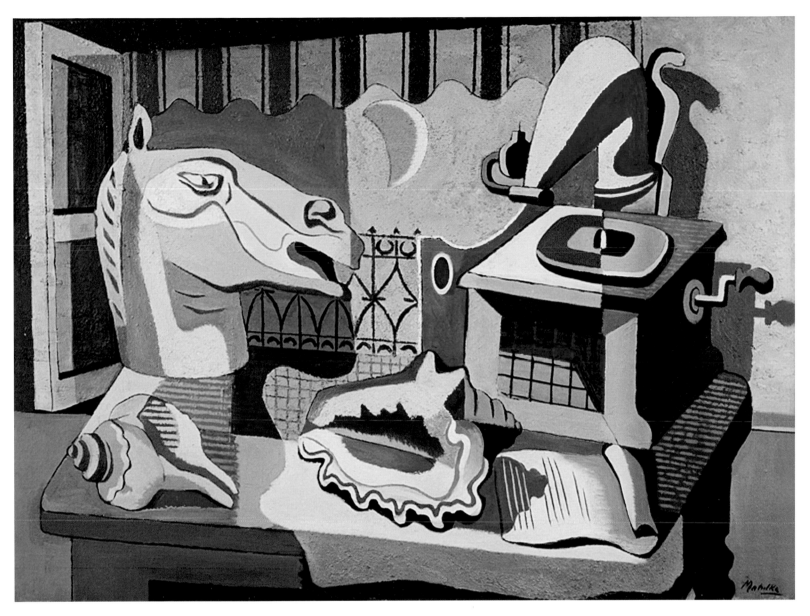

25

Jan Matulka (1890–1972)

Still Life with Horse Head and Phonograph, 1930

Oil and sand on canvas

24 × 40¼ in. (61 × 102.2 cm)

The Art Students League of New York, Permanent Collection

26

David Smith (1906–1965)
Untitled (Table Top Still Life), c. 1930
Oil on canvas
18 × 12 in. (45.7 × 30.5 cm)
The Estate of David Smith, Courtesy
Gagosian Gallery, New York

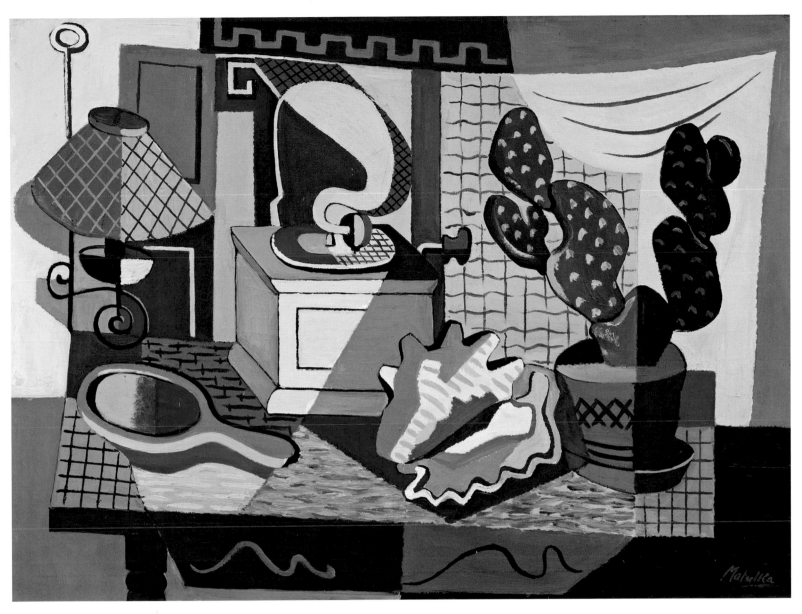

27

Jan Matulka (1890–1972)

Composition, c. 1930

Oil on canvas

30 × 40 in. (76.2 × 101.6 cm)

Collection of Bunty and Tom Armstrong

Karen Wilkin

All for One:
A Dedication to Modernism

Coming Together

History is sporadically illuminated by brilliant constellations of talent
and creativity, groups of remarkable artists who appear, by some
amazing serendipity, in the same place, at the same time. We look back
with fascination from other centuries and other locales, wondering what
quattrocento Florence was like in the years when Masaccio, Donatello,
Lorenzo Ghiberti, Filippo Brunelleschi, and Paolo Uccello were all making
work that would forever transform Western painting, sculpture, and
architecture. How would cinquecento Venice have felt during the decades
when Titian and his younger protégés—and sometime rivals—Tintoretto
and Veronese were competing for patronage and commissions? What
was seventeenth-century Leiden like when the young Rembrandt and his
prodigiously gifted friend Jan Lievens were experimenting with a staggering
variety of approaches, possibly even in the same studio, and receiving visits
from the discerning poet-statesman-connoisseur Constantijn Huygens?

Such dazzling concurrences have happened more recently—in Paris,
during the first years of Impressionism, when Frédéric Bazille could
populate a casual gathering in his studio with portraits of his friends
Claude Monet, Pierre Renoir, Émile Zola, and Edouard Manet (who was
entrusted with depicting the very tall Bazille's image). Or in the early
part of the twentieth century, when Pablo Picasso, Georges Braque, Henri
Matisse, and their colleagues reinvented how painting might be defined
from their studios in Montmartre and the Left Bank. More recently,
in New York, there is the Abstract Expressionist constellation in the
1950s, the moment when, we are told, "everyone"—Willem de Kooning,
Jackson Pollock, Franz Kline, Adolph Gottlieb, Mark Rothko, and their
colleagues—gathered at the Cedar Tavern and the Club. Fueled by heroic
amounts of alcohol, they debated burning issues of "authenticity" and the
necessity of abstraction, ultimately altering the definitions of painting and
sculpture as dramatically as they had been in quattrocento Florence or
early-twentieth-century Paris.

Detail, pl. 63

Yet the legendary era of the Cedar Tavern and the Club was not the first time that a group of gifted New York artists came together and profoundly affected the trajectory of American modernism. Decades earlier, from the years just before the Great Depression started until the entry of the United States into World War II, a cluster of ambitious, talented, young (and youngish) men and women individually expanded the possibilities for American art through their work and collectively laid the foundations for the notions so ardently discussed, sometimes by their own older selves, at the Club and at that celebrated blue-collar bar near Eighth Street. Today, these artists are recognized as some of America's most important painters and sculptors, but then they were, for the most part, at the beginning of their professional lives. They included such now iconic figures as Stuart Davis, Arshile Gorky, Willem de Kooning, Jackson Pollock, Adolph Gottlieb, and David Smith, as well as Dorothy Dehner and Lee Krasner, along with a powerful (and sometimes influential) "supporting cast" that included Alexander Calder, Edgar Levy, Jan Matulka, and David Burliuk, among others.

This small, notably diverse group was linked by shared aesthetic assumptions, by friendship and common aspirations, by proximity as neighbors, and often, during the 1930s, by their shared progressive politics and experience as members of the Federal Art Project. From the late 1920s to the early 1940s, they forged their identities as artists, as they strove to assimilate the lessons of innovative new European art and to find their own voices. United by their enthusiasm for the visual language of the European vanguard and their rejection of the sentimental, conservative social realism of the American Scene painters—whom Gottlieb derisively called "the Corn Belt Academy"—these artists embraced, with equal enthusiasm, Cubism's geometry and spatial inventions, and Surrealism's biomorphism and ambiguity.[1] They embraced, too, the conviction that a work of art's material presence was part of its meaning and that the artist's role was not to report on the seen but to reveal the invisible. Their fusion of these ideas, first in the 1920s and 1930s, later expanded and more fully explored in their own mature work, announced the advent of a brash, uniquely American idiom based on generous scale, openness, and an emphasis on physicality.

It is plain that in the 1920s and '30s these enthusiastic pro-modernists looked to such masters as Picasso, Joan Miró, Alberto Giacometti, and Julio González for stimulus and direction. Frequently, it is easy to identify which European vanguard works exhibited in New York during these years of search and experiment elicited which response, whether the result was adoption, homage, or reinvention. But these burgeoning artists were also alert to each other's efforts. Their own verbal and visual conversation was as vital to the course of adventurous American art as the example of the vanguard painters and sculptors they admired on the other side of the Atlantic.

Most of these forward-looking young artists were more or less coevals, born between 1901 and 1912 (except for Davis, born at the end of 1892), but their backgrounds varied dramatically. Gottlieb and Krasner were the only native New Yorkers, although Davis, born in Philadelphia and raised in New Jersey, had lived in the city since he enrolled at Robert Henri's art school at sixteen. Pollock, Smith, and Dehner came to New York from the West and Midwest. (Smith and Dehner met in 1926, soon after his arrival in the city, when he moved into the Upper West Side rooming house where she lived and, at the landlady's suggestion, asked Dehner for advice about where to study art; she recommended the Art Students' League. They married the following year.) De Kooning and Gorky were European immigrants, de Kooning from the Netherlands and Gorky from Armenia, although he often presented himself as Russian. Some of them lived near each other in Brooklyn Heights, which was then, Dehner recalled, an inexpensive, quieter alternative to Greenwich Village, where many of the others were based.[2] Their formations as artists and their experience of art were equally diverse at the time they all met. Most were essentially autodidacts before coming to New York; Smith had only a few unhelpful college art courses, Dehner, who saw a good deal when she had—remarkably—traveled on her own in Europe, had no formal art training, and Gorky had taken one semester of drawing classes before becoming a drawing instructor himself. Gottlieb, by contrast, was a knowledgeable sophisticate, having worked his passage to Europe at seventeen to spend a year and a half studying art in Paris and traveling to museums in Germany and elsewhere. De Kooning had been thoroughly trained in both commercial art and traditional painting techniques at the Rotterdam Academy of Fine Arts and Technical Sciences.

If their divergent backgrounds separated these artists, many of them were united by having studied at the Art Students League in the early 1920s, in John Sloan's drawing class, or between 1929 and '31 in the Czech Cubist Jan Matulka's life drawing, painting, and composition course.[3] Matulka, the League's instructor most informed about modernism, was particularly influential. His introduction to the clearly differentiated shapes, evenly saturated color, and rhythmic patterning of Synthetic Cubism can be seen in the work of most of his students, such as Dehner's *Still Life* (pl. 33), Levy's *Still Life, Figure, Self-Portrait* (pl. 52), and Smith's *Untitled (Billiards)* (pl. 45). The combination of School of Paris formal strategies with vernacular subject matter in Matulka's own work (pl. 27) may have spoken with particular directness to his students, who were searching for an American identity. Many found his teaching so stimulating that they followed him to his private classes after he left the League.

If a fervent commitment to making art and to modernism drew this heterogeneous group together, the key element that kept them connected was their common friendship with the painter, connoisseur, theoretician, and mystic John Graham. He is an enigmatic figure, older than most of them, described by Dehner as a "brilliant, contrary, witty, insightful and sometimes exasperating personality."[4] He figures in most accounts of twentieth-century American art, but his pivotal role during the complex period of the 1920s and '30s has yet to be sufficiently acknowledged. Graham proves to be a ubiquitous, possibly essential figure in the evolution of the art of his American friends. His strange, cranky volume, *System and Dialectics of Art,* published in Paris and New York in 1937, provides a glimpse of the passionate discussions held among his circle. A Socratic dialogue of questions and answers, the book reads at once as a reflection of Graham's conversation and a manifesto of the agreed-upon truths within his milieu. *System and Dialectics of Art* dissects current ideas about creativity, the collective unconscious, primitivism, and abstraction; it even addresses such problems as the relationship between art and crime: "two things apart. . . . The perfect form of crime is murder, it is fundamentally destruction. Art is construction."[5] Throughout, we find assertions of fundamental modernist beliefs of the period—that art is a kind of communication, that it is independent of mimesis, that it reveals the unknown, that the unconscious is the source of creativity—along with the occasional nod at social responsibility. "What is art?" is answered by "*a creative process of abstracting,*" italicized for emphasis. "Art in particular is a systematic confession of personality," Graham continues. "Art in general is a social manifestation."[6] There are allusions to Freudian concepts of the self and Jungian ideas about shared cultural memory, echoes of Wassily Kandinsky's spiritually charged writings and of *The Golden Bough,* Sir James Frazer's pioneering account of how religion and rituals transcend time and place, and more.

"The business of art," Graham wrote, "is not to portray life or nature or their aspects . . . but by using nature as a point of departure draw pertinent conclusions, create new values which will eventually enlighten people on the subject of pure truth."[7] More specifically, "the purpose of art in *particular* is to reestablish a lost contact with the unconscious . . . with the primordial racial past and to keep and develop this contact in order to bring to the conscious mind the throbbing events of the unconscious mind."[8] Establishing a connection with those "throbbing events" was essential to the creative process. "Our unconscious mind," Graham wrote, "contains the record of all our past experiences—individual and racial, from the first cell germination to the present day. . . . The unconscious mind is the powerhouse, the creative agent."[9] Even Graham's later mysticism is prefigured. "The origin of art lies in the human longing for

enigma, for the miraculous, for expansion, for social communication . . . for communication and consequently—life eternal."[10] Reading *System and Dialectics of Art* makes us feel privy to the topics Graham and his New York artist friends must have talked about—or listened to him talk about—during their frequent gatherings.

A Mystery Wrapped in an Enigma

Who precisely was the author of *System and Dialectics of Art*? Since Graham habitually embellished or altered his accounts of his history, the question has not been easy to answer, but recent scholarship has clarified things considerably.[11] Born Ivan Gratianovich Dombrowski in 1886, in Kiev, Ukraine, to a family of Polish nobles originally from Warsaw, he had studied law in prerevolutionary Russia and served in the czarist cavalry. After the revolution, he was imprisoned by the Bolsheviks and, it appears, then released (although he preferred to say that he escaped), leaving Moscow soon after and arriving in the United States via a circuitous route in 1920. Before 1917, Graham, like many young Muscovites interested in art, frequented Sergei Shchukin's remarkable collection of French modernist art, installed in his home in the Trubetskoy Palace, and became acquainted with its extraordinary Cézannes, Matisses, Picassos, Bonnards, and more. Toward the end of his life—he died in 1961—Graham recalled visiting the discerning textile merchant's collection about 1905 or 1906 and seeing a small room "where he had some new paintings of a young painter, by name of Picasso." (Shchukin had about fifty works and exhibited them separately from the rest of the collection.) Graham claimed, too, that he told Shchukin that Picasso was "by far the best of all."[12] The young cavalry officer may also have seen some of the vanguard art exhibitions held in pre-1914 Moscow; he seems to have known such aesthetic radicals as Mikhail Larionov, David Burliuk, Naum Gabo, El Lissitzky, Natalia Goncharova, Vladimir Tatlin, and the poet Vladimir Mayakovsky.[13]

Graham later said that he drew and wanted to be an artist "from earliest childhood," but received no formal art instruction, since for anyone of his class and generation "artist" was not an acceptable profession.[14] But if drawing and looking at art were avocations for the aristocratic military man with legal training when he was in Russia, making art, theorizing and writing about art, advocating modernism, and bringing like-minded artists together became his main preoccupations once he came to the United States. After his arrival in New York, Ivan Gratianovich Dombrowski reinvented himself, as so many immigrants to America did, first as "John Dabrowsky," then as "John Graham."[15] He began to study art seriously by enrolling at the Art Students League in 1922, taking a variety of courses, most importantly John Sloan's drawing class, where his fellow students

included Gottlieb and Alexander Calder. It was the beginning of a multi-strand, extensive web of connections that would make Graham's name crop up repeatedly in any discussion of American art in the years preceding the Second World War. That web became more complex after 1924, when Graham married Elinor Gibson, a fellow student at the League, and moved to her native Baltimore. Supported by the local advocates for advanced art, he began to exhibit, with some success, and soon met the region's leading collectors of modernism, Dr. Claribel Cone and her sister Etta in Baltimore, and Duncan Phillips in Washington. Warm friendships developed, and the Cone sisters and Phillips began to acquire Graham's work, Phillips with such dedication that he can be termed a patron.

Graham's art world network became more intricate after 1926, when he began traveling regularly to Paris. He spent an extended period there in 1928, exhibiting at Leopold Zborowski's Left Bank gallery and being received by French critics as yet another gifted foreign-born member of the School of Paris—as an "American painter." He was even the subject of a modest critical monograph. After Graham reestablished himself in New York later in 1928, he returned annually to Paris, continuing to show there until 1930. His fluent French, the residue of his upbringing as a member of upper-class Russian society, facilitated his connections with the French vanguard, as did his function as a connoisseur-dealer who acquired works of art and African artifacts to sell to American collectors.

A Conduit for Modernism

Back in New York, Graham's artist friends were eager for information about new European art, but in the mid-1920s, little of it was on view in the city. Although it was possible, as it had not been at the time of the Armory Show in 1913, to import European art less than a hundred years old duty free, advanced recent art was shown only at a few commercial galleries; only a handful of institutions, such as the Société Anonyme, founded in 1920, a forerunner of the Museum of Modern Art, or the Whitney Studio Club, founded in 1918, an ancestor of the Whitney Museum of American Art, could be described as dedicated to new movements in the arts. By the late 1920s the climate had improved slightly. Works from Albert Gallatin's collection, which emphasized French Cubism, were shown at the Gallery of Living Art, which opened in December 1927 at New York University, close to the downtown homes and studios of many of Graham's circle. In 1929, the Museum of Modern Art opened, and over the following decade a growing number of commercial galleries began to provide New Yorkers with firsthand, if limited, exposure to radical European ideas.[16] Dorothy Dehner recalled how energetically she and her colleagues sought out exhibitions: "We looked at everything we could see," she said. "We were hungry."[17]

The majority of the American artists in Graham's circle had not yet been to Europe. Gottlieb's teenage sojourn and studies in Paris were exceptional. The extended trip Smith and Dehner made in 1935 and '36 (funded by an inheritance) and Gottlieb's return visit to Europe, with his wife Esther, in 1935, were not typical at the time; most artists could not afford such ambitious travel during the Depression, although Smith later told David Sylvester that "most of us tried to go to Europe if we could; most of us did."[18] Davis's fifteen months of painting and making prints in Paris, in 1928 and '29, conferred lasting authority on him, enhancing his position among his peers as a well-informed, uncompromising modernist. Graham was an even more valuable and admired source of information for his New York friends, as a recognized participant in the Parisian vanguard art world, a regular visitor who exhibited there, knew everyone, and was able to report on the most current exhibitions, bolstered with fresh gossip and new art magazines. Dehner said that Graham "brought the excitement of the French art world to us," noting that he "knew the painters of that time, and the writers Eluard, Breton, Gide, and others were his friends."[19] Perhaps most important, Dehner recalled, Graham showed the members of his New York circle "copies of *Cahiers d'art* and other French art publications of which we had been unaware."[20] The images in these magazines were sometimes supplemented by the works of art Graham brought back to New York for the collectors he advised; the combination offered a far more current notion of what was going on among adventurous Parisian artists than could be gleaned from the limited offerings in New York exhibitions.

Smith's history illustrates just how important Graham's information about new-minted vanguard European art could be. As Dehner recalled, "Matulka was the great influence on David's painting; but John Graham was a perfectly tremendous influence on his life and philosophic attitude. He introduced David to a wider world."[21] The magazines Graham showed Smith, it can be argued, were among the most crucial influences on the young artist's lifelong direction. In the early 1930s, in response to (Graham's friend) Matulka's teachings, Smith, who largely thought of himself as a painter, began to carve and to make three-dimensional constructions in wood, wire, stone, and soldered metal. Matulka encouraged his painting students to differentiate shapes with variations in texture; Smith interpreted this so extremely that "the painting developed into raised levels from the canvas. Gradually the canvas became the base and the painting was a sculpture."[22]

During the summer of 1932, spurred by reproductions of works by Picasso, González, and Henri Laurens in Graham's magazines, Smith began to use a forge and anvil at his Bolton Landing farm. The definitive

and most important stimulus came, once again, from Graham's issues of *Cahiers d'art,* where Smith saw reproductions of Picasso's and González's constructed metal sculptures. Smith was unable to read the French text, but the images and their newfangled materials and techniques, which owed nothing to the history of art, impressed him greatly. Since he knew how to weld from having worked on a Studebaker assembly line between semesters of college, he not only quickly grasped the implications of what he saw in *Cahiers d'art,* but was able to act on them. In 1933, Smith made a series of iron heads, almost certainly the first welded sculptures made in the United States, including *Chain Head* (pl. 35). The same year, Graham arranged for Smith to design and make wooden bases for an important collection of African sculptures that he had helped assemble for Frank Crowninshield (among other things, an organizer of the Armory Show in 1913 and a founder of the Museum of Modern Art). Dehner recollected that the project required her and her husband to live for weeks with "several hundred" works in their apartment, a remarkable opportunity for close study of potent objects.[23] Later, Graham showed Smith several González sculptures, probably the first in the United States, and in 1934 he gave Smith a small, masklike González head. All of these experiences resonate in the paintings Smith made in the 1930s, and even more strongly in his extraordinary early sculptures; we can trace his parallel interest in African carving's embodiment of "the primitive"—as it was then called—and the radical rethinking of what "sculpture" itself meant, embodied by Picasso's and González's open, linear, welded constructions, combined with an admixture of Picasso's paintings, seasoned with Surrealist ideas about the role of the unconscious and transformed into Smith's distinctive workmanlike but astonishingly delicate and responsive idiom.

Not all of Graham's encounters with his artist friends in New York can be diagrammed in terms of such clear cause and effect. But his name recurs persistently from the 1920s to the early 1940s, whether we are dealing with the best known innovators of the period or with less familiar artists. Again and again, Graham seems to be the crucial link in a chain of friendships, the source of vital information, the catalyst in a significant development, the provider of useful advice, the instigator of new connections in an ever-enlarging web of artist-colleagues. Dehner and Smith, for example, met Graham in 1930, when they were studying at the Art Students League.[24] For several summers, in the early 1930s, Graham and his wife rented a farmhouse in the Adirondacks, close to the Smiths' Bolton Landing property, and in 1936 lived near them in Brooklyn. Through Graham, the Smiths came to know Davis, de Kooning, and, as Dehner recounted, "the artists who had come from Russia, Arshile Gorky, David Burliuk, and [Nikolai] Vasilieff among them."[25] Graham may also

have provided initial introductions to Edgar Levy, Milton Avery, Jean Xceron, Frederick Kiesler, and Jackson Pollock, who were also part of his circle in the 1930s. Such introductions often led to more than casual acquaintanceships. The ambiguous biomorphic forms in both Smith's and Gorky's work of the 1930s suggest nourishing exchanges in the studio, Burliuk was enough of a friend to make a flattering portrait of Smith (pl. 83), and Levy and his wife, the illustrator Lucille Corcos, became the Smiths' intimates and neighbors in Brooklyn. Dehner described Levy as "a real intellectual," a cultivated, well-read man whose paintings, which he rarely showed, demonstrate his understanding of Cubist space and Picasso's work of the period; Graham, in *System and Dialectics of Art,* mentions Levy as an "example of highly developed taste."[26] Like Graham he acted as a conduit of information and current ideas. The Greek-born Xceron, who went frequently to Paris, as Graham did, was also a source of up-to-date news; Smith always credited him with having helped him decide to concentrate on sculpture.[27]

Graham seems to have had an instinct for bringing together artists with significant common ground, as starting points in the tangled relationships surrounding him. He may, for example, have played a role in the Smiths' long friendship with the Gottliebs, which began when the two couples became neighbors in Brooklyn Heights in the early 1930s. Graham and Gottlieb had a long history. They met at the Art Students League and became close about 1924; when Gottlieb began collecting African sculpture—a lifelong pursuit—the knowledgeable Graham pointed him in the right direction. Yet simple proximity cannot be ruled out of the equation. The Smiths and Gottliebs were particularly friendly with their mutual neighbors, the Levys; a print made in 1933, a grid of six images, each a portrait of one of the group by one of the others, attests to their close connection quite apart from their relationship with Graham (pl. 82). When the Smiths left Brooklyn in 1935 to travel in Europe, Graham, who was on one of his annual trips, met them in Paris and introduced them to artists and collectors; Smith declined to be presented to Graham's friend Picasso, ostensibly because he spoke no French but really, Dehner has suggested, because he was unwilling to address any artist as "maître," as Picasso required.[28] When the Smiths went on to the Soviet Union, Graham arranged for them to meet his ex-wife and adult children in Moscow. Such intertwined stories are typical.

The Three Musketeers

Graham appears to have been everywhere and known everyone during the 1920s and '30s, but at the core of his multivalent, wide-reaching reticulum of connections were his close relationships with Davis and Gorky. Davis and Graham are thought to have met sometime in 1928,

before Davis left New York for Paris; they were probably introduced by Sloan, whom Graham knew from the League, and whom Davis had been close to since boyhood, when Sloan did newspaper illustrations for Davis's art editor father.[29] Gorky and Graham seem to have met sometime in 1928 as well, possibly brought together by "the artists who had come from Russia," Burliuk and Vasilieff. Gorky and Davis did not know each other until Graham introduced them after Davis's return to the United States in the late summer of 1929, but by 1929 or 1930, when de Kooning had gotten to know all of them, they were so close that the admiring young Dutch painter dubbed them "the Three Musketeers" and joined them as d'Artagnan did the fictional heroes of Alexandre Dumas.[30] William C. Agee has suggested that the four enigmatic figures in Stuart Davis's mysterious, often reworked *American Painting,* 1932 and 1942–54, may have been intended as "portraits" of the Musketeers and de Kooning (fig. 1). The Three Musketeers were an impressive, if unlikely trio: two rather exotic immigrants and one irreducibly American native son, two of them distinguished by their mustachioed good looks, all three notable for their assured manner, and all revered among their fellow artists for their knowledge of modernism and their commitment to adventurous art. Looking back on his early years in New York, de Kooning often spoke of meeting the Musketeers as crucial to his understanding of modernism and his life as a painter. "I was lucky enough when I came to this country," he told Harold Rosenberg in 1974, "to meet the three smartest guys on the scene: Gorky, Stuart Davis and John Graham."[31]

Graham and Davis's friendship seems to have solidified while Davis was working in Paris in June 1928. With funds from the sale of two paintings to the director of the Whitney Studio Club for Gertrude Vanderbilt Whitney's collection, Davis rented a studio—formerly Matulka's—on rue Vercingétorix in Montparnasse; Graham soon arrived for an extended sojourn and moved into a studio on nearby rue Huyghens. The two painters almost certainly worked at the same print studio during this period, while Davis's letters and recollections suggest other time spent together. Graham arranged for Fernand Léger and Davis to exchange studio visits and may also have connected Davis to Calder, who was then dividing his time between New York and Paris; Graham knew Calder from Sloan's class at the League and was close enough to him to be the subject of one of his wire portraits, which Graham later gave to Smith as a token of friendship (pl. 81). The informal contacts among the expatriate American community, however, may have made an introduction unnecessary. Davis noted in his biography: "The prevalence of the sidewalk café was an important factor. It gave easy access to one's friends."[32] In any event, meeting Calder at the time would probably not have been high on an

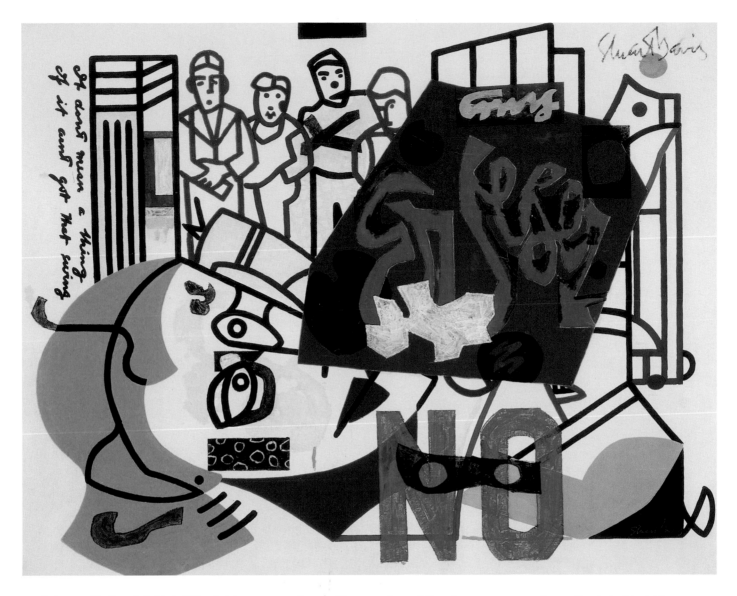

aspiring artist's wish list. "Tonight we are going to the opening of Sandy Calder's exhibit on the Rue de Boëtie (son of Sterling Calder)," Davis wrote home. "Nobody is much interested in his work but it is an excuse for a lot of people to bump into each other."[33]

Graham's and Davis's paintings of the period bear witness to their friendship. They often reflect a common fascination with distinctively "French" subject matter, as well as an interest in aggressive surfaces, sometimes thickened with sand, as were Braque's still lifes of the time. Such paintings include Davis's *Rue des Rats, No. 2,* 1928, and *Adit No. 2,* 1928 (pls. 8 and 10), and Graham's *Vigneux,* 1929, *Fountain,* circa 1929, and *Still Life with Pipe,* 1929 (pls. 13, 14, and 12). Yet there are equally strong similarities in Graham's and Davis's work from before they met; given the respective dates of Graham's *Sailboat,* 1927 (pl. 2), and Davis's *Early American Landscape,* 1925 (fig. 2), for example, the compressed space and crisply delineated shapes in both paintings must speak not to contact but to a common awareness of European modernist precedents. Whatever the inspiration, Davis's stylized improvisation on a New England harbor in *American Landscape* is more formally audacious than Graham's *Sailboat,* just as most

Fig. 1. Stuart Davis (1892–1964), *American Painting,* 1932 and 1942–54. Oil on canvas, 40 × 50¼ in. (101.6 × 127.6 cm). On permanent deposit to the Joslyn Art Museum from the University of Nebraska at Omaha Art Collection.

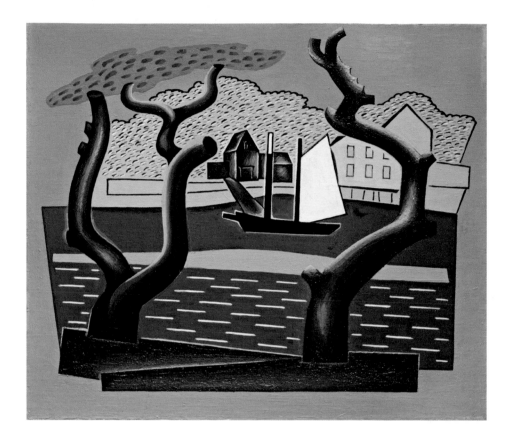

Fig. 2. Stuart Davis (1892–1964), *Early American Landscape,* 1925. Oil on canvas, 19 × 22 in. (48.3 × 55.9 cm). Whitney Museum of American Art, New York, Gift of Juliana Force, 31.171.

of Davis's Paris pictures are more structurally daring than Graham's French scenes, no matter how attached he was to the particulars of the streetscape.

In marked contrast to Davis's forthright paintings of the late 1920s, some of Graham's canvases of the period reveal his interest in the recently launched Surrealist movement. He originally dismissed Surrealism as appropriate only to literature, but he seems to have changed his mind about its underlying principles, adopting its faith in the potency in what he called in *System and Dialectics of Art* the "throbbing events of the unconscious mind" and "the human longing for enigma." Graham's insistence on the importance of our interior life to art making, stated explicitly in his provocative book and implicitly by the overtones of early Miró and of Giorgio de Chirico in works such as *Horse and Rider,* 1926 (pl. 1), makes his close friendship with the famously pragmatic, ironic Davis all the more surprising. Davis always stressed his independence from the literal but, at the same time, adamantly refused to be called an "abstract" painter, insisting that his art of what he called "color space logic" derived solely from his empirical experience of actuality—sights, sounds, textures, moods, and temperatures; these experiences were then translated into linear "configurations" and spatially animated with color.

It is true that some of Davis's strongest paintings of the early 1930s, made after his return to New York from Paris—pictures such as *Radio Tubes* and *Salt Shaker* (pls. 28 and 29)—seem indebted to Miró as well as to Picasso, but they depend on objective observation as the source of their imagery, filtered through a wholly American conception of Cubist construction. Nowhere in his voluminous notations, made over a lifetime, did Davis attribute to the unconscious mind the importance that Graham

does in *System and Dialectics of Art,* and he wholly rejected art based on internal rather than external sources. "Surrealism," Davis wrote, "denies the objective world and is escapist. It denies the classic function of art—bold assimilation of the environment."[34] In 1922, Davis declared that a work of art should be "first of all impersonal in execution, that is to say it should not be a seismographic chart of the nervous system at the time of execution."[35] Twenty years later, he had not changed his mind. "Emotion, Sensibility, Stimulation does not produce Art except when it is integrated with an emotionally conscious theory of dimensional structure," Davis wrote—a typically convoluted verbal equivalent of such firmly constructed works as *Red Cart,* 1932, *Gloucester Harbor,* 1938, and *Shapes of Landscape Space,* 1939, which distill perception into syncopated but disciplined patterns and rhythmic, hard-edge color planes (pls. 31, 50, and 54).[36]

Yet we draw firm conclusions about the chameleon Graham's position at our peril. In *System and Dialectics* he may have emphasized the central role of the enigmatic, but he also stated that *"Art is a subjective point of view expressed in objective terms"*—italics his—as well as asserting that "The only legitimate abstract painting is the painting based on and departing from hard reality and not from the imagination," and "A painting is a *self-sufficient* phenomenon and does not have to rely upon nature." More forcefully and peevishly, he asserted: "Art has nothing to do with representation, impersonation, interpretation, decoration, compromise, character or psychological problems. It contains psychological problems but deals with them in terms of form and not subject matter."[37] These are sentiments worthy of Davis and might even reflect his conversations with Graham on the subject.

Unlike Davis, who was firm in his cool-headed dedication to "color space logic," but like many artists of his circle, Graham seems to have been equally attracted to Cubist notions of reinterpreting perception and Surrealist conceptions of making visible the unseen, oscillating between internal and external reality as his starting point. He could, as Davis did, derive his imagery from the visible world, in Cubist-inflected works such as *Table Top Still Life with Bird,* 1929, or *The White Pipe,* 1930 (pls. 3 and 23). But he could also produce highly charged mythological images, such as *Europa and the Bull* (pl. 44), conjuring up an imagined event by means of obsessively interlocked shapes that at once pay homage to the Surrealists' biomorphic dreamscapes and to Picasso's paintings of the 1930s—themselves a response to Surrealist notions.

By the early 1940s, Graham's work, while still wide ranging, seems more driven by what he called "the human longing for enigma, for the miraculous, for expansion" than by "departing from hard reality." A work such as *Interior,* 1939–40 (pl. 61), still seems obedient to Cubist

notions of space, but it is populated by configurations that anticipate the unidentifiable symbols scrawled on a continuous, non-specific ground in paintings such as *Sun and Bird,* circa 1941–42, and *Untitled,* 1942 (pls. 62 and 66). These suggest an affinity with the aesthetic preoccupations at the time of Graham's old friend Gottlieb. Gottlieb was then well embarked on his mysterious *Pictograph* series of paintings (pl. 65), with their ambiguous glyphs arranged on loose grids, having moved from freely rendered visions of the urban environment to accomplished abstractions informed by Cubism, by way of sharply observed Surrealist-inspired still lifes and landscapes (pls. 16, 49, and 64). The arresting but unreadable calligraphic fragments of the *Pictographs* speak to Gottlieb's faith in the eloquence and universality of wordless signs excavated from the unconscious mind, an assumption that would later inform the expressive opposition of "characters" in his signature *Bursts.* Yet just as Graham's French paintings of the 1920s lacked the formal daring of Davis's Paris pictures, the rather expedient imagery of his "symbolic" canvases of the early 1940s lacks the subtlety and variety of Gottlieb's *Pictographs.*

For all of Graham's flirtation with Cubism or Surrealism, the Three Musketeers long had broader aims for their art, independent of its connection with existing European-inspired approaches. In December 1930, Graham wrote to his patron, Duncan Phillips, in Washington, that "Stuart Davis, Gorky, and myself have formed a group and something original, purely American is coming out from under our brushes."[38] Yet for all his desire to identify himself as an "original, purely American" artist and significant as his friendship was with the American-born Davis, Graham's work often suggests that he had more in common with his fellow immigrant Gorky. Like Graham, Gorky had reinvented himself in the United States, disguising his identity as Vosdanig Adoian, a survivor of the horrific persecution of Armenians in the wake of World War I, by becoming "Arshile" (a version of Achilles) "Gorky," a Russian, related, he said, to the writer Maxim Gorky—a name that itself was a pseudonym. (Although Dehner included him among "the artists who had come from Russia," his close friends knew his real origins; the fiction clearly could not be sustained with the Russian-born Graham, and Davis even visited Gorky's Armenian relatives near Boston with his friend sometime in the 1930s.)[39]

Like Graham, too, Gorky was sure of his aesthetic convictions and apparently ready to lecture anyone about art at any time. He was deeply informed about the art of the past, the recent past, and the present, as a result of his passionate study of works of art and his self-imposed apprenticeship to his artist heroes, as he systematically absorbed the aesthetic lessons of Paul Cézanne, Picasso, Matisse, Braque, and Miró.

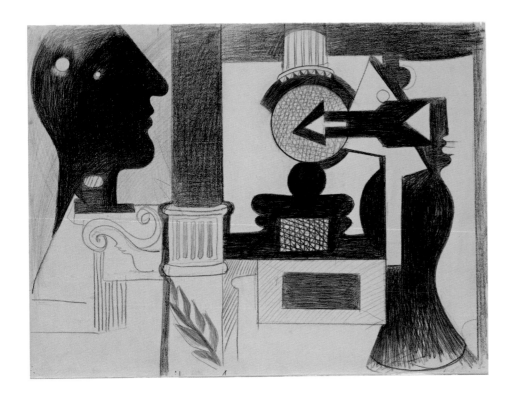

Fig. 3. Arshile Gorky (1904–1948), *Column with Objects (Nighttime, Enigma, and Nostalgia)*, c. 1931–32. Graphite on paper, 18⅞ × 25 in. (47.9 × 63.5 cm). Private collection.

By 1930, Gorky's own voice had emerged clearly, without obscuring either his earlier obsessions or his ongoing conversation with his fellow Musketeers and the rest of Graham's circle. Gorky's ferocious study of Picasso and Miró is visible in works such as *Xhorkom—Summer,* 1936, and *Organization,* 1933–36 (pls. 38 and 42), for example, but their simplified, expressively shaped, clearly bounded planes and unexpected marzipan palette have equally clear connections with Davis's *Egg Beater* series, made almost a decade earlier, in 1927–28 (pls. 5, 6, and 7). The argument appears to be taken up again, by yet another member of Graham's circle, in works such as Smith's *Amusement Park,* 1938, or *Structure of Arches,* 1939 (pls. 53 and 56), which transform the thickly painted version of Cubist construction proposed by Gorky's paintings into subtle, three-dimensional metal lines and volumes. The dense surfaces of Gorky's *Organization* and paintings such as *Enigma (Composition of Forms on Table),* 1928–29 (pl. 19)—evidence of prolonged reworkings, overpaintings, and adjustments—may have something to do with Braque's sand-thickened expanses from that time, but they probably owe as much to Graham's insistence on the importance of edges. Dehner recalled that "the quality of the 'edge' was something that Graham spoke about constantly," recalling, too, that he admired Milton Avery's edges, and that he "stressed the necessity of keeping the paint alive."[40]

Gorky's work offers suggestive evidence of fruitful cross-fertilization among the Musketeers and their friends. *Column with Objects,* for example, a drawing from his surrealizing series *Nighttime, Enigma, and Nostalgia,* circa 1931–32 (fig. 3), seems to pay homage to Picasso with its overscaled silhouetted profile and to Graham with its title, yet a brash street sign arrow seems to have come straight from one of Davis's urban improvisations. The two painters were close at the time and the influence seems to have been reciprocal. The eerie, atypically biomorphic shapes

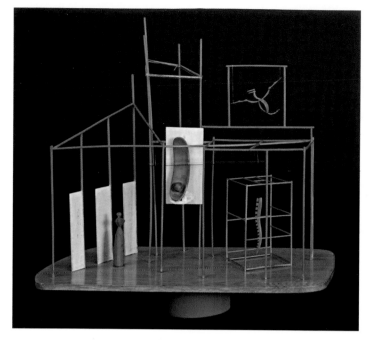

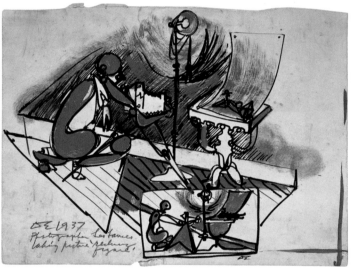

Fig. 4. Alberto Giacometti (1901–1966), *The Palace at 4 a.m.*, 1932. Wood, glass, wire, and string, 25 × 28¼ × 15¾ in. (63.5 × 71.8 × 40 cm). The Museum of Modern Art, New York, Purchase.

Fig. 5. David Smith (1906–1965), *The Photographer Leo Lances Photographing a Sculpture*, 1937. Ink and wash on paper, 17½ × 10¼ in. (44.5 × 26 cm). The Estate of David Smith.

in works such as Davis's *Radio Tubes* (pl. 28) and *Flags,* both from 1931, seem provocatively similar to those of Gorky's paintings of about the same moment. That the two artists deeply appreciated each other's work is well documented. In September 1931, Gorky wrote an enthusiastic appraisal of his friend Davis's work for the magazine *Creative Art,* praising him—surprisingly, given the simmering intensity of Gorky's own work—for his Apollonian detachment. "The silent consequences of Stuart Davis move us to the cool and intellectual world where all human emotions are disciplined by rectangular proportions," a place, Gorky wrote, "where all dreams evaporate and logic plays its greatest victory."[41]

Davis returned the favor twenty years later, several years after Gorky's death, in a wry, affectionate memoir written for the *Magazine of Art.*[42] Gorky was also close to Davis's younger brother, Wyatt, a photographer, in part because his wife, Mariam, was of Armenian origin. Gorky's *Aviation* murals, which he worked on between 1934 and 1937, begun for Floyd Bennett Field and eventually installed in the Newark Airport administration building, originally were intended to incorporate photographs by Wyatt Davis, although that part of the project was later dropped. Gorky's lucid graphic designs for the finished murals, with their stylized airplane imagery and bold, uninflected shapes, suggest that he paid close attention to the work of Stuart Davis, who had already completed a major mural project for the men's smoking lounge of the new Radio City Music Hall.

There is never a simple—or a single—pattern for the relationship of the works of the Musketeers and their friends. Just how ideas triggered by the European vanguard were tossed back and forth among them and how they were transformed along the way can be intuited from Smith's sculpture *Interior,* 1937 (pl. 47), a complex steel "drawing" that at first acquaintance seems principally deduced from Alberto Giacometti's cage-like "house" sculpture, *The Palace at 4 a.m.,* 1932 (fig. 4). Smith knew the Giacometti well, from both its reproduction in *Cahiers d'art* and its exhibition at the Museum of Modern Art, which acquired the work in 1936. Smith obviously found the frail, haunted construction provocative, since he used its skeletal framework and reference to a building as a point of departure for several of his strongest works from the 1930s to 1950.[43]

Yet several of his drawings suggest a more quotidian
origin for *Interior:* a session with the photographer
Leo Lances to record a sculpture of a reclining nude
(itself indebted to a reclining nude by González owned
by Graham, in the drawing) that became *Interior*'s
vertical figure, constructed out of swelling masses
(fig. 5). More surprisingly, Gorky's *Composition,* 1937,
echoes both the structure and the implicit theme

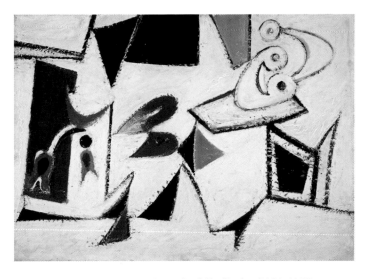

of *Interior,* translated into a two-dimensional arrangement of emphatic
lines and colored shapes against a loaded expanse of white (fig. 6).
Gorky's angular drawing and, especially, his interlocking curved forms
"balanced" on a tilted rectangular plane seem to bear the same relation
to *Interior*'s sketchy "room" and table-mounted "sculpture" that Smith's
construction does to *The Palace at 4 a.m.* An even more surprising, perhaps
fortuitous "reprisal" appears much later, in Davis's bipartite painting
Deuce, 1951–54, which derives from notebook drawings dated 1947 (fig. 7).
Davis's schematic studio interior, with a table supporting an exuberant

Fig. 6. Arshile Gorky (1904–1948),
Composition, 1937. Enamel on canvas,
29⅛ × 39⅞ in. (73.9 × 101.3 cm).
The Museum of Fine Arts, Houston,
Bequest of Caroline Weiss Law.

Fig. 7. Stuart Davis (1894–1964), *Deuce,*
1951–54. Oil on canvas, 26 × 42¼
in. (66 × 107.3 cm). Collection San
Francisco Museum of Modern Art,
Gift of Mrs. E. S. Heller.

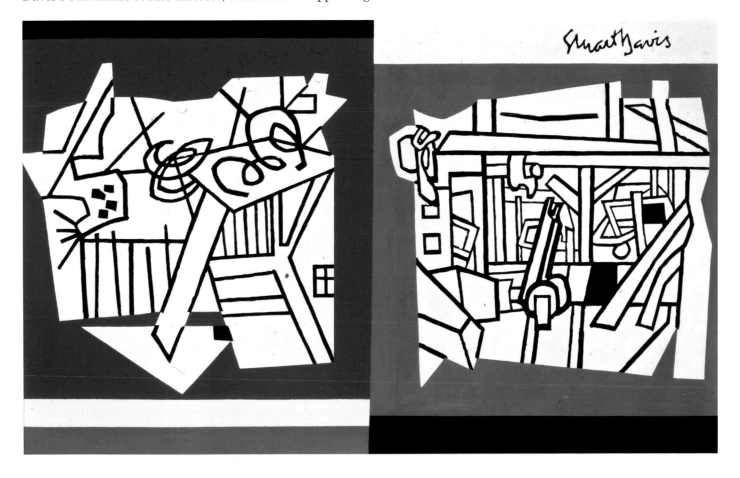

spiral "sculpture," seems uncannily like both Smith's and Gorky's earlier versions of the theme. Accident or memory of old friendships? We will never know.

The Fourth Musketeer

If, as de Kooning teasingly claimed, Graham, Davis, and Gorky were the Athos, Porthos, and Aramis of the New York art world before World War II, he himself quickly assumed the role of d'Artagnan—with considerably less drama and none of the swordplay of the hero of Dumas's celebrated novel. Accounts differ and dates of some events vary a bit, but it seems fairly certain that in the spring of 1929, de Kooning encountered Graham, who was holding forth at an exhibition of his paintings at Dudensing Gallery, and introduced himself. Sometime later that year, according to one of de Kooning's versions of the story, he and Gorky met at the Russian artist Misha Reznikoff's studio and nearly came to blows, but when he visited Gorky's studio about a year later, the result of a chance meeting, an intense friendship began.[44]

Each of the Musketeers was significant to the eager young Dutchman's evolution as an artist, but the most important of the three was Gorky. He was de Kooning's near contemporary and fellow immigrant, but a far less recent one, and a far more sophisticated modernist. De Kooning always acknowledged his debt to Gorky, cryptically giving the address of Gorky's studio on Union Square as the place he "came from."[45] The studio itself provided a model of professionalism and dedication for de Kooning, as it had for many others of the Musketeers' circle; Gorky's "interpretations" of Picasso and Miró, in the 1930s, provided de Kooning's education as a modernist. De Kooning returned the favor by introducing Gorky to the sign painter's liner brush, which permitted him to paint the thin, supple, whiplash lines that became such a crucial aspect in his mature work.[46]

Although works such as Gorky's *Xhorkom—Summer* and de Kooning's *Untitled,* circa 1934 (pls. 38 and 37), provide ample evidence of their shared interest in highly charged, biomorphic abstraction, the clearest evidence of the two painters' closeness can be found in their exquisitely crafted figure paintings, which both continued to make in the 1930s and into the 1940s, including Gorky's *Self-Portrait,* circa 1937, and *Portrait of the Artist's Wife,* 1942–46 (pls. 86 and 76), and de Kooning's *Seated Figure (Classic Male),* circa 1940 (see fig. 40). These mysterious works aspire to a similar fusion of abstraction and reference, delicacy and robustness. These qualities are obviously present in both artists' ravishing later abstractions—witness Gorky's *The Pirate I,* 1942–43 (pl. 68)—but it is nonetheless tempting to speculate about what the evolution of modernist

painting in New York might have been, had these two virtuosos of the enigmatic portrait not abandoned figuration.

Gorky's figure paintings, such as *Portrait of Akabi,* circa 1936–37, or his celebrated *Self-Portrait,* circa 1937 (pls. 39 and 86), overlap with his initial exploration of abstraction—as does his extended engagement with the two versions of his mesmerizing double portrait, *The Artist and His Mother,* between 1926 and 1936 (see fig. 41). De Kooning, too, as he searched for his identity as a painter, seems to have shifted back and forth from the economical abstraction of *Untitled,* circa 1934 (pl. 37), or *Mother, Father, Sister, Brother,* circa 1937, to the hypersensitive interpretation of the seen that is manifest in *Portrait of Rudy Burckhardt,* 1939, *Seated Woman,* circa 1940, or *Woman,* 1943 (pls. 57, 73, and 74). It is conceivable that the clean shapes, limited palette, and assertive drawing of *Untitled* and *Mother, Father, Sister, Brother* reflect de Kooning's awareness of Davis's work at the time—during the mid-1930s, Davis was so involved with social activism that he had little time in the studio and concentrated on lean drawings constructed with bold, even-handed lines, sometimes punctuated with sharply defined planes of color.

A much earlier de Kooning, *Still Life with Eggs and Potato Masher,* circa 1928–29 (pl. 4), suggests that the young Dutchman may have been paying attention to the older American modernist's work even before they were introduced by Graham. The inclusion of the utilitarian wire gadget irresistibly suggests a connection with Davis's *Egg Beater* series, with its eponymous kitchen tool, electric fan, and rubber glove, as well as its predecessors, a group of earlier still lifes incorporating such useful objects as a saw, a lightbulb, a giant eggbeater, or a percolator—banal trophies from the hardware store or the kitchen chosen, perhaps, as much for their ordinariness as for their particular forms (fig. 8).

Whether de Kooning was aware of Davis's "gadget still life" remains a matter of speculation. There is no doubt about the reciprocal relationship of paintings such as Gorky's *Portrait of Akabi* and *Mougouch,* circa 1941–42, or de Kooning's *Seated Woman* or *Woman,* 1943, to Graham's intermittent forays into figure painting at the time. In Graham's *Portrait of Elinor Gibson,* 1930, and in *Woman,* 1943 (pls. 80 and 77), as in Gorky's and de Kooning's portraits, features and forms melt into passages of refined brushwork or detach themselves into almost autonomous shapes

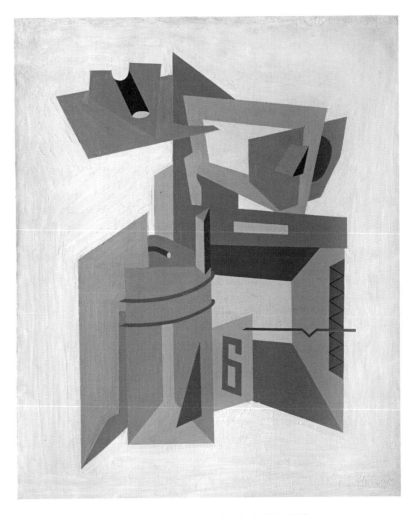

Fig. 8. Stuart Davis (1892–1964), *Percolator,* 1927. Oil on canvas, 36 × 29 in. (91.4 × 73.7 cm.), The Metropolitan Museum of Art, New York, Arthur Hoppock Hearn Fund, 1956, 56.195.

to create enlivening tension between unstable suggestion and autonomous form, allusion and materiality. It can seem as if the artists' aims were to make their paintings solely about the act of painting itself, independent of subject matter, without ceding any of the mysterious power inherent in recognizable images. All three had complicated responses to the presumed need to choose between image and abstraction. Gorky continued to work on his two great portraits of himself as a child with his mother even while he was becoming increasingly fascinated by psychologically loaded imagery unidentifiable to almost everyone but himself. Graham later repudiated abstraction entirely and devoted himself to strange, carefully rendered figures. De Kooning returned regularly to figural references, most notoriously in his *Women,* beginning in 1950, brazen goddesses whose fierce brushwork and staring eyes are strangely anticipated by *Woman.*

Graham's discussion of abstract art in *System and Dialectics* provides a clue to his intentions during these pivotal years, and, by extension, to those of his circle. Early in the book, Graham defines all art as a process of abstraction, since "a painter abstracts three-dimensional phenomena on a two-dimensional plane," and later categorizes abstract art as being "based on profound knowledge of reality, knowledge of anatomy of space and bodies and plastic destination as well as origin of forms"; the abstract painter, Graham continues, "uses this knowledge as a *point of departure.*" Abstract art is "materialistic." "It operates directly in the medium itself—paint, stone, etc.—with full understanding of their *sensuous qualities* and potentialities instead of relying on make-believe representation."[47] The eerie portraits and figures painted by Graham and his colleagues, while intensely evocative of particular individuals, also embody Graham's ideas. Rather than dissembling their medium in quest of an illusion—a "make-believe representation"—the most adventurous figurative works by Gorky, de Kooning, and Graham at this time seem poised on the brink of dissolution into incidents of "pure" painting. Only at the last minute do they resolve themselves as compelling, contingent *images.* Paint has not been put into the service of representation but rather brought to life, made to coalesce into something we recognize, at least momentarily.

"Young, Outstanding American Painters"

System and Dialectics of Art was published in both Paris and New York in 1937. By then, although Graham continued to go annually to France, refreshing his friendships with the Paris vanguard and his knowledge of their work, and acquiring art and artifacts for resale, he was exhibiting solely in the United States and defining himself in terms of his circle of

New York artist colleagues. Not surprisingly, Graham's book addresses the question "What is American art?" The answer: "Art made in America by American artists." In the same section, he presents a list of "Young, outstanding American painters: Matulka, Avery, Stuart Davis, Max Weber, David Smith, W. Kooning, Edgar Levy, Boardman Robinson, S. Shane and a few others. Some are just as good and some are better than the leading artists of the same generation in Europe."[48] For the renamed Ivan Gratianovich Dombrowski, the definition "American" was not conditioned by the accident of birth; many of his candidates, such as Matulka, Weber, and de Kooning, were immigrants as he was. ("Young" also seems to have been a flexible category. Davis was forty-five, Matulka forty-seven; Avery at fifty-two and Weber at fifty-six were older than Graham.) Weber's presence is explained by his Cubist-inspired paintings, the product of his early years in Paris, where he studied at Matisse's short-lived school and became friendly with the Parisian vanguard. Other artists on the list are immediately explicable because of their dedication to modernist ideas. Friendship may account for others. Robinson, though he flirted with Cubism, is best known for updated Ashcan School–type social realist works. Just who "S. Shane" was remains an enigma. Gorky's name is conspicuously absent from this list, although he is mentioned elsewhere, along with Levy and Matulka, in an extended answer to "What is good taste?" as an "example of highly developed taste." The names that follow include "A. Gorky," and "Eluard, Zervos, Jacques Lipchitz, Breton," and a few others.[49] Gottlieb, surprisingly, is omitted from the book completely.

In 1935, only two years before the publication of *System and Dialectics,* the relationships of all Four Musketeers and at least some of their friends seem to have been intact. But there are indications that the connections within Graham's circle were fraying about the time his book was published. The admiring friendship between Davis and Gorky, which endured despite the differing character and objectives of their work, eroded because of their disparate attitudes toward social action. Davis was deeply involved in the artists' organizations formed during the Depression, as was his friend initially. But as Davis wrote in a recollection of Gorky in the 1930s, "Gorky was less intense about it and still wanted to play. . . . Our interests began to diverge and finally ceased to coincide altogether. Our friendship terminated and was never resumed."[50] Although the break may not have been as complete as Davis suggests, the two painters were never as close again. Gorky seems to have become increasingly fascinated by Surrealism by the end of the 1930s and eventually became part of quite another group of artists. Other members of the circle simply moved. In 1940, the Smiths abandoned New York to live permanently at Bolton

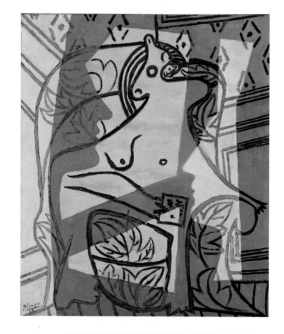

Fig. 9. Pablo Picasso (1881–1973), *Woman in an Armchair (Two Profiles),* 1927. Oil on canvas, 28¼ × 23¼ in. (71.8 × 59.1 cm). Minneapolis Institute of Arts, Gift of Mr. and Mrs. John Cowles.

Fig. 10. Amedeo Modigliani (1884–1920), *Anna Zborowska,* 1917. Oil on canvas, 51¼ × 32 in. (130.2 × 81.3 cm). The Museum of Modern Art, New York, Lillie P. Bliss Collection.

Landing, and even though Smith came often to the city to see art and art world friends, such meetings were far less frequent.

Perhaps the clearest indication of incipient change may be found in the exhibition *French and American Paintings,* which Graham organized for McMillen, Inc., a design firm that also held exhibitions, in January 1942. It was a remarkable mixture of well-known Europeans (Picasso, Matisse, Braque, Pierre Bonnard, André Derain, Georges Rouault, Amedeo Modigliani, André Dunoyer Segonzac, and de Chirico), established American modernists (Davis, Walt Kuhn, and Graham himself), and unknowns, at the time ("William Kooning," Jackson Pollock, and Lenore Krassner, not yet renamed "Lee Krasner"). Graham's old friends Burliuk and Vasilieff were also represented, along with such unlikely Americans as de Kooning's girlfriend of the period, Virginia Diaz.

It wasn't the first time progressive American artists had been exhibited alongside European vanguardists—in 1928, the Société Anonyme organized an exhibition that included Davis in the company of de Chirico, Kandinsky, Paul Klee, and Léger—but Graham's show was more comprehensive. The extant checklist is tantalizingly approximate, with listings such as "Picasso—Portrait of Dora Mare [*sic*]" and "Bonnard—Large Interior," but the few works that can be securely identified afford some idea of the ambition of the show. Picasso's *Woman in an Armchair (Two Profiles),* 1927 (fig. 9), now in the collection of the Minneapolis Institute of Arts, and Modigliani's portrait *Anna Zborowska,* 1917 (fig. 10), now at the Museum of Modern Art, were hung with Davis's *Autumn Landscape,* 1940 (fig. 11), and one of his Paris pictures, *Arch Hotel,* 1929 (pl. 15). Graham may have shown *Portrait of a Woman Seated (Seated Woman),* circa 1942 (pl. 75), while "Kooning," Krasner, and Pollock were represented by equally current work, de Kooning possibly by *Seated Figure (Classic Male),* Krasner by a now destroyed Picasso-derived work closely related to *Untitled,* circa 1940, and *Composition,* 1943 (pls. 69 and 70), and Pollock by *Birth,* circa 1941 (fig. 12).

It is difficult to imagine how Graham managed to assemble the European works in the show, which opened while World War II raged in Europe, less than a month after Pearl Harbor and America's entry into the conflict. He obviously had to work with what was available to him in the United States, but the high quality of the identified works indicates his good relations with American collectors and other sources.

On the strength of the show, de Kooning always credited Graham with having discovered Pollock, and on the strength of Pollock's painting in the show, Krasner was prompted to introduce herself to its author. The exhibition attracted some attention. A sympathetic reviewer in the *Art Digest* wrote:

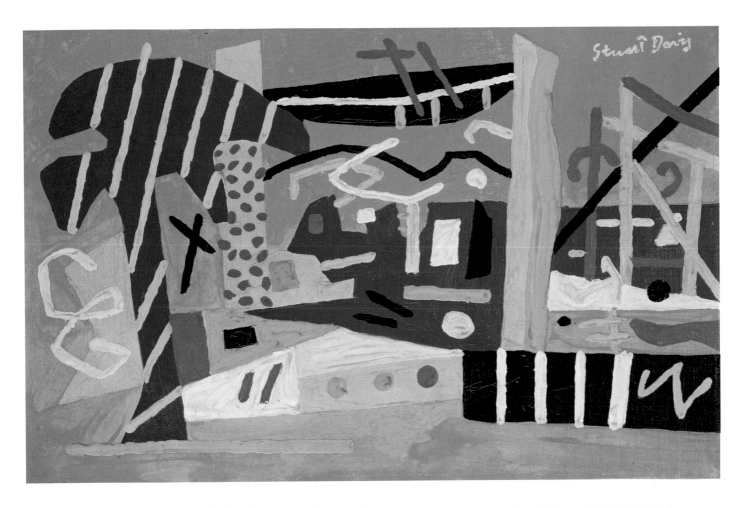

Fig. 11. Stuart Davis (1892–1964),
Autumn Landscape, 1940. Oil on canvas,
8 × 12 in. (20.3 × 30.5 cm). Private
collection.

Further proof that all kinds of works, as long as they are
good examples, mix well together is offered by McMillen, Inc.
New York, where a combined show of French and American
painters is in progress. . . . John Graham fits well between
Picasso and Rouault, while Walt Kuhn's fresh bouquet of
pink roses is harmoniously compared with an early and
surprisingly naturalistic pink rose still life by Picasso. Other
surprises are also found, for, with the exception of Kuhn,
Graham, Burliuk and Stuart Davis, the American section is
given over to unknown painters who haven't shown before.

The writer was particularly struck by an intense painting of a male nude.
"A strange painter is William Kooning [*sic*] who does anatomical men with
one visible eye, but whose work reveals a rather interesting feeling for
paint surfaces and color."[51]

Among the most unexpected inclusions in *French and American
Paintings* is a de Chirico identified on the checklist as *Trojan Warriors,*
possibly one of the extended series of gladiators and antique soldiers made
between about 1925 and 1929, and replicated in the early 1930s. At least one
of these is titled *Memories of the Iliad,* while others are more ambiguously
labeled *End of Combat* or *Gladiators in the Arena* (figs. 13, 14). Assuming that
the identification is accurate and the selection was not purely expedient, it
is a surprising choice. While Graham and his circle admired de Chirico's

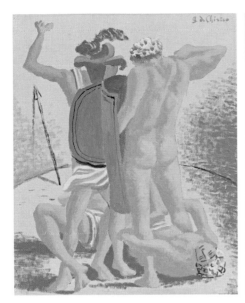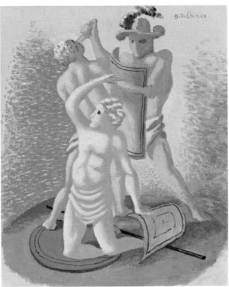

Fig. 12 (*opposite*). Jackson Pollock (1912–1956), *Birth,* c. 1941. Oil on canvas, 45¾ × 21⅝ in. (116.4 × 55 cm). Tate Gallery, London.

Fig. 13 (*far left*). Giorgio de Chirico (1888–1978), *End of Combat,* 1927. Oil on canvas, 16⅛ × 13⅛ in. (41 × 33.3 cm). The Barnes Foundation, Merion, Pennsylvania.

Fig. 14. Giorgio de Chirico (1888–1978), *Gladiators in the Arena,* 1927. Oil on canvas, 16⅜ × 13¼ in. (41.6 × 33.7 cm). The Barnes Foundation, Merion, Pennsylvania.

metaphysical paintings and his haunting townscapes, the presence of a fairly insipid neoclassical painting of male nudes signals a radical shift in Graham's taste that prefigures his later dedication, in his own work, to a meticulous, Ingres-inspired fidelity to appearances. The absence of the Third Musketeer, Gorky, from the McMillen show is further evidence of change, as is the absence, as well, of anyone from Graham's published list of "young, outstanding American painters," apart from Davis and de Kooning. These omissions anticipate Graham's later removal of the entire list from his handwritten notes for a proposed new edition of *System and Dialectics of Art.*

Yet if the selection of American artists in the McMillen exhibition indicates that by the end of 1941, Graham, his fellow Musketeers, and their colleagues were no longer as cohesive or close a group as they had been in the past, their work makes plain the shared aspirations that drove their efforts and the rich cross-fertilization of ideas that stimulated their ambition. The paintings and sculptures made by this vibrant constellation of artists bring to vivid life the animated, now lost, exchanges among Graham and his friends in the days when they frequented each other's studios and homes, looked at exhibitions together, and spent time in passionate discussion in cheap neighborhood hangouts, banded together like Dumas's heroes to do battle for the cause of progressive art in America.

Notes

1. Adolph Gottlieb, in a response to a review of the 1943 exhibition of the Federation of Modern Painters and Sculptors by art critic Edward Alden Jewell, *New York Times,* June 13, 1943.
2. Dorothy Dehner, conversation with the author, various dates, spring 1978.
3. Sloan's students at the League in the early 1920s included Barnett Newman, Adolph Gottlieb, Alexander Calder, and Elinor Gibson; John Graham was the class monitor; Matulka's students included David Smith, Dorothy Dehner, George L. K. Morris, Edgar Levy, and Lucille Corcos.
4. Dorothy Dehner, Foreword, in John Graham, *System and Dialectics of Art,* ed. Marcia Epstein Allentuck (Baltimore: Johns Hopkins Press, 1971), xiii.
5. Graham, *System and Dialectics of Art,* 111.

6. Ibid., 94.

7. Ibid., 95.

8. Ibid.

9. Ibid., 102.

10. Ibid., 101.

11. Eleanor Green, *John Graham: Artist and Avatar,* exhibition catalogue (Washington, D.C.: The Phillips Collection, 1987), is the most complete published volume on Graham; Alicia G. Longwell's unpublished dissertation, *John Graham and the Quest for an American Art in the 1920s and 1930s,* City University of New York, 2007, includes the most complete and accurate information on the artist to date.

12. John Graham, unpublished manuscript "Installment Art II," quoted in Longwell, *John Graham and the Quest for an American Art,* 25.

13. Marcia Epstein Allentuck, Critical Introduction, in Graham, *System and Dialectics of Art,* 4; Longwell, *John Graham and the Quest for an American Art,* 28.

14. John Graham to Duncan Phillips, April 2, 1928, quoted in Longwell, *John Graham and the Quest for an American Art,* 46.

15. Dorothy Dehner recalled Graham telling her that "Graham" written in English looked like his mother's name written in Cyrillic (Dehner, Foreword, xvi). This seems doubtful, since his mother's name was Brezinska, according to a translation of 1891 baptismal records in the John D. Graham records, Archives of American Art, cited in Longwell, *John Graham and the Quest for an American Art,* 24. A more likely explanation is that he adapted his patronymic "Gratianovich," since the first syllable of his father's name Gratian, when written in Cyrillic script, resembles "Gram" written in English.

16. The chronology in William S. Lieberman, ed., *Art of the Twenties,* exhibition catalogue (New York: Museum of Modern Art, 1979), and the chronology by Julia May Boddewyn in Michael FitzGerald, *Picasso and American Art,* exhibition catalogue (New York: Whitney Museum of American Art, 2006), are particularly informative.

17. Dehner, conversation with the author, spring 1978.

18. David Smith, interview with David Sylvester, June 16, 1961, published in *Living Arts,* April 1964, reprinted in Garnett McCoy, ed., *David Smith* (New York: Praeger, 1973), 170.

19. Dehner, Foreword, xiii, xiv.

20. Ibid., xiii. *Cahiers d'art,* founded by Christian Zervos in 1926, was a relatively new publication in 1930.

21. Dorothy Dehner, comments on David Smith, unpublished biographical notes, circa 1950, in Cleve Gray, ed., *David Smith by David Smith* (New York: Holt, Rinehart and Winston, 1972), 174.

22. David Smith, paper delivered at a symposium on "The New Sculpture," Museum of Modern Art, February 21, 1952, reprinted in McCoy, ed., *David Smith,* 82.

23. Dehner, Foreword, xiv.

24. Dehner recalled that they were introduced to Graham by Tomas and Weber Furlong, painters whom they had met at the Art Students League, who also introduced them to Bolton Landing.

25. Dehner, Foreword, xv–xvi.

26. Dehner, conversation with the author, spring 1978; Graham, *System and Dialectics of Art,* 128.

27. David Smith, letter to Jean Xceron, February 7, 1956, in McCoy, ed., *David Smith,* 206.

28. Dehner, conversation with the author, spring 1978.

29. Davis remained close to Sloan, an associate of Robert Henri's, during his time as a student at Henri's school. Sloan and his wife, ardent socialists, had a strong influence on Davis's embrace of leftist politics. In the early 1910s, when Sloan was art editor of *The Masses,* he recruited Davis to contribute drawings to the magazine. Davis shared a house with the Sloans in Gloucester, Massachusetts, in the middle of the decade, and, with his brother, Wyatt, joined the Sloans in Santa Fe in 1923.

30. James T. Valliere, "De Kooning on Pollock," *Partisan Review* (Fall 1967): 603.

31. De Kooning, interview with Harold Rosenberg, in Harold Rosenberg, *De Kooning* (New York: Abrams, 1974), 38.

32. Stuart Davis, "Autobiography," from *Stuart Davis* (New York: American Artists' Group, 1945), reprinted in Diane Kelder, ed., *Stuart Davis* (New York: Praeger, 1971), 27.

33. Stuart Davis, letter to his mother, Helen Stuart Foulke Davis, January 25, 1929. Despite Davis's opinion, the exhibition garnered considerable interest, with the *Chicago Tribune* calling it "the most curious exhibition that Paris has ever seen."

34. Stuart Davis Papers, Harvard University Art Museums, on deposit at Houghton Rare Book Library, Harvard University. Reel numbers refer to microfilm copies of the papers; there are no frame numbers; some pages are dated; Reel 4, January 8, 1942.

35. Davis papers, Reel 1, December 30, 1922.

36. Davis papers, Reel 7, October 29, 1943.

37. Graham, *System and Dialectics of Art,* 131, 106, 119, 94.

38. John Graham to Duncan Phillips, December 28, 1930, in Green, *John Graham,* 139. Green adds: "This group never coalesced," an observation contradicted by the evidence of fruitful exchange in the three artists' work during the 1930s and by de Kooning's characterization of them as "the Three Musketeers."

39. Stuart Davis, "Arshile Gorky in the 1930s: A Personal Recollection," *Magazine of Art* (February 1951), reprinted in Kelder, ed., *Stuart Davis,* 182.

40. Dehner, Foreword, xv.

41. Arshile Gorky, "Stuart Davis," *Creative Art* (September 1931), reprinted in Kelder, ed., *Stuart Davis,* 192.

42. Davis, "Arshile Gorky in the 1930s."

43. See David Smith, *Interior for Exterior,* 1939, Carnegie Museum of Art, Pittsburgh; *Home of the Welder,* 1945, Tate, London; *Cathedral,* 1950, Private Collection.

44. Mark Stevens and Annalyn Swan, *De Kooning: An American Master* (New York: Alfred A. Knopf, 2004), 97.

45. Ibid.

46. Ibid., 105.

47. Graham, *System and Dialectics of Art,* 93, 118, 117.

48. Ibid., 153, 154.

49. Ibid., 127, 128. Graham later eliminated this list in one of his copies marked for intended republication.

50. Davis, "Arshile Gorky," in Kelder, ed., *Stuart Davis,* 18.

51. Unsigned, "Congenial Company," *Art Digest* (January 15, 1942): 18.

Detail, pl. 42

Plates · 1931–1935

28

Stuart Davis (1892–1964)
Radio Tubes (Still Life Radio Tube), 1931
Oil on canvas
50 × 32¼ in. (127 × 81.9 cm)
Rose Art Museum of Brandeis University, Waltham,
Massachusetts, Bequest of Louis Schapiro

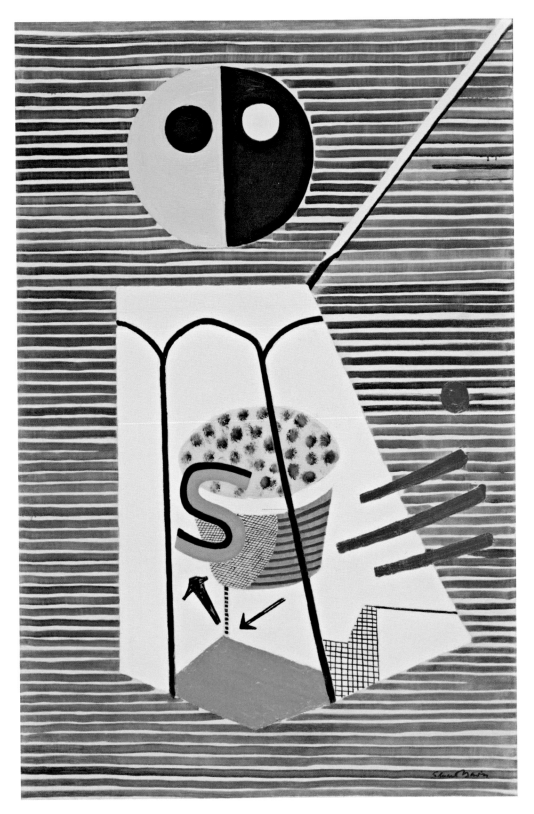

29
Stuart Davis (1892–1964)
Salt Shaker, 1931
Oil on canvas
49⅞ × 32 in. (126.7 × 81.3 cm)
The Museum of Modern Art, New York,
Gift of Edith Gregor Halpert, 1954

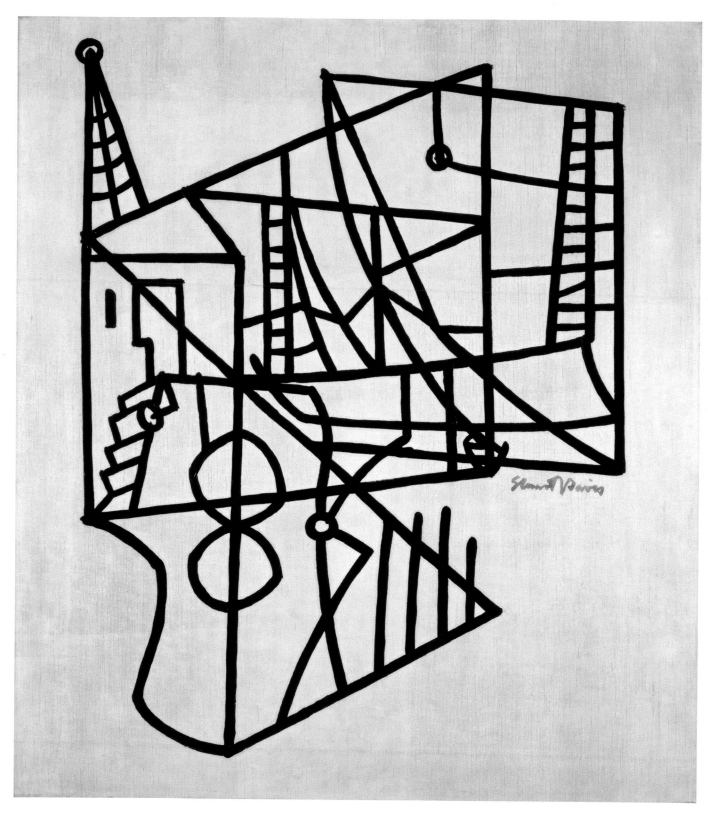

30

Stuart Davis (1892–1964)

Landscape, 1932 and 1935

Oil on canvas

32½ × 29¼ in. (82.5 × 74.3 cm)

Brooklyn Museum, Gift of Mr. and Mrs.

Milton Lowenthal, 73.150

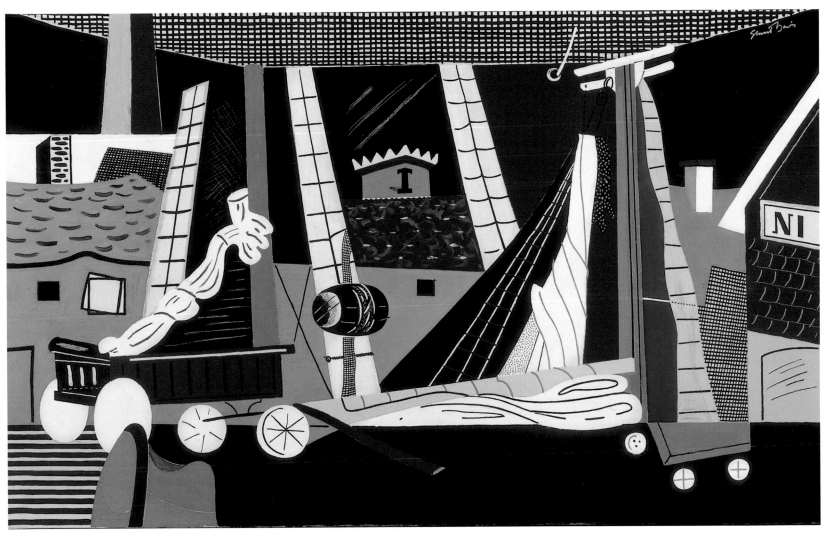

31
Stuart Davis (1892–1964)
Red Cart, 1932
Oil on canvas
32¼ × 50 in. (81.9 × 127 cm)
Addison Gallery of American Art,
Phillips Academy, Andover,
Massachusetts, Museum purchase

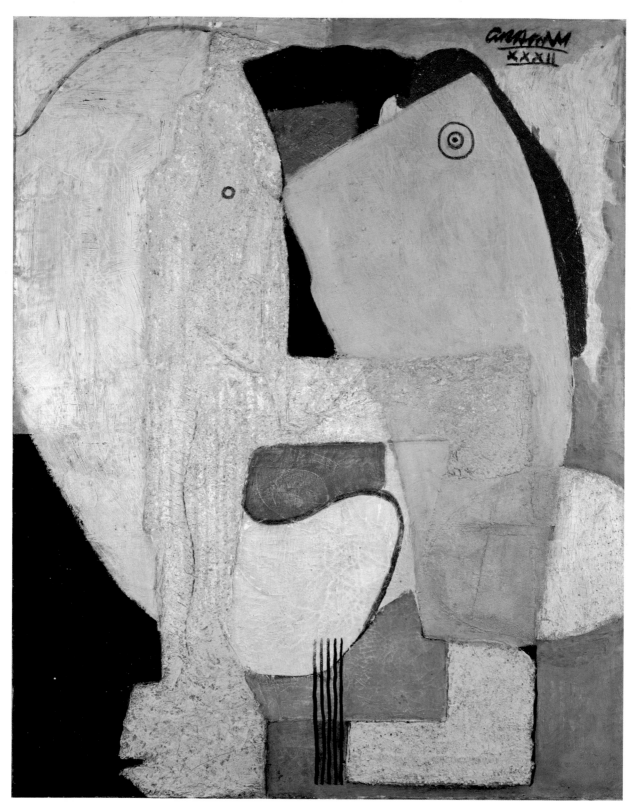

32
John Graham (1887–1961)
Embrace, 1932
Oil on canvas
30 × 36 in. (76.2 × 91.4 cm)
The Phillips Collection, Washington, D.C.,
Bequest of Dorothy Dehner Mann, 1995

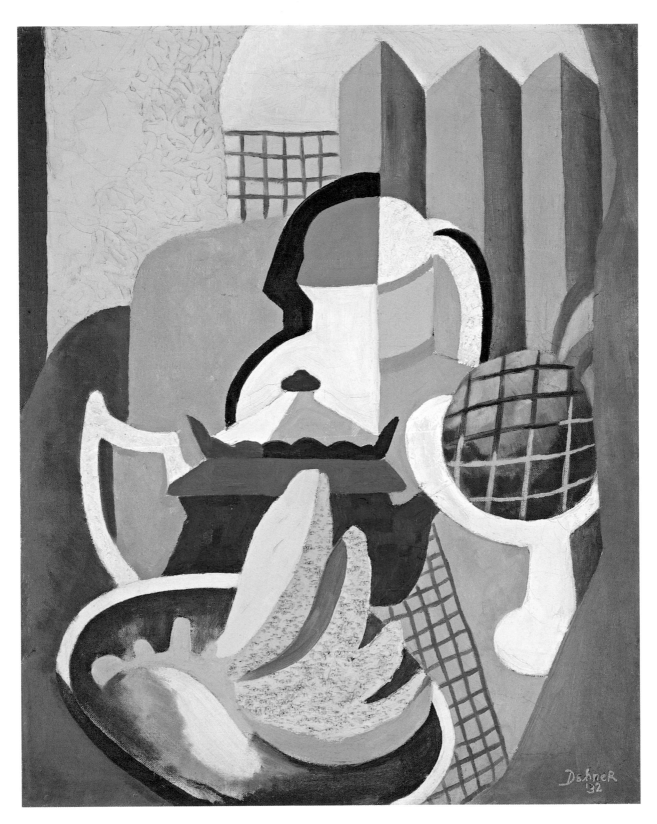

33
Dorothy Dehner (1901–1994)
Still Life, 1932
Oil on canvas
20½ × 16 in. (52.1 × 40.6 cm)
Collection Zimmerli Art Museum at
Rutgers University, Gift of the artist

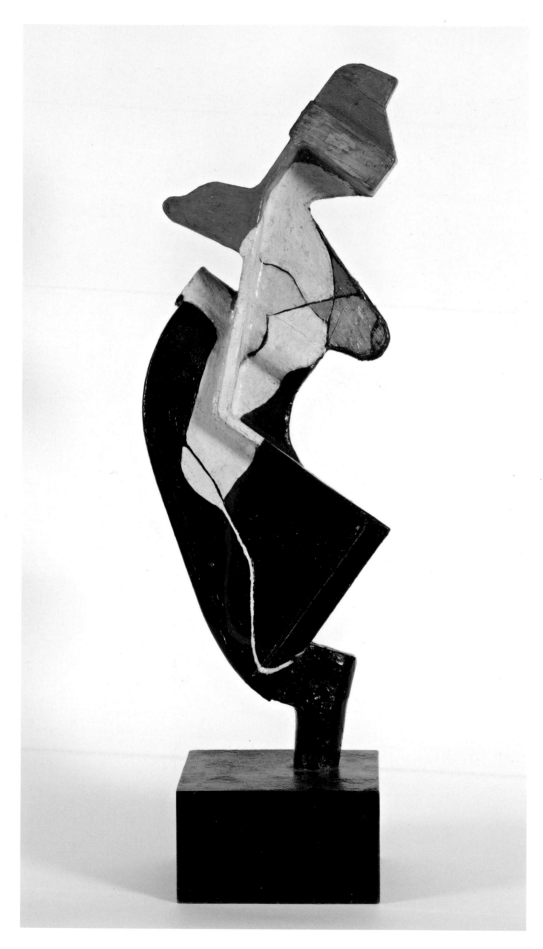

34
David Smith (1906–1965)
Head, 1932
Wood on artist's base, painted
23 × 8⅜ × 5⅝ in. (58.4 × 21.2 × 13.6 cm)
The Estate of David Smith, Courtesy
Gagosian Gallery, New York

35 (*opposite*)
David Smith (1906–1965)
Chain Head, 1933
Iron
19 × 10 × 7 in. (48.3 × 25.4 × 17.8 cm)
The Estate of David Smith, Courtesy
Gagosian Gallery, New York

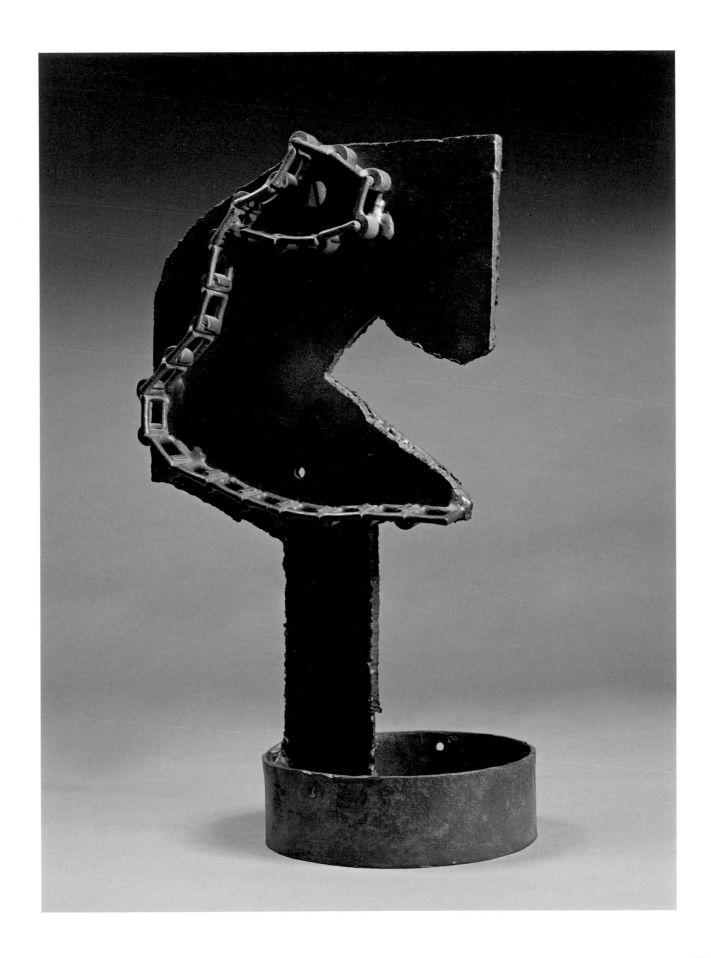

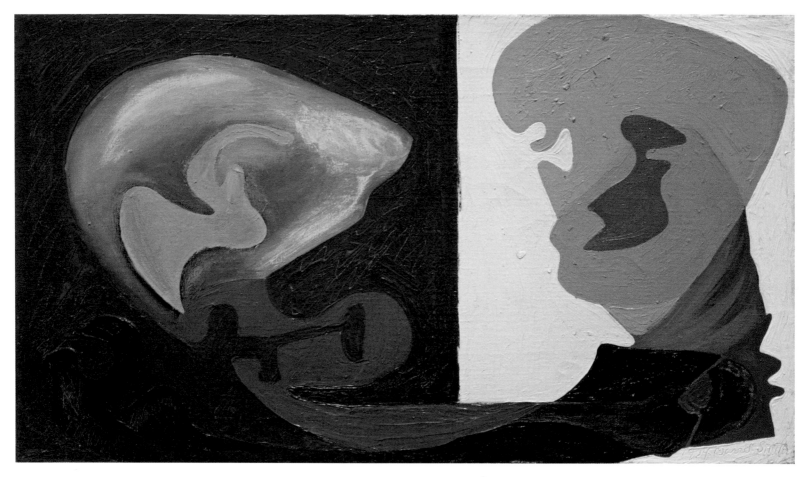

36
David Smith (1906–1965)
Untitled (Untitled [Head, Blue and White]), 1934
Oil on canvas
14 × 24 in. (35.6 × 61 cm)
The Estate of David Smith,
Courtesy Joan Washburn Gallery, New York

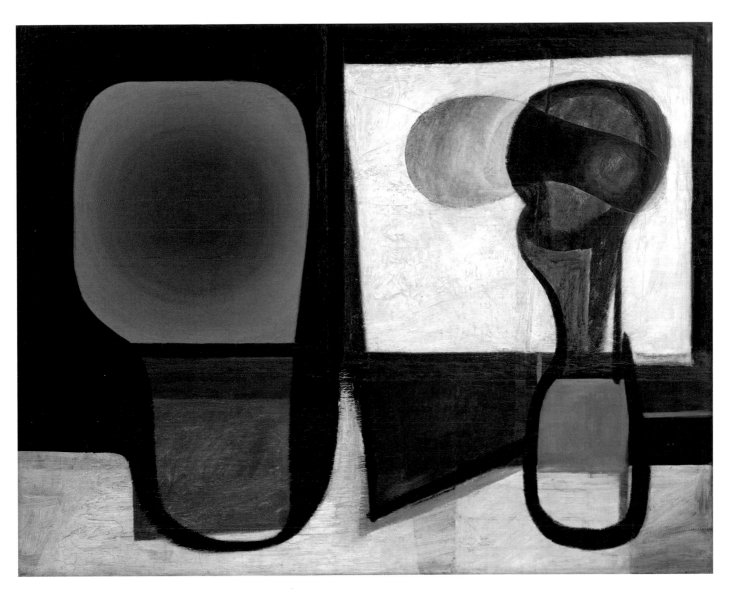

37
Willem de Kooning (1904–1997)
Untitled, c. 1934
Oil on canvas
36 × 45⅛ in. (91.4 × 114.6 cm)
Private collection, Courtesy
Eykyn Maclean, LP, New York

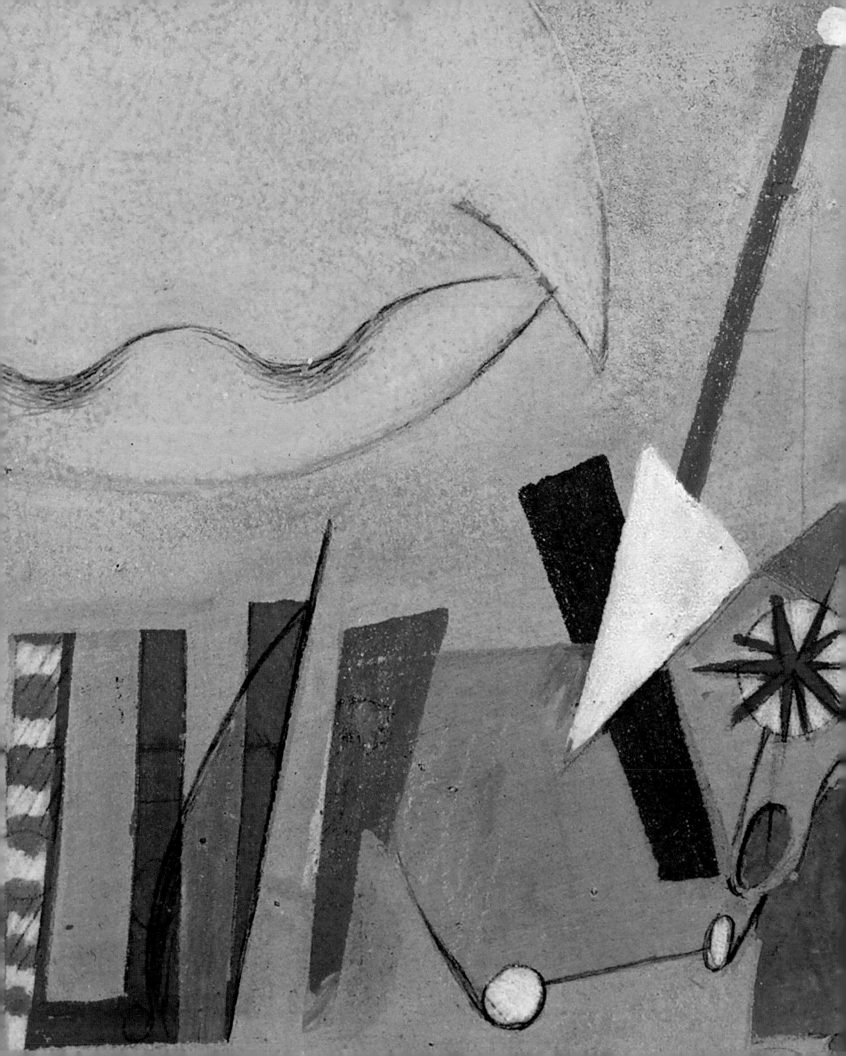

Irving Sandler

The Four Musketeers of Modernism at the Height of the Great Depression

The 1930s, the decade of the Great Depression, is often looked down upon as a barren period in American art. It was not. As Willem de Kooning recalled, "There was a terrific amount of activity going on in the thirties. It was not a dead period. You don't have to like the art to appreciate the excitement. But many of the people were good artists—John Graham, Stuart Davis, Arshile Gorky. We knew each other."[1] It was hard for modernist artists in New York to avoid each other since there were so few of them, well under a hundred. Everyone knew everyone and they followed one another's activities closely.

The years 1936 and 1937, at the height of the Depression, were particularly lively. The American Artists' Congress Against War and Fascism, the most significant political assembly of artists in the decade, took place in 1936. The Museum of Modern Art mounted the two most influential exhibitions in its illustrious history: *Cubism and Abstract Art* and *Fantastic Art, Dada, and Surrealism*. The following year saw shows of the American Abstract Artists (AAA), the largest group of modernist artists in the United States, and of the Ten, a band of modernist expressionists. John Graham's *System and Dialectics of Art* and his article "Picasso and Primitive Art" were both published in 1937.

Indeed, 1936 and 1937 were watershed years in the history of American avant-garde art, witnessing the eclipse of the then hegemonic Social Realism and the first concerted bid for recognition by American modernist artists. This essay treats the art events of the time as a backdrop for the art making of an informal coterie of advanced artists whose leading figures were Stuart Davis, John Graham, Arshile Gorky, and Willem de Kooning, or the Four Musketeers of modernism. My aim is to reveal the broader social and aesthetic context of their work, notably what ideas and styles were available to them and what they accepted or rejected.

The Four Musketeers met in the late 1920s and became friends because they admired each other's work and ideas. As early as 1931, Gorky hailed Davis as "this man, this American, this pioneer, this modest

Detail, pl. 58

75

painter. . . . One is he, and one of but few, who works upon that platform where are working the great painters of this century—Picasso, Léger, Kandinsky, Juan Gris."[2] De Kooning said, "I was lucky when I came to this country to meet the three smartest guys on the scene: Gorky, Stuart Davis and John Graham."[3] During the 1930s, the Four Musketeers attracted younger artists to the cause of modernism, primarily students of Jan Matulka (who could be considered the fifth musketeer), among them David Smith, Dorothy Dehner, Edgar Levy, George McNeil, and Burgoyne Diller. In 1937, in *System and Dialectics of Art,* Graham hailed Davis, Gorky, de Kooning, Levy, and Smith, along with Milton Avery, Jan Matulka, Boardman Robinson, and Max Weber. "Some are just as good and some are better than the leading artists of the same generation in Europe."[4]

The Four Musketeers and their younger friends met casually in various Greenwich Village eateries. As de Kooning said, "We were the cafeteria people."[5] Smith recalled,

> Our hangouts were Stewart's Cafeteria on Seventh Avenue
> near Fourteenth Street close to Davis's studio and school,
> and 5-cent coffee was much closer to our standards, but on
> occasion we went to the Dutchman's McSorley's and Romany
> Marie's. We followed Romany Marie from Eighth Street, where
> Gorky once gave a chalk talk on Cubism, to several other
> locations. Her place came closer to being a Continental café
> with its varied types of professionals than any other place
> I knew.[6]

The Four Musketeers' coterie gathered often enough to think of organizing themselves on a formal basis. As Smith recalled,

> It was in Marie's where we once formed a group, Graham,
> Edgar Levy, [Misha] Resnikoff, de Kooning, Gorky and myself
> with Davis being asked to join. This was short-lived. We never
> exhibited and we lasted in union about thirty days. Our only
> action was to notify the Whitney Museum that we were a
> group and would only exhibit in the 1935 abstract show if all
> were asked. Some of us were, some exhibited, some didn't, and
> that ended our group. But we were all what was then termed
> abstractionists.[7]

Of the Musketeers Davis was the best-known and recognized as the most developed; as Smith recalled, he was "the solid citizen for a group a bit younger who were trying to find their stride."[8] Graham was the most

knowledgeable since he was writing an art theoretical and historical treatise and made yearly trips to Paris; Dorothy Dehner recalled, "Graham knew everything about Paris."[9] He brought back copies of *Cahiers d'art,* with the latest art news, which were pored over by his friends.[10] It is noteworthy that the personal relations of the artists were not always love-feasts. Gorky, for example, was once alleged to have called Smith a "German sausage-maker" and Smith once chased Gorky down the street shouting "You f—— little rug peddler."[11] Gorky and Graham often badmouthed each other. Hedda Sterne recalled, "Then they'd meet, throw their arms around each other, embrace, apologize, and swear that they were the best of friends."[12]

The Four Musketeers looked for inspiration to Synthetic Cubism, in particular that of Picasso, Braque, Léger, and Gris. They tended to compose their paintings using cleanly edged forms of clear, flat color, which were so related as to yield cogent pictorial structures. Above all, the Americans emulated Picasso. Graham so revered him that in *System and Dialectics of Art* he devoted three pages of hyperbole to Picasso, proclaiming that he was "so much greater than any painter of the present or the past. . . . He has painted everything and better; he has exhausted all pictorial sources. [It] is safe to say that Picasso is the greatest painter of the past, present and future."[13] Gorky copied Picasso's work so closely that he was teased by fellow artists as "the Picasso of Washington Square." De Kooning was also reverent. He recalled to me in 1958: "There was this Picasso painting—yellow on the right, dotted floor—that had a certain 'lift.' I decided I had to get it in my own pictures. I thought if I couldn't, I ought to give up painting."[14]

Picasso's work was frequently on view in New York museums and galleries. In 1936, *Cubism and Abstract Art* at the Museum of Modern Art included thirty-two of his works dating from 1907 to 1929. This selection was complemented by three one-person gallery shows of his paintings in 1937.[15] Moreover, word of Picasso's *Guernica,* which was installed in the Spanish Pavilion at the Paris World's Fair in 1937 and became a main attraction, quickly reached New York. *Cahiers d'art* devoted a special issue to the mural. *Guernica,* whose subject was the recent bombing of the Spanish city by Nazi and Fascist planes during the Spanish Civil War, was of particular interest to artists because it was political and topical, referring to the struggle for democracy, the devastation of war, and the plight of its suffering victims. It also contained allegorical and mythological references (to horse and bull) of a universal nature, embodied in Picasso's idiosyncratic style.[16] And he had incorporated all of this in a modernist form that combined both Cubist flat-patterning and Surrealist invention in a mural, the mode of art-for-the-masses espoused by Social Realists.

Fig. 15. Pablo Picasso (1881–1973), *The Studio,* Paris, winter 1927–28; dated 1928. Oil on canvas, 59 × 91 in. (149.9 × 231.2 cm). The Museum of Modern Art, New York, Gift of Walter P. Chrysler, Jr.

It is significant that the Four Musketeers worked in both nonobjective and figurative modes. In 1936, for example, Gorky painted three very different canvases. He completed *The Artist and His Mother,* a photo-based double portrait he had been working on since 1926 (see figs. 41 and 42), and a fully abstract painting he had begun in 1933, *Organization* (pl. 42), derived from Picasso's *The Studio,* 1927–28 (fig. 15), and *Painter and Model,* 1928 (fig. 16), with an eye to Miró and Mondrian. He also began *Composition with Head* (which he finished in 1937) (fig. 17), which was a kind of composite of Picasso's motifs culled from *Girl Before a Mirror,* 1932 (fig. 18), as well as other canvases. In 1937, Gorky installed a major mural at the Newark Airport under the auspices of the Federal Art Project. Titled *Mechanical Aspects of Airplane Construction,* it was an abstraction based on airplane parts. Legible though the images were, the mural was too abstract for many bureaucrats who roundly attacked the work. Alfred Barr came to its defense by writing: "It is dangerous to ride in an old-fashioned airplane. It is inappropriate to wait and buy one's ticket surrounded by old-fashioned murals."[17]

Graham's book published in 1937, *System and Dialectics of Art,* reflected the thinking of the Musketeers and their circle. There was too much verbal give and take to know who said what first. The ideas were in the air. Or, as Hayden Herrera later wrote, Graham's "defense of modern art . . . captures the seemingly endless talk about the Freudian unconscious, Jungian primordial memories, Marxist politics, Surrealism, and above all, the primacy of abstract art."[18]

Synthetic Cubism had been developed by Picasso and Braque in the second decade of the twentieth century and in the 1920s had influenced the Four Musketeers as young artists. But in the New York art world of the 1930s, it was still considered avant-garde, if not as cutting edge as geometric abstraction. As Meyer Schapiro recalled, "To be a disciple of Picasso in New York in the 1920s and early '30s was an act of originality and, for a young artist in the solitude of his exceptional taste, an enormous task."[19] Nevertheless, Cubist

Fig. 16. Pablo Picasso (1881–1973), *Painter and Model,* Paris, 1928. Oil on canvas, 51⅛ × 64¼ in (129.8 × 163 cm). Museum of Modern Art, New York, The Sidney and Harriet Janis Collection.

design was a known quantity and the artists who embraced it knew they were imitative and eclectic. The Four Musketeers justified their role as followers by claiming that their mission was to develop artistic proficiency, and to do so they felt they had to study how old and new masters achieved their mastery and emulate them. As they viewed it, art was primarily a language to be learned. Originality was secondary. The Four Musketeers tended to look upon art making less as subjective self-expression and more as objective problem-solving. In 1931, Graham said, "We use all the discoveries of the past as we all use brushes and canvas."[20] Picasso had answers, and so did Uccello and Ingres. Gorky, de Kooning, and Graham would even copy details from each other's pictures; Graham once borrowed de Kooning's drawings to copy his representation of the male shoulder.[21] David Burliuk, a friend of Graham's, said he believed that "for a given problem, like in a shooting gallery, there is only one perfect solution."[22]

For the Musketeers Picasso served as a model of how to be an avant-garde painter with a reverence for tradition. With Picasso in mind, Graham wrote: "Great art, no matter how revolutionary, presents a legitimate link in the unbroken chain of the development of tradition. In fact revolutions are only possible there, where tradition exists."[23] Gorky developed as an artist by imitating artists from Monet and Cézanne to Picasso and Miró to learn how they painted. Gorky would carry illustrations of Ingres or Uccello and other old masters and lecture anyone who would listen about their artistry. Edwin Denby, thinking of de Kooning, summed it up: To be an artist "meant meeting full force the professional standards set by the great Western painters old and new."[24]

The thinking of the Four Musketeers was similar to that of Jan Matulka and Hans Hofmann, both influential art teachers.[25] As his classroom props, Matulka used large photographs of two Picasso paintings and one of an African wood sculpture of a woman's head. Smith recalled: "It was from him that for the first time I learned Cubism and Constructivism. . . . Matulka was the most notable influence on my work."[26]

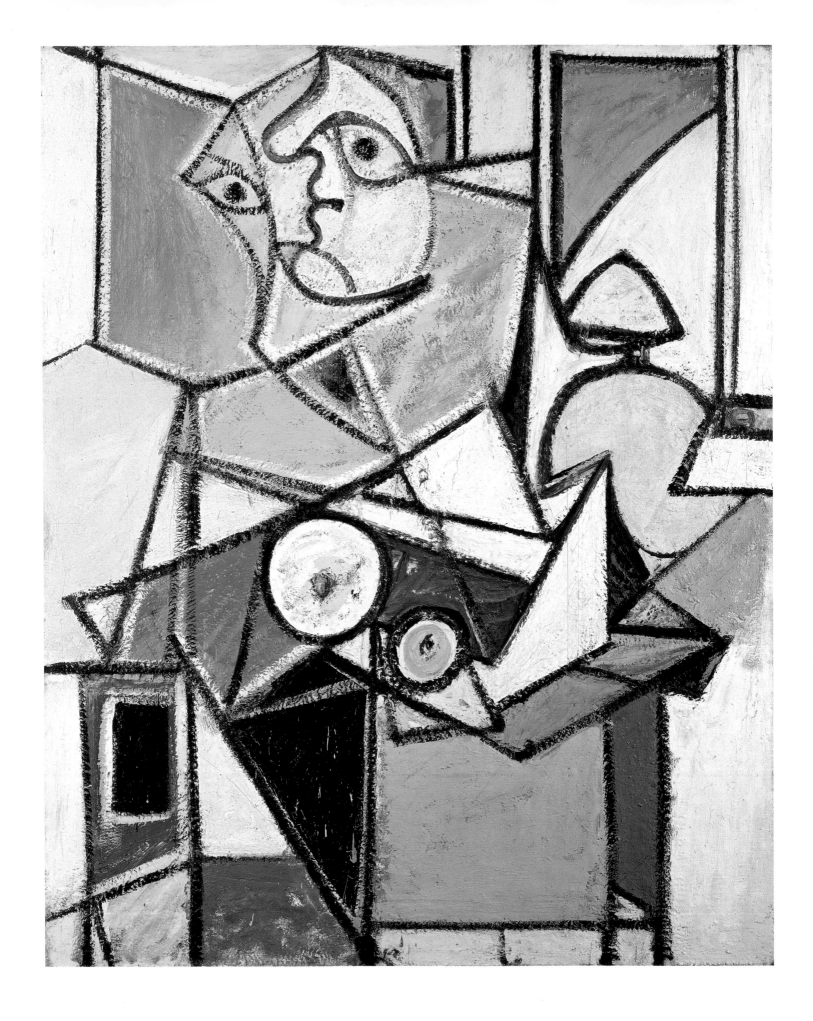

Hofmann was the most important teacher of modern art in the United States. Half of the avant-garde in the 1930s had been enrolled in his classes. Like Matulka, Hofmann's teaching was based on Cubist drawing. Wolf Kahn recalled that he inculcated his students with two main ideas. The first was "that there is a mainstream that stretches from Cimabue to abstract expressionism and that there is a formal logic that governs all masterpieces past *and* present—a kind of formal common denominator which guarantees [their] quality." He urged his students to become art-book hounds and to hunt for an underlying structure in all great paintings. Hofmann's second idea was that there was such a thing as "good" painting, even "an ideal of a *perfect* picture" toward which students ought to constantly strive.[27]

Stuart Davis was the most politically aware and committed of the Musketeers. Appalled by the economically depressed condition of American artists and the rise of international fascism, he decided that political action took precedence over art making. In fact, in the decade of the Great Depression, the Spanish Civil War, and the growing threat of world war, artists could not help being obsessed with politics and the question of its relation to art. Davis was the chief organizer of political activities on the left. In 1935, he was elected president of the Artists' Union, whose main activity was to lobby the federal government for aid to artists. He was also appointed the editor of the union's publication, *Art Front,* where he served until the following year. He turned *Art Front* into an important and lively forum. To maintain the solidarity of the left, Davis gave the apologists for Social Realism more space than they deserved. However, he made sure that articles on modernist movements, such as Cubism (for example an essay by Léger titled "The New Realism"), nonobjective art, and Surrealism, were published. He then became national executive secretary of the First American Artists' Congress Against War and Fascism. Believing that the political situation was of surpassing urgency, Davis neglected his painting and put his aesthetics aside. He worked willingly with any group that agreed with his broad political aims, including communists. Davis got Alexander Trachtenberg, the Communist Party commissar of cultural affairs, to agree not to interfere in the congress. Trachtenberg acquiesced because the party was engaged in a Popular Front policy to unite the

Fig. 18. Pablo Picasso (1881–1973), *Girl Before a Mirror,* Boisgeloup, March 1932. Oil on canvas, 64 × 51¼ in. (162.3 × 130.2 cm). The Museum of Modern Art, New York, Gift of Mrs. Simon Guggenheim.

Fig. 17 (*opposite*). Arshile Gorky (1904–1948), *Composition with Head,* c. 1936–37. Oil on canvas, 70½ × 60½ in. (194.3 × 153.7 cm). Donald I. Bryant Jr. Family Trust.

left against fascism. Nonetheless, the communists, who were the most organized and vociferous group, as was their wont, played a role far beyond their numbers.[28] Some 360 artists participated in the three-day conference held in New York City.[29]

The American Artists' Congresses from 1936 to 1938 marked the heyday of leftist political activities. Social Realism was also at its peak. It was hyped by American Stalinist apparatchiks, who dictated that artists must paint in realist styles and that their subject matter should be the plight of the exploited proletariat. These homegrown commissars derided modernist art as "ivory-tower escapism," "bourgeois decadence," and "fascist." But Social Realism was on the edge of an irrevocable decline, even though it did not seem so at the moment.

The Four Musketeers dismissed Social Realism as retrogressive, academic, and banal. Its disregard of formal values led Gorky to famously ridicule it as "a poor art for poor people."[30] In published articles, Davis was in the forefront of the modernist attack on the Social Realists. He faulted them for ignoring aesthetic quality because of their preoccupation with the class struggle. He maintained that aesthetics transcended social issues. Why else did past works of art continue to be moving if not because their "formal relations . . . have another content which continues to have special meaning for us and this content can only be Art?"[31]

Davis was even more hostile to the Regionalists than the Social Realists, because like them, he claimed to be a painter of the American scene. He castigated John Steuart Curry for being blind to the innovations of modern artists. "How can a man who paints as though no laboratory work has ever been done in painting, who willfully or through ignorance, ignores the discoveries of Monet, Seurat, Cézanne, and Picasso and proceeds as though painting were a jolly lark for amateurs, to be exhibited in country fairs, how can a man with this mental attitude be considered an asset to the development of American painting?"[32]

Davis, an admitted Marxist, was nevertheless intent on refuting the communist claim that modernist art was socially irrelevant. He likened his role as a socially committed abstract artist to that of experimental physicists whose abstract exercises extend the frontiers of human knowledge and experience. And as Karen Wilkin has remarked, "Hopes for a new social order ran parallel to hopes for a new aesthetic order."[33] Or, as Davis put it, "the powerful urge to organization may well be . . . the forerunner of a better social order."[34]

But above all, Davis sought to rebut the accusation that his work was not realistic. In this, he challenged both the Social Realists and the Regionalists. He stressed not only that his work was figurative but that "I paint what I see in America. In other words, I paint the American scene."[35]

Davis disparaged Social Realist and Regionalist imagery for being "static" and formulated a competing justification for the realism of his abstract art.[36] He pointed to changes in contemporary life, exemplified by "new materials, new spaces, new speeds, new time relations, new lights, new colors, all of which are part of the daily experience of every living person."[37] Davis maintained that contemporary experience was distinguished by flux, fragmentation, disjunction, and dynamism. Its cacophony, complexity, and simultaneity could best be expressed by abstract form and space.[38] His thinking was also inspired by jazz, a twentieth-century American form, whose syncopation he emulated in his own work. Referring to Davis's *Swing Landscape* of 1938, John Lucas wrote that "its arbitrary repetition, alteration and superimposition of forms . . . offers something comparable to [Louis] Armstrong's variations on a theme as well as his interpolation of fragments from other tunes."[39] Indeed, in his paintings, Davis caught the tempo of American life by the collage-like dissociation and juxtaposition of motifs, as in *New York Mural* (fig. 19).

Social Realism also came under attack from another prominent figure on the political left, namely Leon Trotsky. In 1938, he published a letter in *Partisan Review* in which he castigated Stalin's repression of the arts, asserting that "artistic creation has its laws—even when it serves a social movement. True intellectual creation is incompatible with lies, hypocrisy and the spirit of conformity. Art can become a strong ally of revolution only in so far as it remains faithful to itself."[40] Trotsky had few followers compared with the communists, who considered Trotskyists devils incarnate, but they made their presence felt because such brilliant intellectuals as art historian Meyer Schapiro were sympathizers. It is noteworthy that Davis invited Schapiro to address the American Artists' Congress on "The Social Bases of Art." Trotsky's polemic might have gone unnoticed, but not after its argument was seconded in the next issue of *Partisan Review* by André Breton, the "pope" of Surrealism, and Diego Rivera, the exemplary Mexican revolutionary muralist. In a "Manifesto," they declared that it was the artist's inalienable right to escape from all restrictions on his imagination and that they stood for "*complete freedom for art*."[41]

Fig. 19. Stuart Davis (1894–1964), *New York Mural*, 1932. Oil on canvas, 84 × 48 in. (213.4 × 121.9 cm). Norton Museum of Art, West Palm Beach, Florida, Purchase, the R. H. Norton Trust.

Political events in the larger world also contributed to the waning of Social Realism. From 1936 to 1938, trumped-up trials in Moscow of Stalin's close comrades, followed by their executions, called the entire Soviet experiment into question. And, most significant, Picasso's *Guernica* showed that it was possible to create a socially relevant modernist work that was also masterfully painted. The major New York museums were not sympathetic to American avant-garde art. In 1935, the Whitney Museum mounted an important show, *Abstract Painting in America*. Davis, Gorky, and Graham were included, and Davis wrote one of the catalogue introductions. However, one-third of the show consisted of veterans of the Armory Show in 1913, making clear the Whitney's lack of interest in recent abstraction.[42] In 1936, the Museum of Modern Art organized *New Horizons in American Art,* consisting of works executed that year by more than a hundred artists on the Federal Art Project. Davis, Gorky, and de Kooning were included but the show was heavily weighted toward Social Realism and Regionalism. Of the seventy-five illustrations in the catalogue not one was of an abstract work. Alfred Barr lamely justified the museum's neglect of modernists by claiming that the Whitney Museum had dealt with them the year before. Moreover, in *Cubism and Abstract Art,* the Modern treated Cubism as a historic movement that was passé, and neglected living American Cubists. Barr believed that Surrealism offered artists viable prospects for fresh developments as Cubism no longer did. He continued to champion Picasso but treated him as a living old master.[43]

In reaction to the neglect of modernist artists by the official art world, the artists formed their own organizations to exhibit their work, promote their ideas, and rebuke their enemies in the art world. The chief groups were the Ten and the American Abstract Artists. Davis, Gorky, Graham, and de Kooning were involved in the activities of these groups.

Formed in 1935, the Ten, whose leading members were Adolph Gottlieb and Mark Rothko, sought to "combine a social consciousness with [an] abstract expressionist heritage, thus saving art from being mere propaganda on the one hand, or mere formalism on the other."[44] The Ten were so infuriated by the Whitney Museum that in 1938, as the Whitney Dissenters, they organized a rival show. In 1923–24, Gottlieb and Graham had been fellow students in John Sloan's class, and they remained close friends. Gottlieb sponsored Graham's bid for American citizenship.[45] Graham showed with the Ten in 1938, although he did not become a member of the group.

The Ten's paintings were often foreboding in feeling, reacting to the appalling global situation and anticipating World War II. As early as 1936, the critic Herbert Lawrence observed that the Expressionist paintings of the Ten embody "futility, abandonment and the insecurity of modern life."[46]

In 1937, Jacob Kainen, a close friend of Rothko, added that their canvases are "expressive of the violence of our time, of the swift tempo of disaster which threatens to engulf us." He concluded, "We are closer to chaos than we think."[47]

In 1936, some three dozen abstract and nonobjective artists formed an organization they named the American Abstract Artists (AAA). Through its shows and catalogues, the AAA played a vital role in achieving recognition for nonobjective art. As Clement Greenberg recalled, "The annual exhibitions of the American Abstract Artists . . . were the most important occasions of these years as far as advanced art in New York was concerned."[48]

The members of the AAA were influenced by Synthetic Cubism but tended to work in geometric nonobjective styles derived from Dutch de Stijl, German Bauhaus, and Russian Constructivism and Suprematism. Geometric abstraction appealed to avant-garde artists in the 1930s because it prized reason and order and shunned, as Josef Albers put it, "disorder and accident."[49] It was also appealing because it was the most advanced stage to which modern art had progressed, because it was constructive, and because it was internationalist in outlook. Moreover, the Americans were impressed by European nonobjective artists, notably Mondrian, who were very active in Paris, the center of global art, and had formed influential organizations: Abstraction-Création, Cercle et Carré, and Art Concret.

Most members of the AAA were motivated by a will to order. They aspired to perfection in art and, by extension, in society. Their intentions had both artistic and social implications. On one hand, aestheticist geometric artists were inclined to value art-for-art's-sake in the conviction that art was autonomous and self-sufficient. On the other hand, socially minded geometric artists could envision their ideal designs to be the representative art of a future international collectivist brave new world governed by reason. It is not surprising that during the Great Depression even nonobjective artists justified their art in social terms. Both the aestheticist and brave-new-world rationales enabled modernist artists to uphold abstract art in the face of the reigning Marxist and nationalist rhetoric.

Gorky and de Kooning attended the first meeting of the American Abstract Artists—and walked out. De Kooning said to me, "I wasn't a member . . . but I was with them. I disagreed with their narrowness, their telling me *not* to paint something."[50] Davis agreed. He also criticized what he considered their purist art's lack of social consciousness. Graham admired Mondrian, but with reservations. He wrote that "Mondrian had the vision and the heart to start anew. Maybe he did not go far enough but he had the courage at least to say a new 'a.'"[51] Nonetheless, Graham allowed himself to be nominated for membership in the American Abstract Artists.

He was rejected by one vote.[52] Smith, however, joined the AAA in 1937 and showed with the group the following year.

Like the Four Musketeers and their circle, the members of the AAA considered their works individual but allowed that they were derivative of European models. George L. K. Morris, a spokesman for the AAA, even made a virtue of imitation. He wrote: "It is in no way unnatural that any large group of artists . . . should continue in the direction of others whom they have admired. The average conception of 'originality' usually denotes little that is important or profound. . . . The greatest art . . . is frequently derivative. . . . Intelligent derivation is to be recommended."[53]

Surrealism was very much in the air in the 1930s, but it found few if any supporters among the Social Realists, the Regionalists, or the geometric abstract artists. The Social Realists condemned Surrealism as "counterrevolutionary" and singled out Salvador Dalí's painting as "miserable eclectic art."[54] According to Samuel Putnam, in an essay in *Art Front,* Surrealism was anti-Marxist. It set out not "to change . . . the material, real world of Social relationships [but] to change . . . the reflection of the world in consciousness."[55] The Regionalists, intent on portraying agrarian and small-town America, or their dream of it, spurned Surrealist fantasy imported from Europe.

Cubist-inspired abstract artists, who prized the rational, rejected Surrealism's obsession with irrational inward-looking. As Alice Mason wrote in the catalogue of the AAA's show in 1936, the Surrealists "still use their materials as props for narrative; they find a source of wonder in dreams, in automatism and in the subconscious, and depict this feeling academically. . . . Not working plastically, they seek to record such things as nostalgia, dreamlike fancies and incongruous shapes that have no place at all with abstract art."[56]

Shows of Dalí's painting in New York galleries, however, generated heated controversy among artists. The responses of the Four Musketeers were mixed. Davis and Graham disagreed with each other in reviews published on the same page in the January 1935 issue of *Art Front.* Graham had reservations about current Surrealist painting but wrote that "Surrealisme is an art which insists upon the irreality of the material world and the reality of the immaterial world; it brings to one denominator things never brought together before; . . . it is, as all abstract art, truly revolutionary, since it teaches the unconscious mind . . . revolutionary methods, thus providing the conscious mind with material and necessity for arriving at revolutionary conclusions."[57] Graham also advocated automatism, or as he put it, "automatic 'ecriture,'" Surrealism's central technique, as a way of tapping the unconscious.[58] Davis acclaimed Dalí's artistry in glowing words, but berated his painting for its lack of

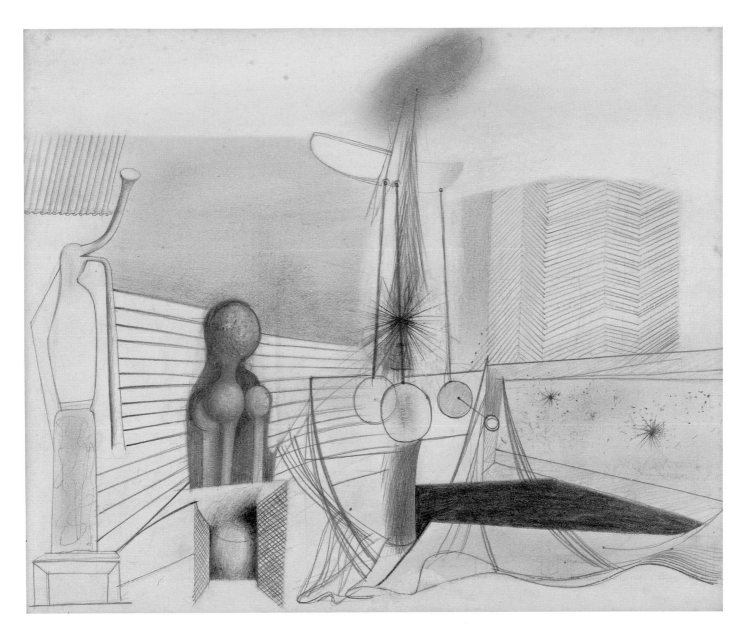

Fig. 20. Willem de Kooning (1904–1997), *Design for World's Fair Mural for Hall of Pharmacy,* 1937. Graphite on paper, 9½ × 11⁷⁄₁₆ in. (24.1 × 29 cm). Courtesy of the Allan Stone Gallery, New York.

originality. "There is no form of painting of Dalí with which we are not familiar. [One] looks only backward and the sun is setting. Artists who intend to continue will have to change cars."[59]

Gorky and de Kooning, however, had already begun to look to Surrealism for inspiration, Gorky as early as 1931 in his *Nighttime, Enigma, and Nostalgia* series. By the middle of the decade, these works had evolved into Miróesque biomorphic abstractions, such as *Xhorkom—Summer,* 1934 (pl. 38), and *Enigmatic Combat,* 1937. The egglike images and enigmatic atmosphere in a number of de Kooning's figurative and abstract paintings from 1931 to 1937 could be labeled Surrealist (fig. 20). But the following year, he turned to painting pictures of shabby, isolated, vulnerable, and abject men, several of them self-portraits of sorts, the poignant progeny of the Great Depression.

How might the early experiences of the Musketeers have contributed to their future careers? By the late 1920s, Davis, who had painted American scenes as early as 1921, had established himself as the premier modernist

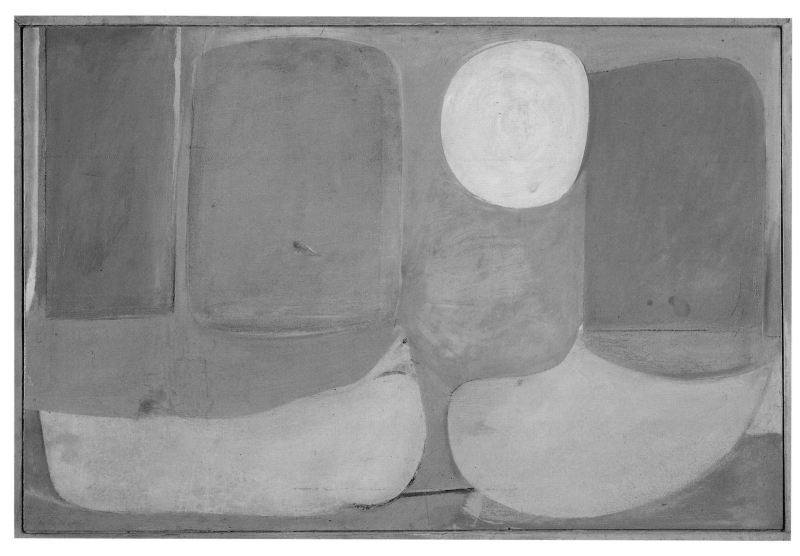

Fig. 21. Willem de Kooning (1904–
1997), *Pink Landscape,* c. 1938. Oil
on composition board, 25 × 37⅛ in.
(63.5 × 94.3 cm). Private collection.

American Scene painter, and he continued to develop and enrich his Synthetic Cubist style. In the early 1940s, Graham, Gorky, and de Kooning rejected Synthetic Cubism. However, the example of Picasso remained in their minds. He showed them that painting could be inclusive and open-ended as well as revolutionary and traditional. Inspired most likely by Picasso's image as protean genius, they aspired to be as original as he was, but they ceased to be dependent on and subservient to Picasso and asserted their individual artistic identities. By the mid 1940s, Graham vilified Picasso as a "charlatan" with the passion with which he had earlier championed him. At that time, Graham was looking back to Uccello, Raphael, Poussin, Ingres, and other "classical" masters. He painted "portraits," many with crossed eyes and wounds, as if injured by knives or swords, and arcane diagrams, numbers, signs, and symbols superimposed on the images. Highly idiosyncratic, these strange pictures have only recently received the recognition they deserve.

Gorky and de Kooning moved on from Cubism, even though vestiges remained, and evolved radical non-Cubist styles, Gorky as an avant-garde abstract Surrealist and de Kooning as an innovator of Abstract Expressionism. Gorky and de Kooning achieved prominence because they were able to meet the challenge of a pervasive change of sensibility that developed with the outbreak of World War II in 1939 and, more directly, the United States' entry into the war in 1941. Both painters embodied the mood of this historic time in a way that the Social Realists, Regionalists, and American Abstract Artists did not. Social Realism lost its appeal as the war ended the economic depression and Stalin's true monstrosity was revealed, despite the Soviet Union's role in the victory over Nazism in World War II. The nationalism of Regionalism also lost its cachet as the concerns of the United States turned international.

The nonobjective styles of American Abstract Artists, whether they embodied rationality, art-for-art's-sake, or visions of the perfectibility of art, humankind, and society, also seemed irrelevant during and after World War II. Gorky and de Kooning appear to have recognized that irrationality was inherent in the human condition and could not be suppressed in an art that aspired to be *true*. Their early acceptance of Surrealism had prepared them for the changed world situation. Moreover, as artists who painted both abstract and figurative pictures, Gorky and de Kooning refused to accept the formal limitations called for by the nonobjective artists in the AAA. Thus, they were able to move stylistically—and conceptually—in new directions (fig. 21).

Taking to heart Graham's call for Surrealist automatism, Gorky used an improvisational approach to recall tragic events of his childhood, among other subjects. He boldly moved his abstraction beyond where

Surrealists were willing to venture. Adolph Gottlieb would write that Gorky recognized that "the vital task was a wedding of abstraction and surrealism. Out of these opposites something new could emerge, and Gorky's work is part of the evidence that this is true."[60] De Kooning used improvisation to create innovative black and white Abstract Expressionist paintings in which he melted down Cubism's rigid structure to create a new gripping image of flux, ambiguity, and violence.

In retrospect, it is not surprising that artists as gifted and forward-looking as Davis, Graham, Gorky, de Kooning, and David Smith should have found one another, become fast friends (at least for critical periods in their lives), agreed as they did on what art needed at a crucial time in their careers, formed a group, if an informal one, influenced each other, and gone on to create unique bodies of work. Perhaps Barnett Newman was right when he once said, "Art is a series of historical miracles. It either happens or it doesn't."

Notes

1. Irving Sandler, "Conversations with de Kooning," *Art Journal* (Fall 1989): 116–17. Recent historians generally agree with de Kooning; see William C. Agee's essay in this catalogue. The published report of the First American Artists' Congress Against War and Fascism, which I encountered in the Museum of Modern Art's library in the 1950s, was of profound significance to me as a critic-historian. In it, I read Meyer Schapiro's address on the social bases of art, which he started by saying that art has its own conditions that distinguish it from other activities. However, he went on to say, with these conditions alone one cannot understand why styles change. In Schapiro's view, the social need for a new style plays the critical role. Confronted by an existing art that no longer seems real or relevant, artists sensitive to the changing world respond in deeply felt ways and develop new values and new ways of seeing. I have been mulling over the question of style change for some six decades, and Schapiro's approach still seems the most useful. See Matthew Baigell and Julia Williams, eds., *Artists Against War and Fascism: Papers of the First American Artists' Congress* (New Brunswick, N.J.: Rutgers University Press, 1986), 103–13.
2. Arshile Gorky, "Stuart Davis," *Creative Art* 9, no. 3 (September 1931): 213. In "Arshile Gorky in the 1930s: A Personal Recollection by Stuart Davis," *Magazine of Art* 44 (February 1951): 58, Davis reciprocated by characterizing Gorky as "one who had the intelligence and energy to orient himself in the direction of the most dynamic ideas of the time."
3. Harold Rosenberg, *De Kooning* (New York: Abrams, 1974), 38.
4. John D. Graham, *System and Dialectics of Art* (New York: Delphic Studios, 1937), 75.
5. Hayden Herrera, Conversation with Willem de Kooning, December 1972, in "We Were the Cafeteria People," *Mulch* 8/9 (Spring–Summer 1976): 41.
6. David Smith, "Atmosphere of the Early Thirties," in Garnett McCoy, *David Smith* (New York: Praeger, 1973), 86.
7. Ibid.

8. Ibid.
9. Dorothy Dehner, "Memoir of John Graham," Dorothy Dehner Papers, Archives of American Art, Microfilm reel, D298, frame 1535, quoted in Bruce Weber, *Toward a New American Cubism* (New York: Berry Hill Galleries, 2006), 21.
10. See Herrera, Conversation with Willem de Kooning, 41. Copies of *Cahiers d'art* were available at the New York Public Library. Artists who lived in cold-water studios often visited the library, particularly in the winter, if only because it was heated.
11. Hayden Herrera, *Arshile Gorky: His Life and Work* (New York: Farrar, Straus and Giroux, 2003), 174.
12. "Hedda Sterne in Conversation," Arshile Gorky Research Collection, Matthew Spender Papers, Whitney Museum of American Art, Library Collection, 1, quoted in Weber, *Toward a New American Cubism,* 31.
13. Graham, *System and Dialectics of Art,* 94.
14. Sandler, "Conversations with de Kooning," 216–17.
15. See Mark Stevens and Annalyn Swann, *De Kooning: An American Master* (New York: Alfred A. Knopf, 2004), 137.
16. See Dore Ashton, *The New York School: A Cultural Reckoning* (New York: Viking, 1973), 102.
17. Herrera, *Arshile Gorky,* 267. Gorky's mural was also attacked because it included Texaco's red star logo on the gasoline truck and a government official mistook it for the Communist red star. The logo was also objected to because it might be considered a free advertisement for Texaco. Gorky was asked to repaint the star in blue.
18. Herrera, "We Were the Cafeteria People," 41.
19. Meyer Schapiro, quoted in Ethel K. Schwabacher, *Arshile Gorky* (New York: Whitney Museum of American Art, 1957), 11.
20. John D. Graham, letter to Duncan Phillips, dated 1931, quoted in Michael FitzGerald, *Picasso and American Art* (New York: Whitney Museum of American Art, 2006), 123.
21. Willem de Kooning, handwritten notes of a conversation with the author, New York, 1958.
22. David Burliuk, "Introduction," *John Graham* (New York: Dudensing Gallery, 1929), n.p.
23. Graham, *System and Dialectics of Art,* 81.
24. Edwin Denby, *De Kooning* (Madras: Hanuman, 1988), 22.
25. Fritz Bultman, handwritten notes of a conversation with the author, New York, late 1950s, said that Hofmann was a friend of Graham and admired his *System and Dialectics of Art.*
26. David Smith, "Events in a Life," in *David Smith by David Smith,* ed. Cleve Gray (New York: Holt, Reinhart and Winston, 1968), 24.
27. Wolf Kahn, notes of lectures "On the Hofmann School" at the College Art Association annual meeting in New York, January 1973, and the New York Studio School on January 10, 1990.
28. See Gerald M. Monroe, "The '30s: Art, Ideology, and the WPA," *Art in America* (November–December 1975): 64–67.
29. Graham, Gottlieb, and Smith signed the "Call" for the Congress. Gorky and de Kooning did not. They feared that as immigrants they might be deported. Among the other artists who signed were Berenice Abbott, Milton Avery, Will

Barnet, Alexander Calder, Yasuo Kuniyoshi, Reuben Nakian, Isamu Noguchi, Paul Manship, Louis Mumford, Max Weber, and art historian Meyer Schapiro. Among the foreign participants were Jose Clemente Orozco and David A. Siqueiros.

A second Congress took place in 1937. It was endorsed by Mayor Fiorello LaGuardia and was hailed by "direct wire" by Pablo Picasso.

30. Rosalind Browne, handwritten notes of a conversation with the author, New York, February 11, 1968. She said that Gorky made the remark in a speech at the Artists' Union in the spring of 1936.

The Four Musketeers were on the left politically. Gorky and de Kooning avoided joining political organizations but they participated in occasional activities. For one May Day demonstration during the Spanish Civil War, they were asked to make a float saluting the Abraham Lincoln Brigade, which was fighting fascism in Spain. (De Kooning was supposed to paint the head of Lincoln but didn't know what he looked like. He asked the painter Harry Holtzman, who handed him a penny.) Marching in a May Day parade, Graham, wearing elegant chamois gloves, was observed chanting "We want bread"; Thomas B. Hess, *Willem de Kooning* (New York: Museum of Modern Art, 1968), 144.

So pervasive was communist proselytizing that de Kooning, in conversation with the author, New York, late 1950s, recalled that he, Gorky, and a number of their friends talked about forming a group to paint proletarian pictures but "to put painting into them." It never really got under way. George McNeil, a former student of Matulka, in a conversation with the author, New York, in the late 1950s, said not to forget that in the 1930s he and his avant-garde friends were young and "happy and dumb. We believed in what we were doing because everything else was rotten. The banality of Regionalism made us feel great."

31. Stuart Davis, "Notes 1/30/39," in *Stuart Davis: A Documentary Monograph,* ed. Diane Kelder (New York: Praeger, 1971), 87–89. Davis also wrote, "Art is not politics nor is it the servant of politics. It is a valid, independent category of human activity." Davis Papers, reel 1, 1936, quoted in Karen Wilkin, *Stuart Davis* (New York: Abbeville, 1987), 143.

32. Stuart Davis, "The New York American Scene in Art," *Art Front* 1, no. 3 (February 1935): 6.

33. Wilkin, *Stuart Davis,* 143–44.

34. Davis Papers, reel 1, 1936, quoted in ibid., 143–44.

35. Stuart Davis, quoted in Gilbert Morris, "Eggbeater Artist Defends Credit to France for Help Given American Painters," *New York World-Telegram,* February 21, 1940, 13, quoted in Weber, *Toward a New American Cubism,* 26. Supporters of Regionalism retaliated by accusing Davis of "painting French."

36. Davis Papers, 1936, quoted in Wilkin, *Stuart Davis,* 143.

37. Stuart Davis, quoted in Jerome Klein, "Stuart Davis Criticizes Critic of Abstract Art," *New York Evening Post,* February 26, 1938, 24, quoted in Weber, *Toward a New American Cubism,* 26.

38. Davis said, "I've accepted the noise, the cacophony . . . of present-day American Life"; Katharine Kuh, *The Artist's Voice: Talks with Seventeen Modern Artists* (New York: Da Capo, 2000), 56.

39. John Lucas, "The Fine Art Jive of Stuart Davis," *Arts* 31 (September 1957): 34, quoted in Jody Patterson, "The Art of Swinging Left in the 1930s: Modernism,

Realism, and the Politics of the Left in the Murals of Stuart Davis," *Art History* (February 2010): 113.

40. Leon Trotsky, "Art and Politics: A Letter to the Editors of *Partisan Review*" (August–September 1938): 10.

41. André Breton and Diego Rivera, "Manifesto," *Partisan Review* (Fall 1938): 50–51. Trotsky, in "Letters: Trotsky to André Breton," *Partisan Review* 6, no. 2 (Winter 1938): 126–27, praised Breton and Rivera for their stand, reiterating, "The struggle for revolutionary ideas in art must begin once again with the struggle for artistic *truth,* not in terms of any single school, but in terms of *the immutable faith of the artist in his own inner self.* 'You shall not lie!'—this is the formula of salvation."

42. George McNeil, in "American Abstractionists Venerable at Twenty," *Art News* 55, no. 3 (May 1956): 24, wrote, "The Whitney's genuine 1936 outlook was shown at its Third Biennial Exhibition of Contemporary Art when only ten of the 123 artists could be considered abstract, even with a liberal allowance." Davis and Gorky were among the ten.

43. In 1939, Barr mounted *Picasso: Forty Years of His Art,* accompanied by a major publication.

44. Herbert Lawrence, "The Ten," *Art Front* (February 1936): 10.

45. See Mary Davis MacNaughton, "Adolph Gottlieb: His Life and Art," *Adolph Gottlieb: A Retrospective* (New York: Art Publishers, 1981), 16.

46. Lawrence, "The Ten," 12.

47. Jacob Kainen, "Our Expressionists," *Art Front* (February 1937): 14–15.

48. Clement Greenberg, "America Takes the Lead, 1945–1965," *Art in America* (August–September 1965): 108.

49. Josef Albers, *Despite Straight Lines* (New Haven: Yale University Press, 1961), 75. Albers was highly regarded by American abstract artists because he had been a professor at the Bauhaus before emigrating to America after the Nazis took power, and becoming a professor at Black Mountain College in North Carolina.

50. Sandler, "Conversations with de Kooning," 216–17.

51. Graham, *System and Dialectics of Art,* 33.

52. Carl Holty, handwritten notes of a conversation with the author, New York, August 12, 1968. He thought the vote was 21 to 20 but was not sure.

53. George L. K. Morris, "Introduction," *American Abstract Artists* (New York, 1939), section 4, n.p.

54. Clarence Weinstock, "Surrealism and Reality," *Art Front* (March 1937): 9–10.

55. Samuel Putnam, "Marxism and Reality," *Art Front* (March 1937): 11.

56. Alice Mason, "Concerning Plastic Significance," *American Abstract Artists* (New York, 1938), sec. 6, n.p.

57. John D. Graham, "Eight Modes of Modern Painting," *Art Front* (January 1935): 7.

58. John Graham, *System and Dialectics of Art,* ed. Marcia Epstein Allentuck (Baltimore: Johns Hopkins Press, 1971), 135.

59. Stuart Davis, "Paintings of Salvador Dalí," *Art Front* (January 1935): 7.

60. Adolph Gottlieb, Introduction, *Selected Paintings of the Late Arshile Gorky* (New York: Kootz Gallery, 1950), 1.

Plates · 1936—1939

38
Arshile Gorky (1904–1948)
Xhorkom—Summer, 1936
Oil on canvas
36 × 48 in. (91.4 × 121.9 cm)
Albright-Knox Art Gallery, Buffalo, New York,
Sarah Norton Goodyear Fund and Partial Gift
of David K. Anderson to the Martha Jackson
Collection 1999, 1999:8

39
Arshile Gorky (1904–1948)
Portrait of Akabi, c. 1936–37
Oil on canvas board
12 × 9⅛ in. (30.5 × 23.2 cm)
Hirshhorn Museum and Sculpture Garden,
Smithsonian Institution, Washington, D.C.,
Gift of Joseph H. Hirshhorn, 1966

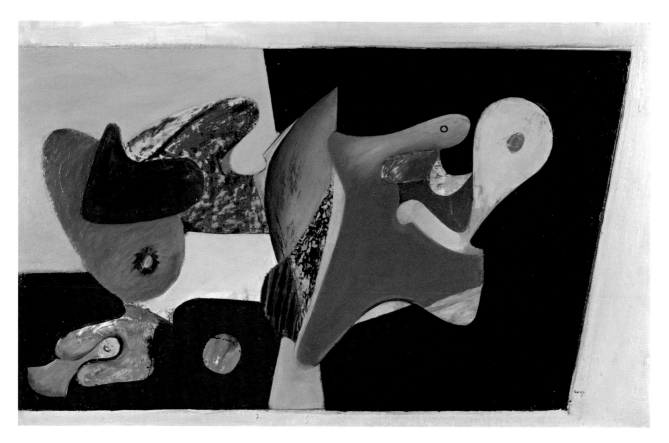

40
Arshile Gorky (1904–1948)
*Organization (Nighttime, Enigma, and
Nostalgia),* c. 1934–36
Oil on linen canvas mounted on masonite
14 × 22 in. (35.6 × 55.9 cm)
University of Arizona Museum of Art,
Tucson, Gift of Edward Joseph Gallagher, Jr.

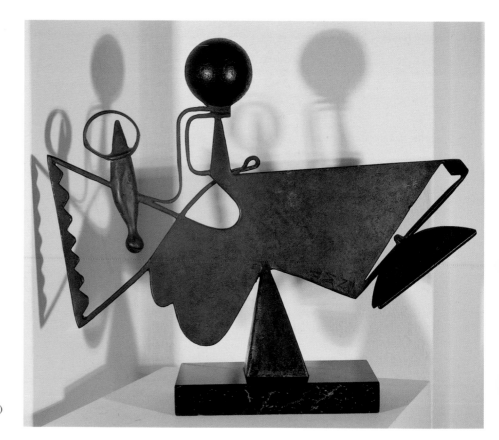

41
David Smith (1906–1965)
Construction on a Fulcrum, 1936
Bronze and iron
14 × 17 × 3 in. (35.6 × 43.9 × 7.6 cm)
Private collection

42
Arshile Gorky (1904–1948)
Organization, 1933–36
Oil on canvas
50 × 59¹³/₁₆ in. (127 × 151.9 cm)
National Gallery of Art, Washington, D.C.,
Ailsa Mellon Bruce Fund, 1979.13.3

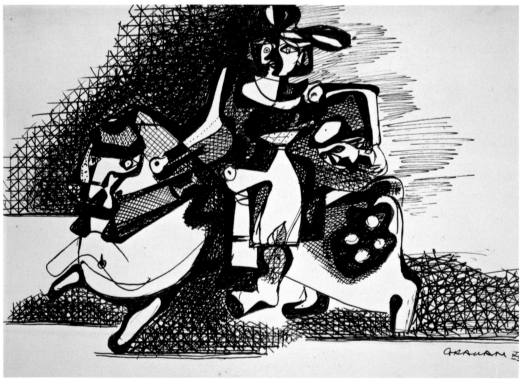

43
John Graham (1887–1961)
Untitled, c. 1933
Pen and ink on paper
8⅝ × 11⅞ in. (21.9 × 30.2 cm)
Allan Stone Collection, Courtesy of
the Allan Stone Gallery, New York

44
John Graham (1887–1961)
Europa and Bull, 1936–37
Pen and ink on paper
8⅝ × 11⅞ in. (21.9 × 30.5 cm)
Allan Stone Collection, Courtesy of
the Allan Stone Gallery, New York

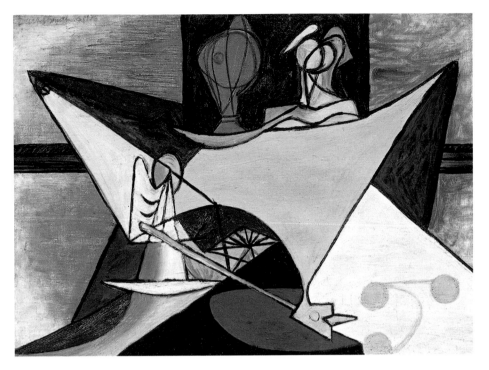

45
David Smith (1906–1965)
Untitled (Billiards), 1936
Oil on canvas
11¾ × 16 in. (29.8 × 40.6 cm)
The Estate of David Smith, New York

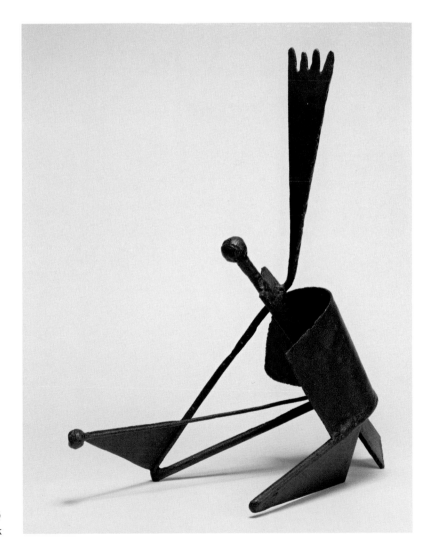

46
David Smith (1906–1965)
Dancer, 1935
Patinated iron
21 × 9½ × 8 in. (53.3 × 24.1 × 20.3 cm)
Collection of Peter Blum, New York

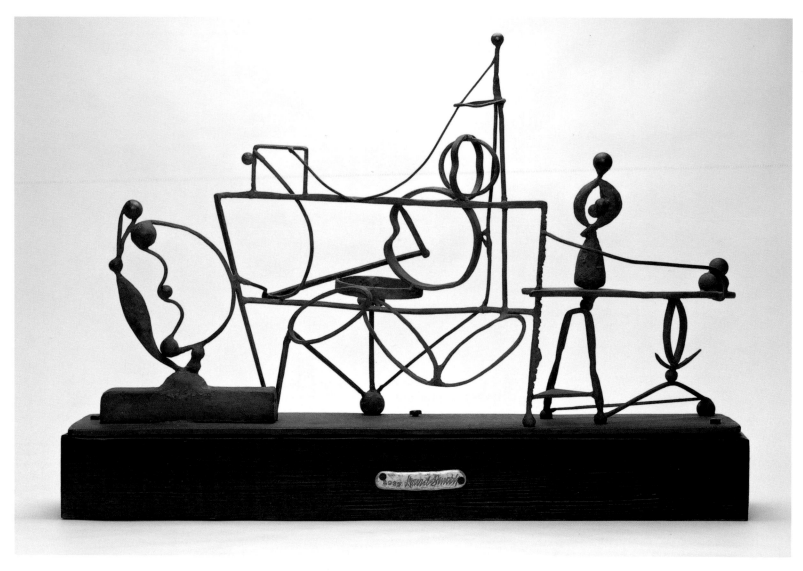

47
David Smith (1906–1965)
Interior, 1937
Welded steel with cast iron balls
15⅝ × 26 × 6 in. (39.7 × 66 × 15.2 cm)
Weatherspoon Art Museum, The University of
North Carolina at Greensboro, Museum purchase
with funds from anonymous donors, 1979 (1979.2668)

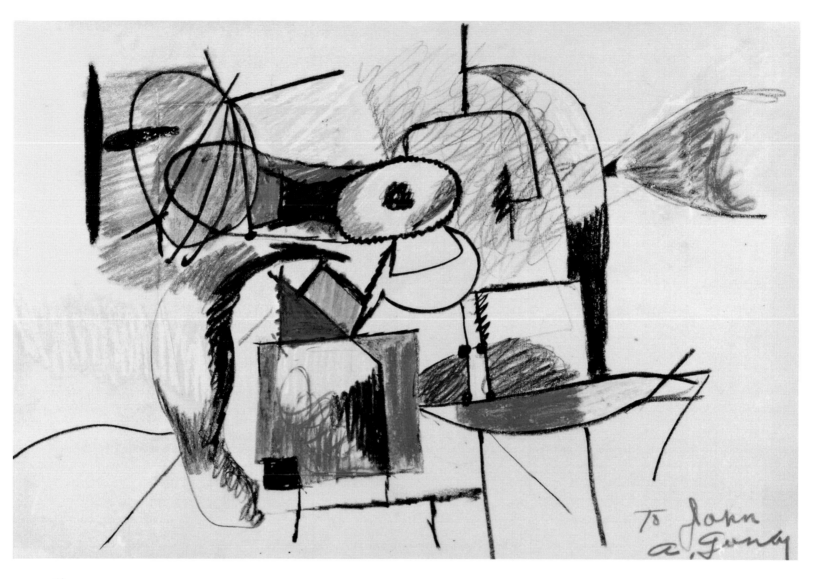

48
Arshile Gorky (1904–1948)
[inscribed "To John"], c. 1938
Crayon on paper
20 × 14¼ in. (50.8 × 36.2 cm)
Collection of Basha and Perry Lewis

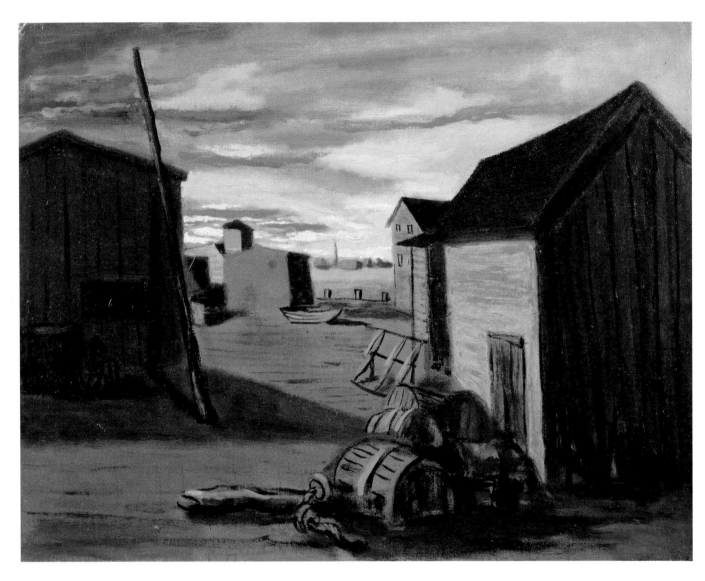

49

Adolph Gottlieb (1903–1974)

Untitled (Gloucester Docks), c. 1938

Oil on canvas

19 × 23⅞ in. (48.3 × 60.6 cm)

Adolph and Esther Gottlieb Foundation, New York

50
Stuart Davis (1892–1964)
Gloucester Harbor, 1938
Oil on canvas, mounted on panel
23¹⁄₁₆ × 30⅛ in. (58.6 × 76.5 cm)
The Museum of Fine Arts, Houston,
Museum purchase with funds provided by
the Agnes Cullen Arnold Endowment Fund

51
Edgar Levy (1907–1975)
Figure in Yellow Window, 1938
Oil on canvas
60 × 48 in. (152.4 × 121.9 cm)
Private collection

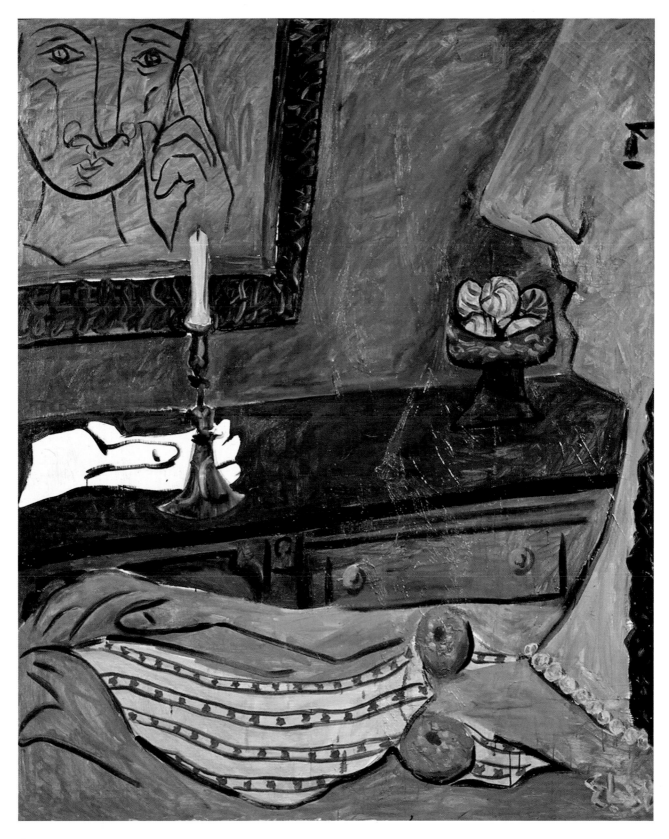

52

Edgar Levy (1907–1975)

Still Life, Figure, Self-Portrait, 1938

Oil on canvas

60 × 48 in. (152.4 × 121.9 cm)

Courtesy Babcock Galleries, New York

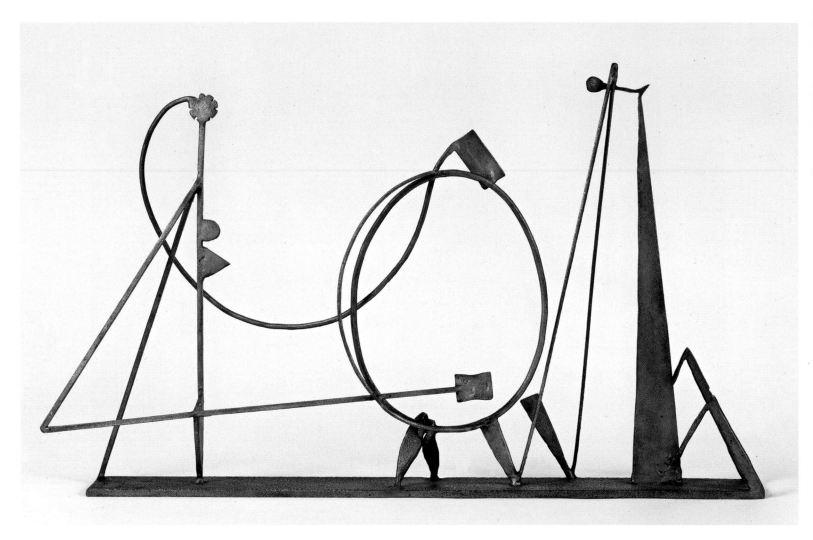

53
David Smith (1906–1965)
Amusement Park, 1938
Welded steel
20 × 34 × 4 in. (50.8 × 86.4 × 10.2 cm)
New Orleans Museum of Art, Louisiana, Gift of Mr. and
Mrs. Walter Davis, Jr., in honor of the museum's seventy-
fifth anniversary, 85.105

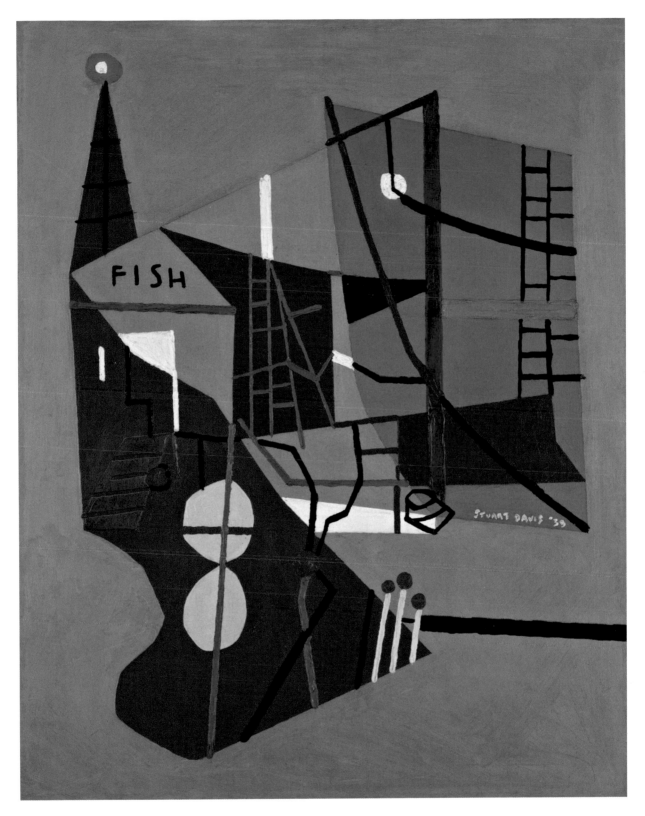

54
Stuart Davis (1892–1964)
Shapes of Landscape Space, 1939
Oil on canvas
36 × 28 in. (91.4 × 71.1 cm)
Neuberger Museum of Art, Purchase College,
State University of New York, Gift of Roy R. Neuberger

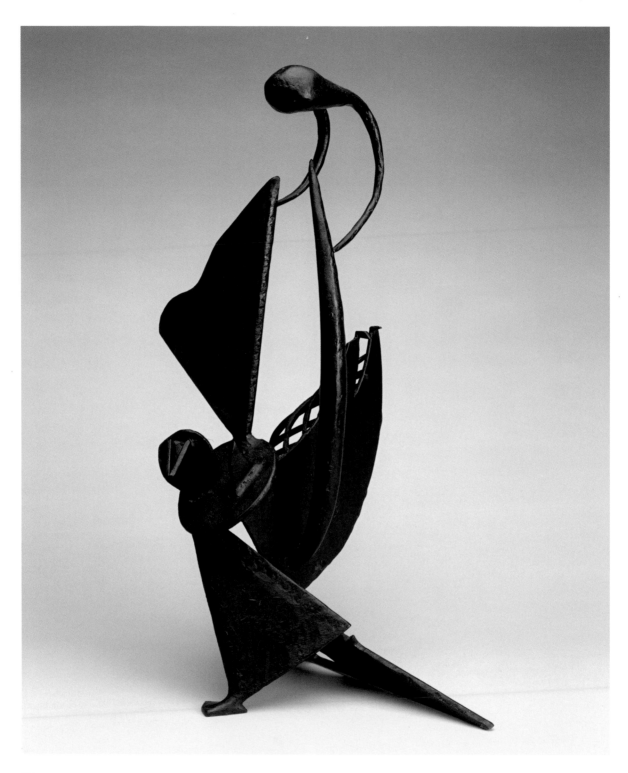

55
David Smith (1906–1965)
Leda, 1938
Painted steel
28⅝ × 15½ × 13½ in. (72.7 × 39.4 × 34.3 cm)
The Museum of Fine Arts, Houston,
Gift of Mr. and Mrs. W. D. Hawkins

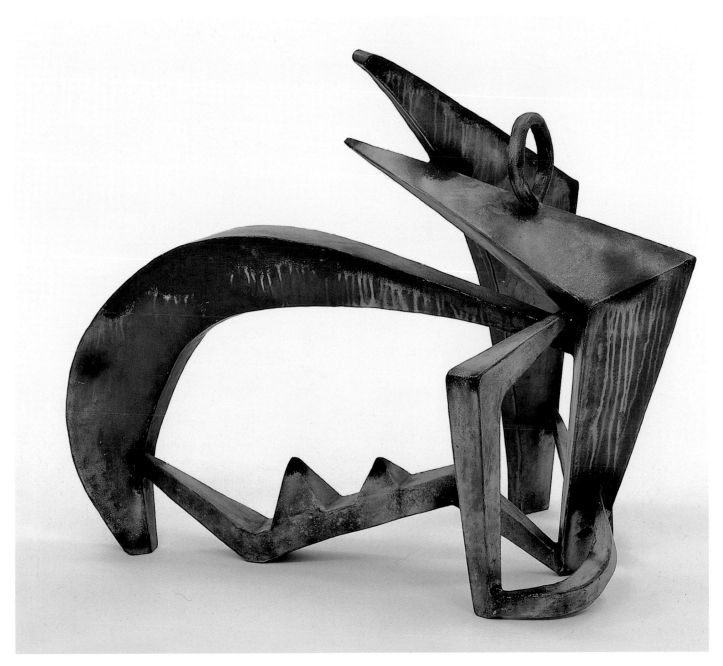

56
David Smith (1906–1965)
Structure of Arches, 1939
Steel with zinc and copper plating
39⁵⁄₁₆ × 48 × 30¼ in. (99.8 × 121.9 × 78.8 cm)
Addison Gallery of American Art, Phillips Academy,
Andover, Massachusetts, Purchased as the Gift of
Mr. and Mrs. R. Crosby Kemper (PA 1945)

58
Willem de Kooning (1904–1997)
Untitled, 1939
Gouache on paper
5½ × 7¾ in. (14 × 19.7 cm)
Allan Stone Collection, Courtesy of
the Allan Stone Gallery, New York

57 (*opposite*)
Willem de Kooning (1904–1997)
Portrait of Rudy Burckhardt, 1939
Oil on canvas
49 × 36 in. (124.5 × 91.4 cm)
Collection of Basha and Perry Lewis

59
Jackson Pollock (1912–1956)
Bird, c. 1938–41
Oil and sand on canvas
27¾ × 24¼ in. (70.5 × 61.6 cm)
The Museum of Modern Art, New York, Gift of Lee Krasner
in memory of Jackson Pollock, 1980

60 (*opposite*)
Jackson Pollock (1912–1956)
Masqued Image, c. 1938–41
Oil on canvas
40 × 24 in. (101.6 × 61 cm)
Modern Art Museum of Fort Worth, Museum purchase made
possible by a grant from the Burnett Foundation, acquired in 1985

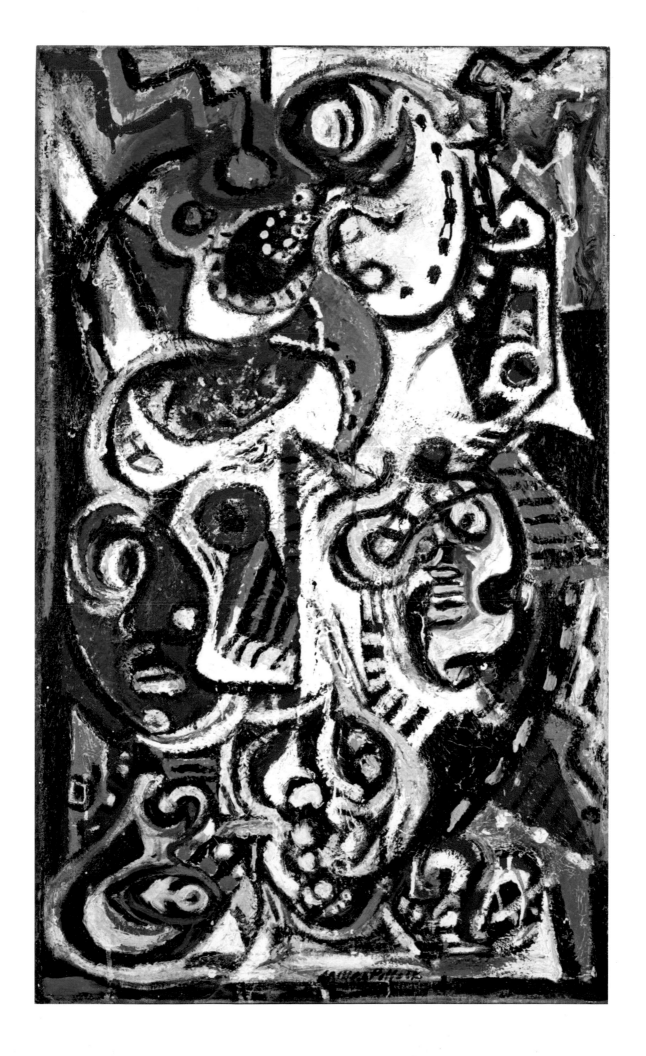

William C. Agee

Graham, Gorky, de Kooning:
A New Classicism, an Alternate Modernism

American Vanguards argues for the continuing vitality of modernism in America in the years after 1920 until World War II, a period still often considered aesthetically provincial and isolationist. In fact, modernism continued apace in these years, in both old and new formats and often in new venues. It continued in the high traditions of advanced art begun before World War I, and added art of the highest accomplishment. Graham, Davis, Gorky, and de Kooning, along with their friends, were major factors in the enrichment of American art at this time. They can be considered members of a true avant-garde whose work was at the forefront of new modernist developments, known and respected primarily by their fellow artists, but with more official recognition than we have suspected. Graham was a mentor in the tradition of Thomas Eakins, Alfred Stieglitz, Robert Henri, and John Sloan for a younger group of artists, telling us that there was always more interaction between younger and older generations than we have thought, and reminding us of how false and artificial has been the barrier between pre- and post-1945 art.

For the most part, we have understood modern and avant-garde to mean abstract and abstracting art, complex and difficult to read and understand, a kind of private language not readily accessible to most viewers. Moving to the abstract meant breaking through to a higher order. In advanced circles, to paint the figure has often meant a step back, to an art not quite as daring or adventurous. This must be rethought when we consider Graham, Gorky, and de Kooning, as well as the entirety of modern art. To be sure, the Graham circle produced some of the best abstract art this country has ever seen, largely based on Synthetic Cubism, primarily the work of Picasso.[1]

Yet in fact some of their best work was based on the figure, grand figurative compositions that were meant to—and did—rival the art of the past. These paintings were not early, youthful endeavors that they soon outgrew. A kind of figurative reference stayed with them, and was interwoven deeply into their art for the rest of their lives. By 1942,

Detail, pl. 86

117

Graham had turned exclusively to the figure, a move that has generally been interpreted as a renouncement of modernism. But it wasn't—it was a wholesale turn to another type of modernism, which we have hardly recognized. Much of Gorky's post-1943 art, thought to be abstract, actually often camouflaged figures of family, friends, and lovers.[2] For de Kooning the figure never left his art except for a few years in the late 1950s. We should not be shocked at the realization that the figure was often at the heart of even Pollock's most abstract art. "I'm very representational some of the time, and a little all of the time," he famously said, not surprising since he had studied and recast old master drawings in the late 1930s, finding new sources of pictorial energy in them.[3]

We have often labeled the abstracting art of the time, especially Gorky's, as a pale if skilled imitation of Picasso, Fernand Léger, and others. It is the tired old refrain about American art. This also needs reconsideration, for the best of it stands on its own, as singular accomplishments, not only better but far more original than we have thought. Graham was the first to think so, and his judgment stands true today.[4] The same is true of their figurative work. In fact, one of the compelling questions at hand is to what extent the artists of the Graham circle brought forth a distinctly American art. This would include what we might identify as an American Cubism, based on a lean precisionist structure, generated by a speed that Graham identified as American.[5] Adapting a universal language of Cubism to a specifically American subject is an old and ongoing saga in the United States that continues to demand our attention. What is American is no longer in fashion in a global multicultural world, but it was crucial to these artists. It was a concern for Graham, who spoke of a specifically American art in *System and Dialectics of Art.* Can this be said about the figuration as well? I think the answer may well be yes, for these paintings are essentially without precedent, and show an American willingness to explore new means, in any and all ways, as well as a willingness to fuse old and new, European and American, that Graham also identified.[6] De Kooning's urge to paint like Chaim Soutine and Jean-Auguste-Dominique Ingres, only at the same time, is but one indication of the American willingness to experiment, to try different modes and different styles, to let it loose, an American empiricism raised to a full working methodology.[7] Graham, Gorky, and de Kooning, all émigrés, found a new freedom in the United States, unbound from an old order and untied to the dictates of the prevailing American aesthetic provincialism. Freed from the burdens of history, theirs and that of their new country, they could make an art based on what they found useful and ripe with promise, including the art of the past. To be sure, most artists respect tradition, but to make something of it in a modern idiom was and is now rare.

If we still think of figurative work as a step back, there are good historical reasons for it. The long-standing, ingrained cliché of American art history after 1918 was one of steadfast retreat, a move back from the prewar experiments of abstract art. This fit the national political and social mood, and certainly many artists did take up a dry and academic style that sought to depict the American scene, as well as the devastating effects of the Great Depression. But this was not embraced by all, certainly not the group around Graham. They saw their art as something unto itself, embodying their ambition and their profession—not as something in the service of social and political causes. They surely all suffered during the 1930s at the height of the Depression, but everyone did, artists included, thus giving them all a common identity. "We were all poor," de Kooning said, "and worried only about the work. It used to be all artistic ideas."[8] De Kooning also recounted how his year in 1935 on the art project of the Works Progress Administration (WPA), which helped keep him alive, also gave him a renewed focus, a new sense of community among artists, a primary legacy of the government art projects. WPA sponsorship certainly freed many artists from any doctrinaire pressure to advance the abstract or treat the figurative as regressive. From the start de Kooning refused to identify with any movement, preferring to keep his art free and open, an attitude shared by others. As usual, Picasso led the way when he said in 1923, "If the subjects I have wanted to express have suggested different ways of expression I have never hesitated to adopt them."[9]

Following the devastation of World War I, the very conception of modernism changed and expanded significantly, taking new directions and forms that we have largely missed or misread. Most important, after 1918 a new wave of classicism came to the forefront that was seen as a way to restore the world to a new harmony. The old masters of modern times, Edgar Degas, Pierre-Auguste Renoir, and Auguste Rodin, had all died by 1919, Paul Cézanne in 1906, and their reputations were at a new peak, elevating the status of an art of the past and devaluing the need for innovation. Their grand figures fused the past with a modern painterly style and made a substantial impression on French art. Renoir himself had started the cycle of looking at older art in 1884 when he introduced cavorting female classical nudes, painted as if made of marble, as a means to make something solid of Impressionism. These once revolutionaries had become grand masters of the classic. The move to classicism, or the New Classicism, as I call it here, embraced multiple ideas, taken from a broad variety of sources from older art.[10] Parallel to this movement was the Call to Order issued by Jean Cocteau in 1918, most evident in the Purism of Le Corbusier and Amédée Ozenfant, a plea for a return to a world of balance

and stability. It was also evident in the Precisionist art of many Americans such as Charles Demuth and Patrick Henry Bruce.

The classicism in question was open-ended and flexible. It could refer to classical Greece and Rome, as did Picasso's famous series of seated figures, started when he visited Rome in 1917 and painted from 1917 to 1924 as one part of his work. Picasso made these gigantic nudes simultaneously with major monuments of Cubism, such as the two versions of *Three Musicians* from 1921. As he did throughout the early twentieth century, Picasso defined and developed the first statements of virtually all new art, including the New Classicism. Picasso became the paragon, the exemplar of new art for the Graham circle, both for his Cubist art and his figurative painting and drawing. Not the least of his teachings in the early 1920s was that art could explore many avenues at the same time, both figurative and abstract, a lead followed by Graham, Gorky, and de Kooning.

In the wake of the utter destruction wrought by World War I, artists, poets, and critics saw the need for a new art to build a better world for the future. Many had thought the war would be over quickly, in three or four weeks, the political and social climate cleared, and all would return to the old normalcy of the world. It was, of course, not to be. By the end of 1916, the battles of the Somme and Verdun had seen hundreds of thousands of men killed, sent to slaughter really, all for the sake of gaining a sliver of ground, only to be given back the next day, the bloodbath repeated one day after the other. Widespread disillusionment with the war spread throughout Europe, especially in France.

Articles in little magazines in Paris began to appear in the course of 1916, as the war steadily spiraled downward, calling for a new type of art.[11] The pre-1914 type of abstraction, based on multiple intersecting shapes and filled with light and color that bespoke an unfettered optimism in a modern age, began to seem frivolous and unsuited for the now war-ravaged continent. In 1916, in the magazine *SIC* (*Sons, idées, couleurs, formes* [Sounds, Ideas, Colors, Shapes]), edited by the poet and artist Pierre Albert-Birot (1876–1967), at first carried a distinct futurist-simultaneist tone, much like prewar art itself, stressing the movement and dynamism of modern life.[12] In an early issue, the editor proclaimed that "style = order = Volonté [will]." By the fall of 1916, the tone had dramatically changed; Guillaume Apollinaire wrote that "the war will change things . . . we will move to a simpler composition, to attain greater perfection." In the same issue, Albert-Birot declared that a "work of art must be composed like a precision machine," and by the November issue he argued that "the artist is going to construct a work of art as an architect makes a house with stone, metal, wood," and "from multiple emotions, he will consolidate and distill. . . . [H]e is going to create a whole, an ensemble, a form."

(Ralph Waldo Emerson had likened the artist's task to building himself a house.) Prewar art seemed indulgent, unstructured, redolent of ease, decadence, and, for the French, even un-French, a departure from the *gloire* of their national past. Georges Braque's famous dictum, "I love the rule that corrects the emotion," well states the change in approach. In the face of postwar realities, artists moved to a clearer, more structured and defined foundation, a more stable art constructed like a well-built work of architecture, for art would now have to rebuild the world. It would be a literal world of new architecture, but also a world based on a redefined morality, a sharper clarity of purpose, with peace and harmony. It would be built on old, well-tested principles that had been at the heart of society. Classical art embodied this need perfectly.

Picasso's neoclassical figures of 1917–24 were the most readily apparent manifestations of this new spirit. But we need to think also of Piet Mondrian and de Stijl in 1917, announcing an art of harmony and balance to create a new world, both spiritually and architecturally, indeed, in all phases of life. In fact, de Stijl sought to unite art with the fabric of life itself, correcting what had been the egocentric focus of prewar art. We now see this as utopian, but it was a sincere belief for Mondrian and for others who saw the vision of a new world to replace the lost, old world. Russian Constructivism proclaimed an art that could build a better post-revolutionary society and country, carried out by the populace, who were now all declared to be artists.

Less known are the changes in course that happened immediately in 1916–17 in American art. In the course of 1916, Patrick Henry Bruce's brilliant compositions changed from a simultaneist format to solid blocks of color architecture that by 1917 evolved into his geometric still life compositions of pure hues, in a format that looked to the monumental late still lifes of Cézanne. Marsden Hartley's paintings in 1916 took on a new, dark sobriety and a few distilled forms, a total shift in approach, as did the work of Charles Burchfield. In the 1920s Hartley revisited Cézanne's art in Aix. As a result, Hartley's paintings of the iconic Mont Sainte-Victoire became glorious high points of American art. In 1917, Charles Demuth moved from overall painterly densities to refined precisionist formats that had a new clarity and classical calm to them. As part of a worldwide shift, America demonstrated that it was every bit as advanced as Europe, for New York was one of several centers of modern art.

Artists looked increasingly to the old masters, to the rock-sure principles of time-tested composition and construction that could meet the new need for stability and clarity. The sources could be as varied as Western art history itself. Greek and Roman art, sculpture, or painting was but one; the Renaissance masters, especially Giotto, Piero della Francesca,

Fig. 22. Pablo Picasso (1881–1973), *The Painter and His Model,* Avignon, summer 1914. Oil and crayon on canvas, 22¹³⁄₁₆ × 22 in. (58 × 55.9 cm). Musée Picasso, Paris, France.

and Paolo Uccello, were others. The seventeenth-century French classicism of Nicolas Poussin was a primary source of renewed attention, appealing especially to French artists as the epitome of French rational art and thought, famously embraced much earlier by Cézanne, who wanted to do nature over after Poussin. Recently, David Anfam has convincingly demonstrated de Kooning's interest in his fellow natives, the northern artists Hieronymous Bosch and Brueghel the Elder.[13] Especially important was the neoclassicism of Ingres, who was treasured by many twentieth-century artists. In his last years, and certainly after his death in 1906, Cézanne was elevated to the rank of old master, a classically oriented artist, whose fullness equaled the Italian Renaissance artists. His art became a reliable, ongoing source for many artists during the 1920s and '30s who wished to incorporate old master clarity and solidity in their art. The wave of Cézannism that appeared in America between the wars can be considered a form of this New Classicism.

The move to a neoclassic type of art had actually appeared earlier, prior to 1918. In 1884, Renoir introduced classical nudes to solidify his painting, which he understood as having become too painterly, and even soft. In 1905–6, Picasso had done drawings whose inspiration came directly from Ingres, and his work of the next three years showed sources in Iberian art, African art, and Cézanne. In the summer of 1907, Henri Matisse, worried that his art had become too impressionistic, went to Italy and looked closely at paintings by Giotto, Piero, and Masaccio, which showed him how to find the scale and solidity of the Renaissance without the actual bulk of its figures. The results were evident by the fall of 1907, when his *Le Luxe* showed a new fullness in his figures, which led to his monumental compositions of 1908–17, all of which were meant to challenge the presence of the old masters. After war broke out in August 1914, Picasso was the first to register its effects, painting his famous *The Painter and His Model,* unfinished, but finished enough to tell us of new directions (fig. 22).[14] It is precisely drawn, with illusionist exactitude, clearly referring to poses used by Gustave Courbet and Cézanne, and rendered with the linear purity of Ingres, who became the exemplar of the New Classicism.

For the French, the New Classicism meant a return to the old glories of French civilization, a reassertion of national pride, the grandeur of French tradition that many felt had been lost in the experimental art of pre-1914. Thus, art no longer had to be one thing—the figurative was just

as current and advanced as the abstract, and both coexisted at the same time. Picasso, the leader, set the tone in his famous statement from 1923 that different motifs called for different forms of expression, and thus affirming that one form of expression was not better than another.[15] His great pictures of 1921, *Three Musicians,* both versions, that were masterpieces of later Cubism, and *Three Women at the Spring* (fig. 23), a powerful example of neoclassicism, had made the case that the figurative was just as modern as anything else. They affirmed the continuity of old and modern art, that one builds on another, one extending the other, that became clear in the period between the two wars. It was the pictorial means of expression that made the work modern, not just its subject.

This is the context in which we must consider Graham and his friends. It tells us why they could move so easily between the abstract and the figurative, with equal value placed on both. De Kooning's figures of circa 1939, for example, are just as painterly and expressionist as his abstractions were, and just as difficult and complex.[16] We need to be clear that by this new form of neoclassicism we do not mean the dry, arcane, and exhausted vocabularies taken up by so many lesser artists in the 1930s that gave the period its dreadful reputation. Rather we mean a vital, dynamic, and progressive type of work that added new painterly vocabularies to our art, that could draw on the best of the past, recharge it, and "say something new," as de Kooning put it.[17] Just as the Graham circle found a new social freedom by coming to the United States, away from the old orders, as D. H. Lawrence called them, so they came to a painting culture that, almost by the force of their talent and will, they could transform into something that was wide open, and offered almost limitless possibilities.[18]

We primarily consider John Graham in the 1920s and '30s as a leading Cubist artist, and to be sure his work in this vein was among the best done by any artist of the time. Yet from the start he worked with great effect in a figurative mode with clear neoclassical sources, so that his total switch to the grand figure in 1942 should not have come as a sudden surprise; it had been there in his work all along. He arrived in the United States in 1920 with no known formal training, although it is probable he knew the great collections of Picasso and Matisse in his native Russia. By January 1923, he had enrolled in the Art Students League, then the best place to start to learn art making. He studied with William von Schlegell and then with John Sloan, one of America's best known and most respected older artists. Graham started with the basics, life drawing and figure composition, like an apprentice learning from a Renaissance master. There is something very American about this, an émigré from a privileged and exotic background

Fig. 23. Pablo Picasso (1881–1973), *Three Women at the Spring,* Fontainebleau, summer 1921. Oil on canvas, 80¼ in. × 68½ in. (203.9 × 174 cm). The Museum of Modern Art, New York, Gift of Mr. and Mrs. Allan D. Emil, 332.1952.

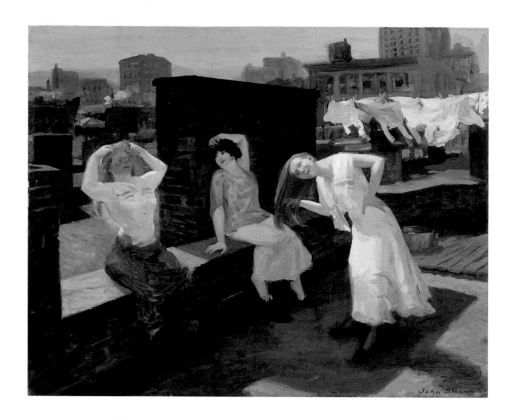

coming to a foreign country and starting from scratch, at the very beginning. He makes something of himself, and finds a previously unknown freedom, from which he creates open possibilities (and a new name, as did his fellow émigré Gorky, an Armenian who later claimed to be Russian).

Graham was a quick and gifted learner, and by 1924 he was a monitor in Sloan's class. His artistic skill and talent were apparent from the start. His first known extant work was an exquisite drawing, the *Seated Woman* of 1923, a classical motif configured by a pure, continuous line worthy of Ingres and Picasso, whose work was in full presence in New York that year. Given the sureness of this drawing, it is hard to believe Graham had not had some training prior to this. However, he had been taught by Sloan, one of America's best art teachers. Sloan is not as well known as a teacher or artist as the more famous Robert Henri, but he was certainly Henri's equal as a teacher, and no doubt a better artist. Sloan took special interest in certain of his students, among them Stuart Davis, and was a wise and practical mentor for them. Davis respected him, and listened to him, and it seems that Graham did too, although we have no records of their relationship. Sloan is best known for his realist scenes of downtown New York (fig. 24), but he also did many large-scale figure paintings that recall old master poses and are solidly constructed. In his *Gist of Art,* the book of teaching methods he published in 1939, Sloan repeatedly called on his students to study the ways of all manner of old master artists, from the Flemish to Rembrandt, and from Leonardo da Vinci to Eugène Delacroix and Ingres, urging them to emulate the solid, architectural construction of the figure. These were no doubt the same lessons he used in his life classes at the Art Students League. In fact, Sloan recommended that students study architecture itself when they lost the clarity in their painting or drawing. Sloan was

surely a prominent voice in speaking, in his own way, for the continuity of neoclassicism and tradition, of fusing the older with the modern, and of urging his students to keep an open mind to all art, including modernist developments. Sloan's presence seems to have continued, furthered by others who studied with him, including Adolph Gottlieb, David Smith, and Barnett Newman. Gottlieb later recalled that "as a result of Sloan's interest in everything that was happening in modern art, I . . . became interested and read every book I could on the subject." He also appreciated Sloan's urging people to do things "not exactly literal and to work from imagination and memory. . . . So he implanted that idea rather early in me."[19]

Sloan also continued—and no doubt taught—painting practices learned from his days with Henri, before 1910, that Graham picked up and carried on, and may have passed along to de Kooning. Guy Pène du Bois later spoke of how at the Henri class many of the students engaged in serious art talk, extensively discussing the craft of painting: "One heard of the tremendous problem involved in painting a white egg on a white table cloth or a black chunk of coal on black stuff."[20] Graham undertook the white-on-white challenge in a remarkable Cubist composition from 1929, *Still Life with Pipe,* a painting of varying textures of paint and sand, as well as multiple tints of white (pl. 12). Graham's friend Jan Matulka, who taught at the League, stressed differentiating shapes with different textures, and Davis was working with varying textures and thicknesses in his Paris paintings of the same time. Matulka incorporated sand into paint on certain defined shapes, as in *Still Life with Horse Head and Phonograph,* 1930 (pl. 25). (We can also note that the thumb hole in Matulka's palette is egg-shaped and located very near the center of his composition.) *Still Life with Pipe* is surely one of Graham's best paintings, and the virtual monochrome must be the only such Cubist painting anywhere, American or European. It is a signal and singular painting in American and world art that looks forward to the white paintings of Richard Pousette-Dart, Jasper Johns, and Robert Ryman, all done in the 1950s, as well as back to Kazimir Malevich and Suprematism. The rough textures can be traced to Picasso, but not to this degree; here Sloan may also have been an echo, for he recommended that students amplify *sculptural texture* to vitalize the form.[21] The relief is so heavy that it suggests the course that Smith took two years later, working in heavy relief to the extent that he quickly moved into three-dimensional objects. It is but one reminder that the lessons of the 1920s were ongoing in the narrative of American art.

The question of the egg has been especially intriguing to me for many years, for what may seem a dry academic exercise turned out to be the source of an extensive series of paintings prominently featuring one or several eggs by Graham and de Kooning in particular, and Gorky in a more limited

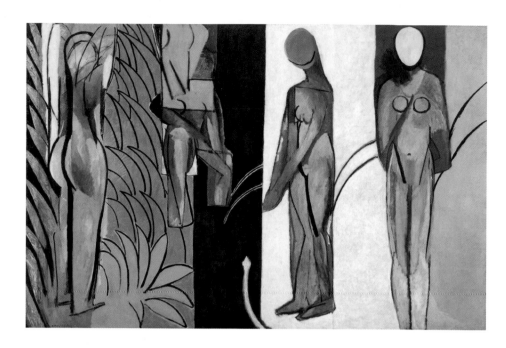

Fig. 25. Henri Matisse (1869–1954), *Bathers by a River,* March 1909–17, May–November 1913, and summer 1916–17. Oil on canvas, 102¼ × 154³⁄₁₆ in. (260 × 392 cm). The Art Institute of Chicago, Charles H. and Mary F. S. Worcester Collection, 1953.158.

Fig. 26. Piero della Francesca (c. 1420–1492), *Virgin and Child with Saints John Baptist, Bernardine of Siena, Jerome, Francis of Assisi, Peter Martyr, John Evangelist; Federico da Montefeltro Kneeling, From the Church of San Bernardino in Urbino, Built to House Federico's Tomb (Brera Madonna),* 1472–74. Tempera and oil on panel. 98 × 59 in. (251 × 172 cm). Pinacoteca di Brera, Milan, Italy.

way. Sloan surely knew of it in Henri's class in Philadelphia, and in his 1939 book he urged his students: "Go buy yourself a lemon and a plate. You will learn more about painting in five weeks than in five years in a class."[22] Sloan emphasized that Leonardo, Delacroix, and Ingres had built their forms within ovals and cylinders, so clearly he understood the oval shape as the very heart of painting. We may recall the story of the competition between the Greek painters Zeuxis and Parrhasios, or of Giotto's perfect circle, true or not; the circle tests a painter's mastery of a basic form. To this day, art teachers like to impress their students by going to the board and drawing a perfect circle, the most elementary yet profound shape in the world.

Pure oval shapes can be traced to Picasso's *Bowl and Jug* of 1908, Matisse's *Gourds* from 1916 and *The Moroccans* of the same year, and most especially to the faces in his monumental *Bathers by a River,* 1909–17, which in fact was on view in New York in the 1930s (fig. 25).[23] Of special interest would have been the Constantin Brancusi show, held in 1926 at the Brummer Gallery, which included the famous pure egg shape in *The Beginning of the World* (1924). If it was the beginning of the world, then so it might well have seemed the beginning of painting as well. In one way, painting the egg, a perfect shape echoing the circle, is a formal exercise, one that keeps the artist's hand loose and supple, in tune and limber, as it were. But it is also much more. The shape becomes a point of focus, a central point of reference within the painting, giving it a kind of symmetry and balance that we seek in any work of art. In his writings on art, Graham always insisted on the need for clarity in one's paintings; the egg and the oval give just that, a clear, clean shape for the eye, and for other elements in the painting, to revolve around. This focus is classical in its origins, in that the Renaissance painting always had a precise focus to the composition, at true center. We see this precisely in Piero della Francesca's *Brera Madonna,* in which an ostrich egg hangs down from the apse at exactly the real and the psychological center of the painting (fig. 26).[24] Further, the clarity and solidity of Piero were universally admired by modern artists. The

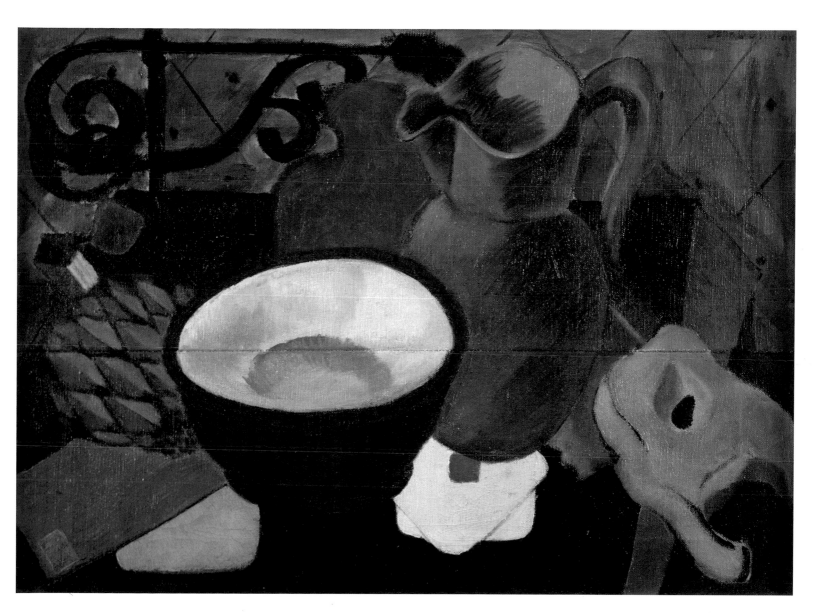

Fig. 27. John Graham (1887–1961),
Untitled, 1925. Oil on canvas, 16 × 22 in.
(40.6 × 55.9 cm). Allan Stone Collection,
Courtesy of the Allan Stone Gallery,
New York.

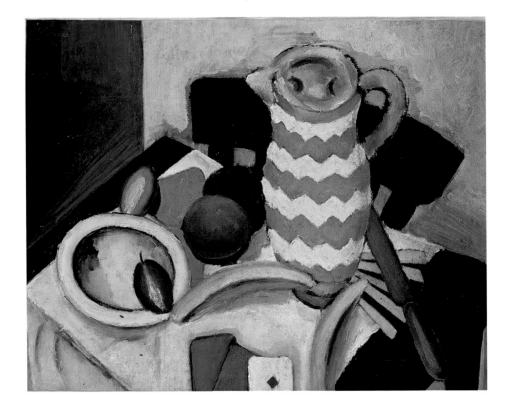

circle and its rough equivalents form a kind of gathering force, bringing the elements of the painting to the center, where we center ourselves, to maintain our balance and focus, our kinesthetic balance by which we engage with the work.[25] In fact, the search for clarity has its own, full history in Western art.[26]

Graham's egg shape apparently first appeared in 1925, in *Untitled,* a bowl with an egg set into it (fig. 27). In fact the multiple shapes and forms it suggests are evident in most of the egg paintings by Graham, and, as we will see, by de Kooning. As such, its multiple meanings refer to Cubist practice, now transferred to the figurative, an interesting cross-pollination within the Graham circle. The egg clearly establishes the center for our focus. In 1926, in *Still Life—Pitcher and Fruit,* the form is also apparent, although it is more likely a tray on the table (fig. 28). But it is one of the primary shapes and establishes a remarkable rhythmic succession of curves, countercurves, and circles, almost like a musical composition. Its still life format suggests Picasso, but also Davis in the brilliant and inventive color, although Davis and Graham had not yet met. The egg—two eggs, actually, on a tipped plate that repeats the shapes—became the single subject in *Two Eggs* (1928), a beautiful and remarkable painting, almost unique in American art (fig. 29). Its inversion of scale and the old master shading make it seem a fusion of the classical with new modes of Cubism and even Surrealism. At the same time the figurative mode places it in the tradition of Henri-Sloan realist art.

Graham's mastery, achieved in barely six years of art practice, is to be marveled at; one may also wonder why these paintings have remained largely unknown in art history. Perhaps they are another casualty of the old insistence on a socially correct art that has blinded us to an appreciation of some of the best paintings. Graham followed *Two Eggs*

Fig. 31. John Graham (1887–1961),
Composition, 1929. Oil on canvas,
18⅛ × 13 in. (46 × 33 cm). Musée Zervos,
Vézelay, France.

with a companion painting in the same year, like a serial sequence, that altered the angle of the objects and added a coffee cup (fig. 30). The shading of the whites is brilliant, working with monochrome and its variant values in a way that suggests the chiaroscuro of Leonardo or Caravaggio. By this time, Graham was developing what he and others called Minimalism, roundly criticized by his patron Duncan Phillips and critics such as Lloyd Goodrich.[27] The white pipe, with its reduced palette, may well be a forerunner of the "minimalist" paintings. His *Composition* from 1929 in the Zervos Museum in Vézelay, France, appears to be the only surviving painting that is certainly one of the minimalist works (fig. 31). Dorothy Dehner remembered them well. They were paintings from 1930 done in Paris; they were "completely non-objective, consisting of rectangles and squares divided by thin vertical and horizontal lines. The colors were muted—soft browns, tans, whites, grays, pinks and blacks."[28] This certainly fits the 1929 painting, including the heavily textured central panel, and the hand-drawn textured line, for Dehner recounted how important texture, the hand made, the personal were to Graham, the better to invoke mystery and what he called "enigma," for he sought in all paintings "an element of news, surprise, and nostalgia."[29] This surely applies to the egg paintings as well, to say nothing of looking forward to de Kooning's paintings of men from the late 1930s.

Graham followed with a series of egg pictures in 1929–30 (fig. 32). The egg takes on a gargantuan and dominant size and scale in three paintings, all of which are Cubist in conception and format. It is as if Graham was carrying out a tour de force of painterly skill while showing his embrace and mastery of both an abstract and a representational vocabulary. There is a use of Cubist tools such as exaggeration and reversal of expected size and placement, as well as a Surrealist mix of unlikely objects in unexpected locations. The dominant egg shape is set within, almost a part of, a hat rack, which takes on an organic shape and life of its own, moving in space like an object in a painting by Joan Miró or Giorgio de Chirico. Indeed, Graham and de Kooning would have been aware of Miró by this time, and it is easy to wonder if they knew his *Peinture (La magie de la couleur),* from 1930 (fig. 33).

The almost illusionist realism of the egg in the mostly abstract painting by Graham, *Le porte-manteau,* points to the possible effects of

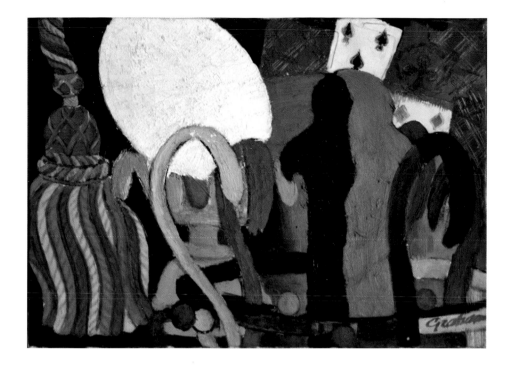

Fig. 32. John Graham (1887–1961), *Le porte-manteau (Hat Rack and Other Objects),* c. 1929. Oil on canvas, 13 × 18½ in. (33 × 47 cm). Wells College Art Collection, Aurora, New York.

Graham's trip to Italy and Paris in 1928 where he would certainly have encountered classical monuments of the Renaissance. How could he not have? His papers show countless sketches. Indeed, the realist egg seems to represent an age gone by, now brought current, into the modern era, into the New York avant-garde milieu, represented by the flat Cubist planes in a shifting time and space. This fusion of the old and the new was a familiar passage in French art and literature since it derived from the theory of duration, *la durée,* formulated by Henri Bergson, the most famous French philosopher.[30] The concept of the old passing into and changing to a new, more modern shape or form, a literal embodiment of the passage of time, was often found in the art of the Puteaux Cubists,

Fig. 33. Joan Miró (1893–1983), *Peinture (La magie de la couleur)* [Painting (The Magic of Color)], 1930. Oil on canvas, 59⅛ × 88⅝ in. (150.5 × 225 cm). The Menil Collection, Houston, 78-158 E.

7. TOP: *Untitled painting.* Ca. 1928. Oil. Collection Elaine de Kooning
8. BOTTOM: *Death of a Man,* detail. Ca. 1932. Now destroyed

Fig. 34. Plates 7 and 8 from Thomas B. Hess, *Willem de Kooning, 1904–1997* (New York: G. Braziller, 1959), showing de Kooning's *Untitled,* 1928, Oil on masonite, 16 × 20 in (40.6 × 50.8 cm) and *Death of a Man* (detail), c. 1932, later destroyed.

Fig. 35 (*opposite*). Willem de Kooning (1904–1997), *Still Life,* 1927. Oil on canvas, 32⅛ × 24 in. (81.6 × 61 cm). Courtesy the Willem de Kooning Foundation.

including Albert Gleizes, Jean Metzinger, and the Duchamp brothers. Graham's frequent trips to Paris and his sharp awareness of current art, so valuable to the circle, would have ensured that he was well aware of this current of thought even though his allegiance was to Picasso. Bergson's ideas remained alive and well in France after World War II and can even be seen in art of the 1950s.

Graham's interest in the egg soon passed, but it had been quickly picked up by de Kooning, who used it as the basis for much of his art for over ten years and more. Whereas Graham could interchange the egg with the shape of a plate and cup, de Kooning could morph the egg into an oval and circle of almost limitless variations, including the in-your-face breasts of his famous women done after 1940, and then again after 1950. This is but one example of how pictorial ideas first developed in the late 1920s could remain and evolve on a continuing basis in the later work of these artists. So prominent is the egg in de Kooning's work that it was first mentioned in the literature in 1959, by Thomas B. Hess, a close friend and associate (fig. 34). It first appears in de Kooning's work in the late 1920s, in two pictures thought to have been done around 1928. One is centered in a stark forest scene that seems to derive from the Picasso of 1908–9, sitting as if on a stage, in large scale, almost a giant egg, thus suggesting a hint of Surrealist awareness. Another from 1927 contains a group of eggs on a table in a quasi-Cubist format (fig. 35). In the mysterious painting *Death of a Man,* from around 1932, suggesting a Renaissance Lamentation scene, eggs are grouped to the rear, as if in a barnyard of some sort.[31] This type of scene is not surprising since de Kooning had studied at the Rotterdam Academy of Fine Arts in Holland, the only member of the later Abstract Expressionist group to have had a formal art education.

At about the same time, 1928–29, de Kooning did a more severe, architectonic still life (*Still Life with Eggs and Potato Masher,* pl. 4) with the eggs at left balancing a white bottle at right. It is almost constructed, put together like a work of architecture, piece by piece, as Patrick Bruce had spoken of Andrea Mantegna, an artist who had reveled in the art and archaeology of the classical past. Mantegna also was well known and respected in the 1920s for the clarity and sureness of his pictorial construction. These virtues became desirable and admired in the 1920s, and were also evident in the newly popular work of Jan Vermeer and Georges Seurat. Hess in 1959 rejected any effort to assign any kind of meaning to the egg shapes in de Kooning's work, but that is too easy.[32] Speculation is in order, although the meaning is as elusive as de Kooning's art then and later. Could the egg be a symbol of creation and fertility for de Kooning and Graham, as it had been centuries before? So, too, in this still life and in others it is almost as if de Kooning (and Graham) were

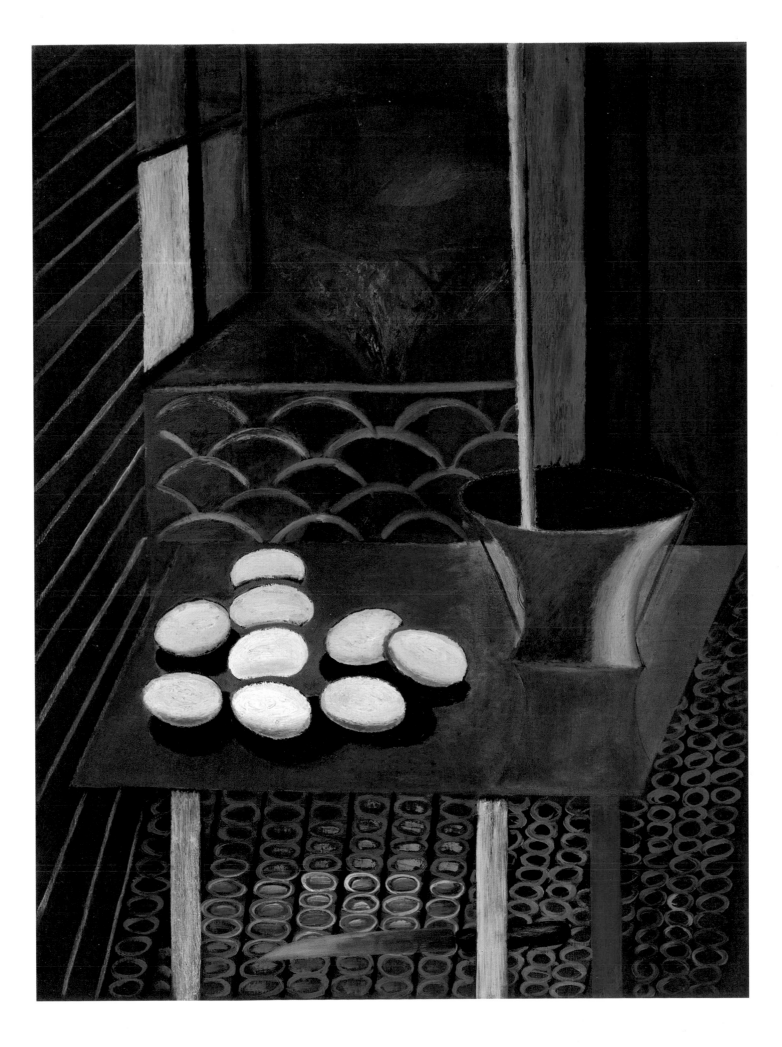

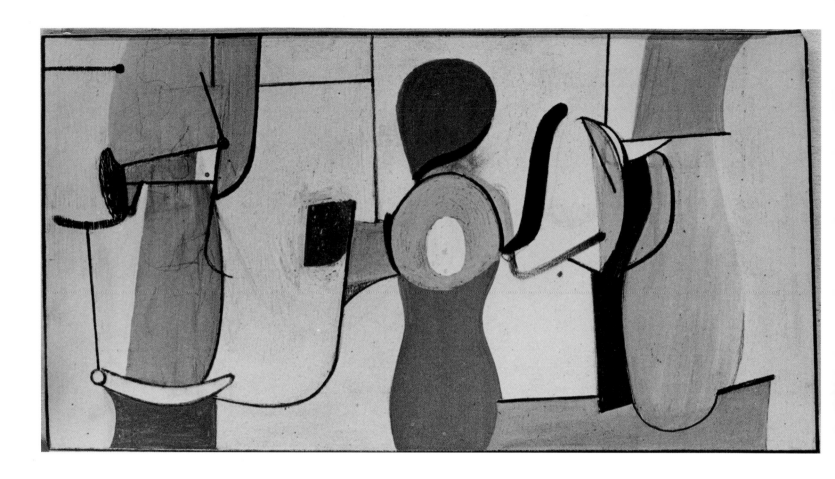

trying to literally embody Cézanne's famous, if misused, advice to paint nature using the oval, the sphere, and the cone. Here we may call to mind Graham's dictum that "Culture is the knowledge of the implication of Symbols."[33]

These are all figurative paintings, but de Kooning carried the egg forward in his abstract work, launching a long series of paintings in which the egg played a prominent role. At least one of these paintings is a precisionist abstraction that reminds us of the formal rigor of Mondrian, with the eggs free floating, animating the surface. In a study painted in 1935 for a WPA mural for the Williamsburg housing project, the egg appears at center, as a focal point of what may be three standing, abstracted figures, an early demonstration of how flexible and generative the egg shape was for de Kooning (fig. 36). It also appears in a small painting from about 1937, *Mother, Father, Sister, Brother,* apparently an abstraction of larger and smaller vertical figures, the family represented according to stature and position in the hierarchy, of the type that a child does. The egg recurs in the series of men of the late 1930s, then morphs into the goddess-type breasts of women of the early '40s, which recall the fulsome nudes of Peter Paul Rubens and the north of Europe, as well as the dollies, the working girls, in Sloan's ashcan paintings. The egg then becomes prominent, in one variant shape or another, in de Kooning's great run of abstractions from the early and late 1940s, from *The Wave* (circa 1942–44), to *Zurich* (1947), to *Orestes* (1947), then moves back to a figurative mode in his return to the woman series starting in 1947–48,

running well into the 1950s. The egg shape can be as diverse as the O in Orestes, a face, or a breast. It seems to be the organic beginning, the source, for his art for at least twenty-five years.

The egg's interchangeable role in both abstract and figurative works suggests once again just how much de Kooning, Graham, and Gorky valued their figure compositions. Even though the three émigrés found a new home, a new freedom in the United States, they would have surely felt a tug to their old and deep roots in the classical past of their countries of origin. We never entirely—if ever—forget our youth and our early training and experience. It is in us, and cannot be helped. Graham began his art career in 1923 with a beautiful drawing of a seated nude and in the same year did a realist self-portrait set in front of a quasi-Cubist background that reminds us of Stuart Davis in 1917. The alternate paths had been set, as Picasso had done at the same time. Among Graham's first known figures was his *Head of a Woman,* 1926, with old master chiaroscuro, which he often employed in his figures up to about 1930 (fig. 37). (Again, I am referring to large-scale figure compositions, grand figures in an old master sense, not figurative elements in still lifes or landscapes.) These will consciously recall classical sources such as Leonardo and Raphael, as well as aspects of Ingres, Cézanne, Matisse, and Picasso.

Graham never lost his love for older art; in *System and Dialectics of Art,* published in 1937 but written over many years, Graham stated that Greece, Italy, and France produced the best art. As early as 1930, in his unpublished *History of Art* he listed as especially important Giotto and the Roman frescoes at Pompeii, and called Uccello the greatest painter of the Italian Renaissance.[34] His connection with the Renaissance would have been reinforced by his numerous trips to France and Italy, confirmed by countless drawings of classical monuments in his notes and papers.[35] These figures appeared regularly in the late 1920s, less so in the 1930s as he reduced his time painting. The figures include harlequins recalling Picasso and other twentieth-century artists. The drawing becomes tighter, suggesting an increasing focus on Ingres, but also the full modeling of Andre Derain, who was well known for his figurative work in the 1920s, paintings that in good measure were reliant on the lessons of Cézanne. Derain was certainly a primary force in continuing the strong wave of Cézannism in the 1920s, for by that time Cézanne had long been considered

Fig. 37. John Graham (1887–1961), *Head of a Woman,* 1926. Oil on canvas, 22 × 18 in. (55.9 × 45.7 cm). Whitney Museum of American Art, New York, Gift of Gloria Vanderbilt Whitney.

Fig. 38. Walt Kuhn (1877–1949), *Clown in His Dressing Room,* 1943. Oil on canvas, 72 × 32 in. (182.9 × 81.3 cm). Whitney Museum of American Art, New York, Gift of an anonymous donor, 50.1.

an old master, in the old classic vein. In America, Cézanne continued to be at the heart of many good paintings, especially those of Walt Kuhn, for example (fig. 38).

In 1941, Graham in effect declared his full allegiance to the classical. For him this was embodied in the French tradition, especially in Ingres, but also now in Poussin. That year he spent considerable time studying Poussin's *The Triumph of Bacchus,* then at the Durlacher Brothers Gallery in New York (fig. 39). In company with Gorky and Jacob Kainen, and no doubt others, the artists studied the painting extensively, in all its details.[36] This Poussin is hardly a model of French rationalism, but in it Graham would have found the energy and drive to replace the force of Picasso, with whom he had become increasingly disillusioned. The painting would have engaged the three artists with its sheer power, expressing primitive internal forces, seemingly called up from the unconscious, that Graham was increasingly referring to as the source of art. That Poussin became a model is evident in Graham's painting *Poussin m'instruit* [Poussin Instructs Me], of 1944, a double self-portrait that implies Graham has become as Poussin himself (pl. 78). It resembles de Kooning's painting *Seated Figure (Classic Male),* circa 1940 (fig. 40); de Kooning probably also was studying Poussin at the time.

Fig. 39. Nicolas Poussin (1594–1665), *The Triumph of Bacchus,* 1635–36. Oil on canvas, 50½ × 59½ in. (128.3 × 151.1 cm). The Nelson-Atkins Museum of Art, Kansas City, Missouri, Purchase: William Rockhill Nelson Trust, 31-94.

After 1942, Graham focused exclusively on grand, even majestic figures of women, often looking loopy or deranged perhaps, but nevertheless paintings of remarkable presence and strength.[37] These works are beyond the scope of the present exhibition, but we should be clear that Graham, although disclaiming Picasso, was perhaps rejecting not modernism but only abstract, Cubist-based art. It is important to remember too that his move in this direction had started with his criticism of Picasso in the early 1930s. Picasso's towering position in the twentieth century made it all but inevitable that artists, as well as critics like Lloyd Goodrich and others, would attack him.[38] Given the virtual apotheosis accorded Picasso (Gorky followed him drip by drip, as a Renaissance apprentice followed his master), Graham was, we may speculate, simply asserting his independence.

We may also wonder if his early training with Sloan at the Art Students League had not stayed with him, at least in small part. When Graham wrote to Phillips in December 1930 about the group that he, Davis, and Gorky had formed, he insisted that its art must be "something original, purely American," a statement that echoed Sloan's admonishments.[39] Graham argued that painting was made American not by its subject, but by a "quality, a certain quality." He did not specify what that "certain quality" would be, but we can speculate: could he have meant a modern, American type of classicism that he was preoccupied with at that time? It is telling that in the same letter he told Phillips that he was painting only figures. Further, classicism was based on a tight, taut balance and rigor, in line with Graham's insistence on clarity and power. Graham's "minimalism," as he said it was called at this time, relates to the old masters' economy of means. In turn, this might parallel the format in his 1929 *Composition* in which the few simple forms stand clearly at front facing us, just as a figure can often do (see fig. 31).[40] The primary shapes are vertical and frontal, as a figure is. This pared-down construction can be related to the minimalist works done by Stuart Davis in 1932, a black scaffold by itself on the dead white of the paper or canvas. Can this minimalist structure be termed a part of an American Cubism? It certainly gained notice, for Duncan Phillips and then Lloyd Goodrich roundly criticized

Fig. 40. Willem de Kooning (1904–1997), *Seated Figure (Classic Male),* c. 1940. Oil and charcoal on wood panel, 54⅜ × 26 in. (138.1 × 66 cm). Private collection.

it, Goodrich commenting that the next step would be to have nothing in the painting.[41]

In his post-1944 painting, we may say Graham was in fact following and developing two alternate modernisms, one that drew from Ingres and his precise line, and one from the massive bulk of Picasso's figures of 1921–24. If Ingres seemed to bypass modernism, we need to remember that it was Picasso himself who had drawn Ingres into the practice and discourse of modern art. In turning exclusively to his classicizing figures in the 1940s, had Graham recalled and felt the need to respond to the same forces that had issued a clarion "call to order" after World War I? Was a new figurative art demanded by the war, as it had been a generation earlier?

Graham was surely the most mysterious of the three painters of grand figures. His ever growing interest in the occult and the unconscious reeks of memories of a dark and distant and exotic Russia of the past, doubtless magnified by his vivid imagination, and paralleling his interest in Freud and Jung. On the other hand, his fellow émigré Arshile Gorky remembered his past in all too real, painful, and horrific detail. He had survived the Turkish genocide, but the loss of his family when the boy was but twelve years old left him deeply scarred. Gorky and his younger sister miraculously made it to the United States safely in 1920, a few months before Graham. Like Graham, he re-created himself by taking a new name, based on Achilles and the Russian writer and poet Maxim Gorky. But he never forgot his childhood, and it is fair to say he spent a lifetime trying to capture—or recapture—his old life and country, and his childhood memories, in paint.

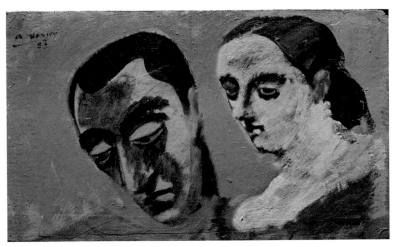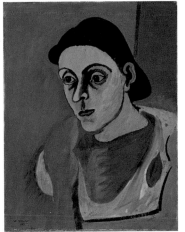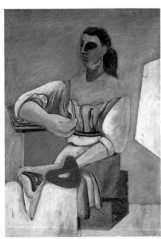

It is little wonder then that Gorky was more poetic, touching, and moving than Graham or de Kooning, especially in his figurative paintings. We mostly—and rightly—celebrate him for his extraordinary abstractions of 1943 and after, until his suicide in 1948. However, although fewer in number (for some things, a few is enough), his figure paintings are among the greatest works of the twentieth century. His two versions of *The Artist and His Mother* are the most loving and deeply felt family portraits imaginable in either modern or older art (figs. 41, 42). They are thought to have been begun around 1926, but it might have been later, after he had met Graham in 1927. The version in the Whitney Museum of American Art, considered to have been left unfinished in 1936, is, by the old adage, finished enough, more than enough to fully engage, even mesmerize us in its profound pathos. The heads are drawn with a precision worthy of Ingres, the bodies roughly, loosely painted as if they were ghost images he was trying to locate and make material; they are elusive, and there is a searching quality to the stroking, recorded in the paint itself and its movement, a record of Gorky's ongoing and frustrated search to find, and bring back, his past life. The means are as radical, as modern, as any abstract painting, telling us once again that each is capable of deep emotion. Certain parts, namely the hands, here and in other paintings seem to elude him entirely, so he ignores them, seeking to capture their presence in other sections. The very touches of paint seem to embed a seismograph of feeling, just as they did in his later abstract work.

Gorky's subsequent portraits and self-portraits in the 1930s are even more masterly in some ways. His *Self-Portrait,* circa 1937, shows a heightened confidence in his abilities and a new assurance of himself, as a man and an artist, finding his way in a foreign, alien country (pl. 86). This work is far different from his earlier portraits and heads, which are sculptural, dense, almost as if carved from paint (figs. 43–45). Gorky and de Kooning haunted the museums in New York, the Metropolitan and the Frick, gaining a knowledge of old master art that few if any artists of that or any other time could rival. Gorky's self-portrait has the stately grandeur and presence of a seventeenth-century painting, prompting a comparison with Rembrandt's late self-portraits.

Other parallels in American art, such as Hartley's *Canuck Yankee Lumberjack at Old Orchard Beach, Maine,* 1940–41 (fig. 46), and Walt

Fig. 43. Arshile Gorky (1904–1948), *Portrait of Myself and My Imaginary Wife,* c. 1933–34. Oil on paperboard. 8⅝ × 14¼ in. (21.7 × 36.2 cm). Hirshhorn Museum and Sculpture Garden, Smithsonian Institution, Washington, D.C., Gift of the Joseph H. Hirshhorn Foundation, 1966, 66.2150.

Fig. 44. Arshile Gorky (1904–1948), *Portrait of Vartoosh,* c. 1933–34. Oil on canvas, 20¼ × 15⅛ in. (51.3 × 38.4 cm). Hirshhorn Museum and Sculpture Garden, Smithsonian Institution, Washington, D.C., Gift of the Joseph H. Hirshhorn Foundation, 1966.

Fig. 45. Arshile Gorky (1904–1948), *Woman with a Palette,* 1927. Oil on canvas, 53½ × 37½ in. (135.9 × 95.3 cm). Philadelphia Museum of Art, Purchased with funds (by exchange) from the bequest of Henrietta Myers Miller and with proceeds from the sale of other deaccessioned works of art, 2004.

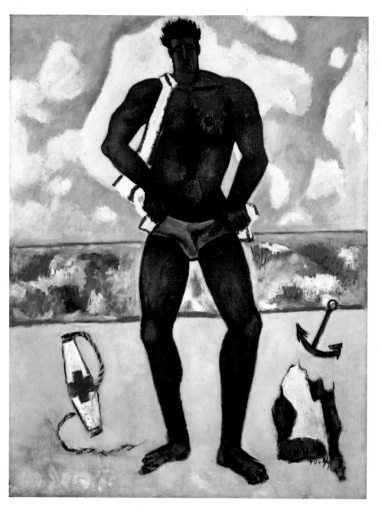

Kuhn's *Clown in His Dressing Room,* 1943 (see fig. 38), both reaching for an Americanized version of a heroic Renaissance figure, tell us that at this time there was a distinct move to a new classicism in other circles. It is as if the best artists, younger and older, were issuing a challenge to the miles of weak and insipid figure painting of the American Scene to not only make it American but make it of the highest order, so that it could rank with the work of John Singleton Copley, Thomas Eakins, and Winslow Homer.

Or, had it been there all along? Had it started in the early work of Sloan, then been picked up by Kenneth Hayes Miller and the Fourteenth Street School, emulating Italian Renaissance art, continued by Reginald Marsh, who sought to embody Rubens's scale and Baroque sense of motion, and, finally, the monumental figures in the sculpture of Gaston Lachaise? In another vein, Stanton Macdonald-Wright and Morgan Russell had based their color abstractions of 1914 on the musculature of Michelangelo and Tintoretto, then passed on these rhythms to Thomas Hart Benton, mannerist swirls that in turn his student Jackson Pollock adapted to his all over compositions. And does it remain with us, forever, that urge to make something that could measure up to standards set by the Greeks and the Renaissance masters? All artists worth their salt respect tradition, but to actually try to match it is another matter, left to artists of the highest skill and ambition. If Graham was the first "minimalist," who insisted the best art of all time came from the classical world, then jump ahead to the early 1990s. There is no direct connection, but once I asked the most famous minimalist, Donald Judd, what his next project might be on his land in the Chinati Mountains in southwest Texas. He hardly paused, sketched out a structure of walls one hundred by one hundred yards, and said: "I want to do something to challenge the Greeks."

Gorky's drawings for the figurative paintings, especially *The Artist's Mother* (fig. 47), are in another class altogether, for they are superb examples of an exquisite drawing that is rare at any time, but surely elevates Gorky to the level of a ranking master. Their sheer skill tells us that they could have been done only by an artist who believed in and maintained the tradition of classical, old master art. He continued this in such overtly figurative works as *Portrait of the Artist's Wife,* 1942–46 (pl. 76). Then there is the matter of his continued use of the figure, though hidden, for the remainder of his life.[42]

If Graham's figures are the most exotic, and Gorky's the most moving, then de Kooning's are the most ambiguous and haunting. They form the bulk of his work in the late 1930s and early '40s, but in truth de Kooning never really abandoned the figure except for a few years in the later 1950s. De Kooning is the one total exception to the pervasive use of Synthetic Cubism in the 1930s. He maintained, and I believe it is true, that he never painted a Cubist picture. The paintings were done first in a series of men such as *Portrait of Rudy Burckhardt*, 1939 (pl. 57), then in women, which turned into his famous floozies of the early and mid-1940s. Their elusiveness was exactly what de Kooning was trying for, a kind of indeterminacy that never allowed a single, clear focus for the viewer. The figures are ghostlike at points, constantly slipping away from us, both physically and psychologically; they often exude a kind of melancholy, a certain sadness, remaining hidden, as it were, in a shifting, indefinable space, again materially and psychically.

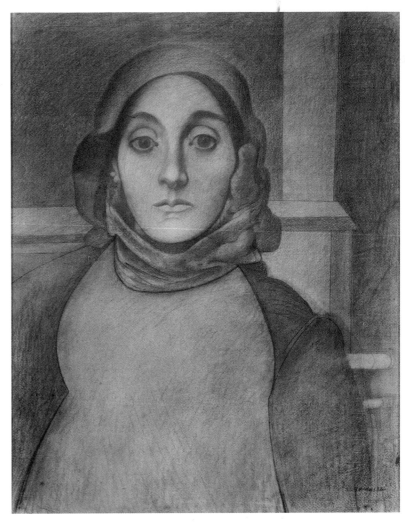

Fig. 47. Arshile Gorky (1904–1948), *The Artist's Mother*, 1926 or 1936. Charcoal on ivory laid paper, 24¹³/₁₆ × 19⅛ in. (63 × 48.5 cm). Art Institute of Chicago, The Worcester Sketch Fund, 1965.510.

They are perplexing and often frustrating, trying to pin them down, but it can't be done. They remind us that we don't explain art, we adjust to it. Again, exactly what de Kooning was seeking. "Art never seems to make me peaceful or pure. I always seem to be wrapped up in the melodrama of vulgarity. I do not think of inside or outside—or of art in general—as a situation of comfort."[43]

The figures have old master antecedents—especially the monumental *Seated Figure (Classic Male)* (see fig. 40) of 1940, which reminds us of a statue of a Roman emperor, or of the Poussin the group had studied at Durlacher's, and in turn was clearly a source for Graham's *Poussin m'instruit*. Others have passages of drawing suggestive of Ingres (as in his figure works on paper). The references may seem endless, a sure indication of how de Kooning and Gorky haunted the Met and the Frick. The ghostly, faded quality of some, plus their red coloration, point directly to the murals from Villa Boscoreale in Italy that hang to this day in the Met. We seem to look back in and through time at these Roman figures who fade and elide into the wall, almost exactly the same sensation as found in the Rudy Burckhardt portrait. Some of the heads reflect Roman portraits from Fayum in Egypt, as certain of Gorky's works do. More modern sources such as Picasso and Matisse also abound. De Kooning fuses the two traditions—the old into the modern, a statement of the continuity of art,

past and present. "You can't make a style beforehand," he said, "otherwise it becomes a way of apologizing for one's insecurity."[44]

De Kooning always understood that this is how art works. "There is a train track in the history of art that goes way back to Mesopotamia . . . Duchamp is on it, Cézanne is on it. Picasso and the Cubists are on it, Giacometti, Mondrian and so many, many more—whole civilizations."[45] He was acutely aware of his background in Holland, the north country where oil painting was invented, in making those rollicking female nudes that appear in the early 1940s. These floozies also may recall John Sloan's women drying their hair, so that de Kooning might be said to have been an unlikely descendent of the Ashcan School and its robust celebration of American low life (see fig. 24). He was by his own admission conservative, "more in tradition," while trying to make something new of it, "to change the past," as he said.[46] With this at his core, de Kooning went about his art with the modern sense of searching, of uncertainty, like Matisse, unafraid to show and record the search, in paint, on the canvas. Like Matisse, who now appears far more important to him than has been recognized, de Kooning might also say, "Exactitude is not truth." His track is one of constant change, leaving virtually "willful pentimenti."[47]

Both de Kooning's and Gorky's figures embody Graham's dictum that a painting's brushstrokes are authentic records of the artist's reactions.[48] The sense of search, of discovery, of revealing something quickly—his famous quote "content is a glimpse of something, an encounter like a flash"—is fully evident in his figures of the 1930s.[49] They speak of something past, dimly remembered, of trying to recall them in the present. At the same time, they have a dark feel to them, the mood of the Depression made tangible, like looking through a dirty window in a tenement or studio downtown. Thereafter, de Kooning's women increasingly took on an aura of downtown New York, its saloons and strip joints, again reminiscent of the locales Henri and Sloan (and Stuart Davis early on) themselves haunted, and urged their students to explore. De Kooning, we will remember, had originally come to America for the wine, women, and wealth. He was leery of the idea of an American art—it was too much like playing for the national baseball team, but nevertheless he became a key part of the story of Europeans coming to the United States and making themselves and their art over.

De Kooning became the most influential painter of his day in the 1950s—his style was more accessible than Pollock's—a story that needs no retelling here. His broad slashing brushstrokes and the mad figures, so present and immediate, so much of the time still called to mind his roots in older art. De Kooning, perhaps more than the others, combined past and present in the most modern way. Even at the end of his life, de Kooning

was struggling with the figure, still looking back and forward. So, too, in the 1960s, Stuart Davis looked at de Kooning's later work (and Pollock's) as David Smith in 1950 had looked to Davis's "minimalist" paintings of 1932 (pl. 30), telling us that the rich connections between these masterful artists did not end with the onset of World War II. Indeed, the figurative tradition was at the heart of David Smith's late work, its grandeur calling to mind, now that we can see it, the earlier figure compositions of his friends. The four artists and others of the circle—remind us, both then and now, as Graham had insisted, that authentic and important art comes from an unbroken chain of development of tradition. (Tradition is not the same as conservatism.) This is not, he concluded, a retreat, or conservatism, but is rather the essence, the very core of art.[50]

Notes

1. See Irving Sandler's essay in this catalogue.
2. See Harry Rand, *Arshile Gorky: The Implications of Symbols* (Montclair, N.J.: Allanheld & Schram, 1981).
3. Pollock quoted in Selden Rodman, *Conversations with Artists* (New York: Devin Adair, 1957); reprinted in Pepe Karmel, ed., *Jackson Pollock: Interviews, Articles, and Reviews* (New York: Museum of Modern Art, distributed by H. N. Abrams, 1999), 217n.2.
4. John Graham, *System and Dialectics of Art,* ed. Marcia Epstein Allentuck (Baltimore: Johns Hopkins Press, 1971), 153.
5. Ibid.
6. Ibid.
7. Rudy Burckhardt, "Long Ago with Willem de Kooning," *Art Journal* 48 (Fall 1989): 222–27, and Melvin P. Lader, "Graham, Gorky, de Kooning, and the 'Ingres Revival' in America," *Arts* 52, no. 7 (March 1978): 94–99.
8. Irving Sandler, *From Avant-Garde to Pluralism: An On-the-Spot History* (Lenox, Mass.: Hard Press Editions, 2006), 35.
9. See Michael FitzGerald, *Picasso and American Art* (New York: Whitney Museum of American Art, 2006).
10. Elizabeth Cowling, *On Classic Ground: Picasso, Léger, de Chirico, and the New Classicism, 1910–1930* (London: Tate Gallery, 1990).
11. This was first outlined in William C. Agee and Barbara Rose, *Patrick Henry Bruce, American Modernist: A Catalogue Raisonné* (New York: Museum of Modern Art, 1979), and then studied in detail by Kenneth E. Silver in his excellent book, *Esprit de Corps: The Art of the Parisian Avant-Garde and the First World War, 1914–1925* (Princeton, N.J.: Princeton University Press, 1989). See also Silver's recent catalogue accompanying the exhibition at the Guggenheim Museum, *Chaos and Classicism: Art in France, Italy, and Germany, 1918–1936* (New York: Guggenheim Museum, 2010). His excellent discussion, in my view, was undermined by the poor quality of the art in the show. The classic revival in America produced much better art.
12. Agee and Rose, *Patrick Henry Bruce,* 26.
13. David Anfam, "De Kooning, Bosch, and Bruegel: Some Fundamental Themes," *Burlington Magazine* 145, no. 1207 (October 2003): 705–15.

14. Silver, *Esprit de Corps,* 68.

15. FitzGerald, *Picasso and American Art.*

16. For a brilliant and comprehensive discussion of the critical debate over de Kooning and his abstract versus figurative art, see Emily Schuchardt Navratil, "The Critical Reception of Willem de Kooning's Woman Series and the 'Canon of de Kooning,'" Honors Thesis, Trinity College, Hartford, Conn., 2003.

17. Burckhardt, "Long Ago with Willem de Kooning," 222–27.

18. D. H. Lawrence, *Studies in Classic American Literature* (New York: Viking, 1964).

19. Dorothy Seckler, *Oral History Interview with Adolph Gottlieb,* October 25, 1967, Archives of American Art, Smithsonian Institution. I am grateful to Pamela N. Koob, curator of the permanent collection at the Art Students League of New York, for calling this to my attention.

20. Guy Pène du Bois, *Artists Say the Silliest Things* (New York: American Artists Group, 1940), 110–12.

21. John Sloan, *Gist of Art* (New York: American Artists Group, 1939), 114.

22. Ibid., 158.

23. Sally Yard, "Willem de Kooning, The First Twenty-six Years in New York, 1927–1952," Ph.D. dissertation, Princeton University, 1980, figure 76.

24. David Anfam has called my attention to the eggs in work by Bosch and Brueghel, two artists he has convincingly demonstrated were important to de Kooning. Anfam, "De Kooning, Bosch, and Bruegel."

25. See Rudolf Arnheim, *The Power of the Center: A Study of Composition in the Visual Arts* (Berkeley: University of California Press, 1988).

26. It would extend from Giotto to Caravaggio, and further, to modern art, extending from the bookend monumental figures in Cézanne's late, large bathers, to Pollock's *One: Number 31,* and finally to the literal center of Kenneth Noland's concentric circle paintings from the late 1950s.

27. See Alicia Longwell, "John Graham and the Quest for an American Art in the 1920s and 1930s," Ph.D. dissertation, City University of New York, 2007; and notes to the author, July 2010.

28. Graham, *System and Dialectics of Art,* xv–xvi.

29. See Tracy Adler et al., *News, Surprise, and Nostalgia: MA Alumni Exhibition, 1952–1981* (New York: Art Gallery, Hunter College of the City University of New York, 1995).

30. See Henri Bergson, *Creative Evolution* (New York: H. Holt, 1911)

31. Thomas B. Hess, *Willem de Kooning* (New York: G. Braziller, 1959), plates 7 and 8.

32. Ibid.

33. Harry Rand, *John Graham: Sum Qui Sum* (New York: Allan Stone Gallery, 2005): n.p.

34. Graham, *System and Dialectics of Art,* 154; John D. Graham Papers, Series 4, Archives of American Art, Smithsonian Institution.

35. Ibid.

36. Jacob Kainen et al., "Memories of Arshile Gorky," *Arts* 50 (March 1976): 96–98.

37. The late Allan Stone told me that Graham had told him that he painted the women with big eyes because that is the way they looked at the height of their sexual pleasure.

38. FitzGerald, *Picasso and American Art.*

39. John Graham, New York, to Duncan Phillips, Washington, D.C., December 28, 1930, The Phillips Collection Archives, Washington, D.C.

40. See Alicia Longwell's notes in the Chronology.
41. Longwell, "John Graham and the Quest for an American Art"; FitzGerald, *Picasso and American Art*.
42. See Rand, *Arshile Gorky*.
43. Quoted in Herschel Browning Chipp, *Theories of Modern Art: A Source Book by Artists and Critics* (Berkeley: University of California Press, 1968), 560.
44. David Cateforis, *Willem de Kooning* (New York: Rizzoli International, 1994).
45. Barbara Hess, *Willem de Kooning, 1904–1997: Content as a Glimpse* (Cologne: Taschen, 2004): 8.
46. Sandler, *From Avant-Garde to Pluralism*.
47. Jacques Guenne, "Interview with Henri Matisse," *L'art vivant* (September 15, 1925), translated in Jack Flam, *Matisse on Art,* rev. ed. (Berkeley: University of California Press, 1995); Yard, "Willem de Kooning."
48. Graham, *System and Dialectics of Art,* 166.
49. Hess, *Willem de Kooning, 1904–1997,* 74.
50. Graham, *System and Dialectics of Art,* 158.

Plates · 1940–1946

61
John Graham (1887–1961)
Interior, 1939–40
Oil on canvas
30 × 20 in. (76.2 × 50.8 cm)
Rose Art Museum, Brandeis University, Waltham,
Massachusetts, Bequest of Louis Schapiro, Boston

62
John Graham (1887–1961)
Sun and Bird, c. 1941–42
Oil on canvas
21 × 18 in. (53.3 × 45.7 cm)
Allan Stone Collection, Courtesy of
the Allan Stone Gallery, New York

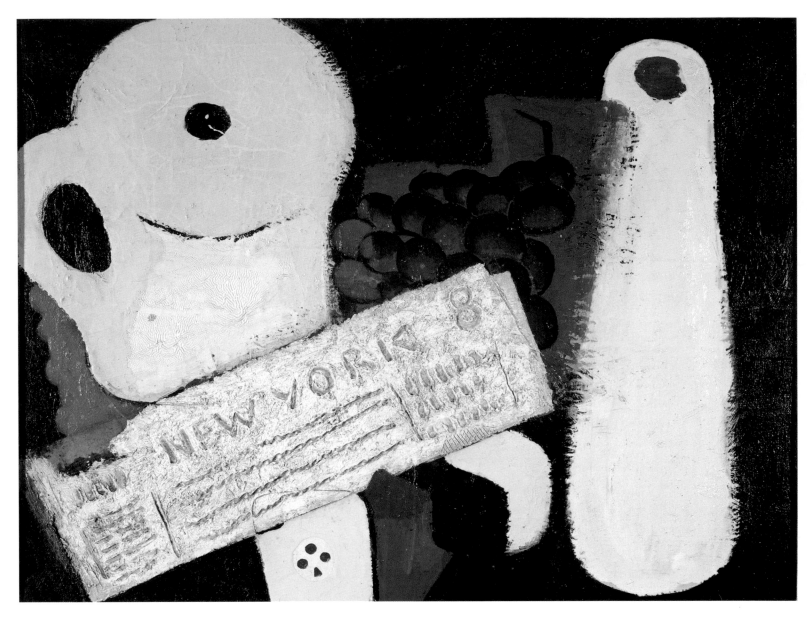

63
John Graham (1887–1961)
New York, 1940
Oil on canvas
25 × 20 in. (63.5 × 50.8 cm)
Allan Stone Collection, Courtesy of
the Allan Stone Gallery, New York

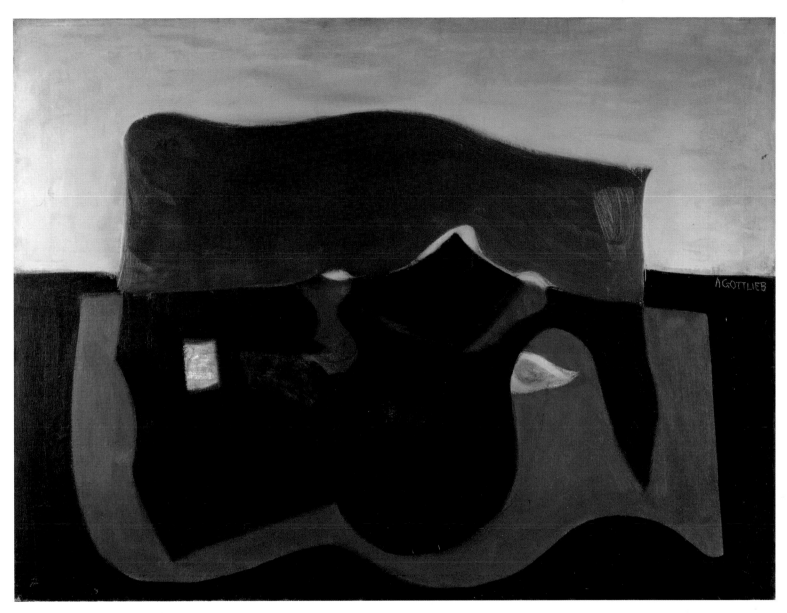

64

Adolph Gottlieb (1903–1974)

Untitled (Still Life), 1941

Oil on canvas

25¹³⁄₁₆ × 34 in. (65.4 × 86.3 cm)

Adolph and Esther Gottlieb Foundation, New York

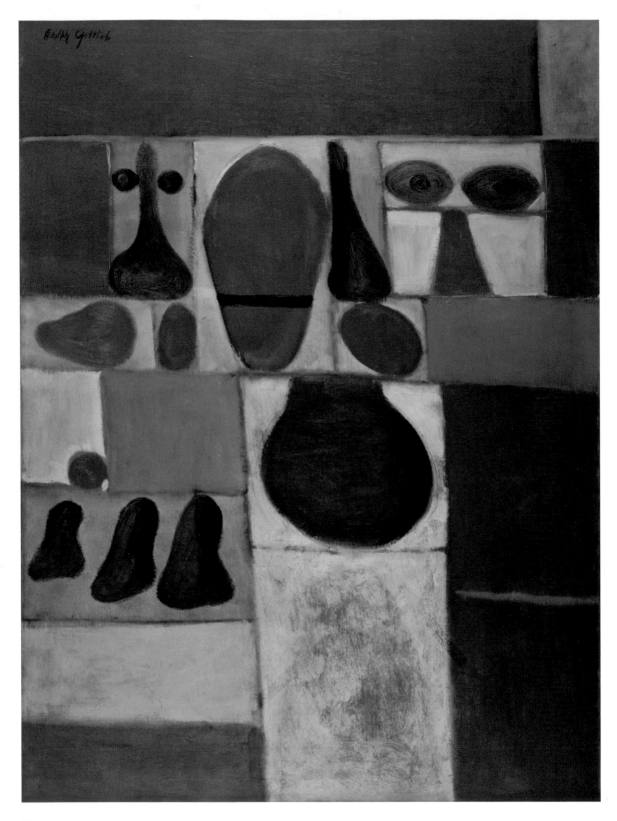

65
Adolph Gottlieb (1903–1974)
Pictograph (Yellow and Purple), 1942
Oil on canvas
48 × 36 in. (121.9 × 91.4 cm)
Adolph and Esther Gottlieb Foundation, New York

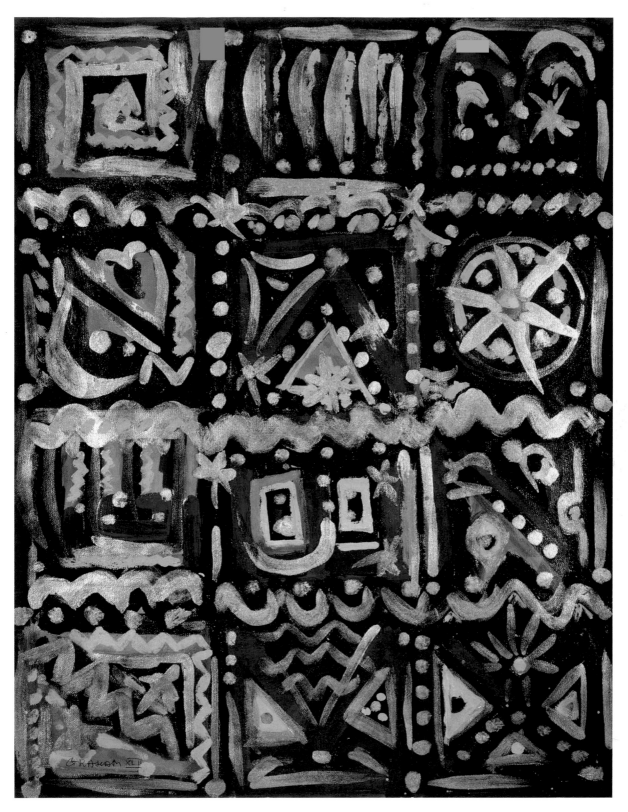

66
John Graham (1887–1961)
Untitled, 1942
Gouache on paper
24 × 18 in. (61 × 45.7 cm)
Allan Stone Collection, Courtesy of
the Allan Stone Gallery, New York

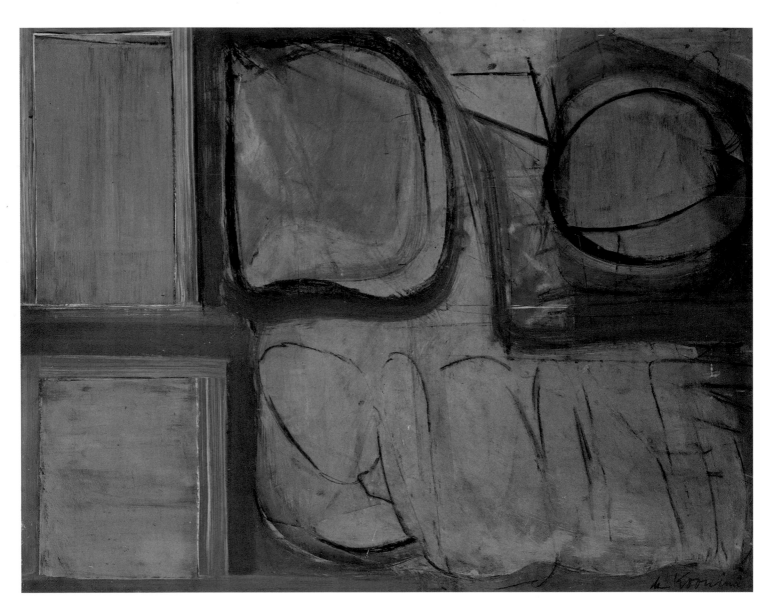

67
Willem de Kooning (1904–1997)
Composition, 1942
Oil on masonite
24 × 36 in. (61 × 91.4 cm)
Allan Stone Collection, Courtesy of
the Allan Stone Gallery, New York

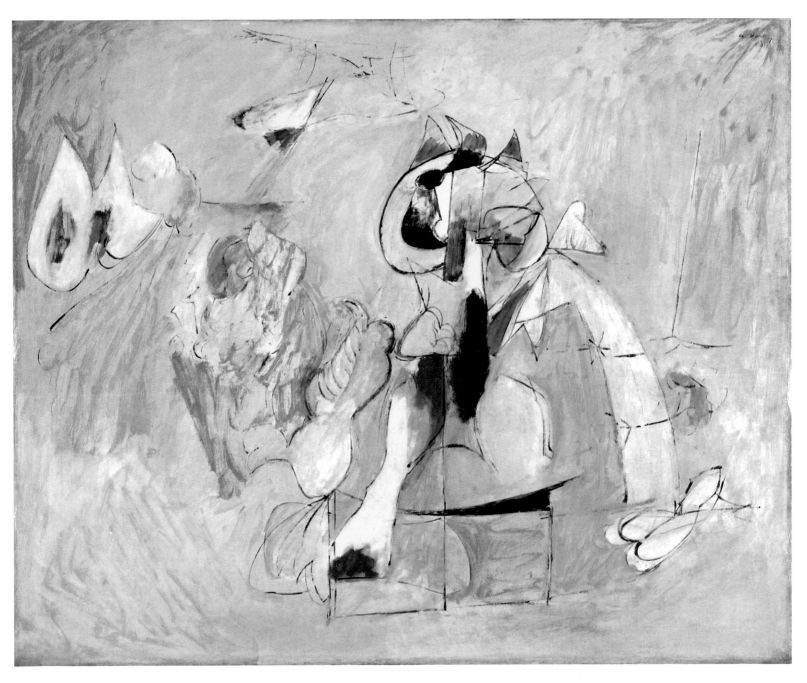

68
Arshile Gorky (1904–1948)
The Pirate I, 1942–43
Oil on canvas
30 × 36 in. (76 × 91.4 cm)
Collection of The Honorable and Mrs.
Joseph P. Carroll, New York

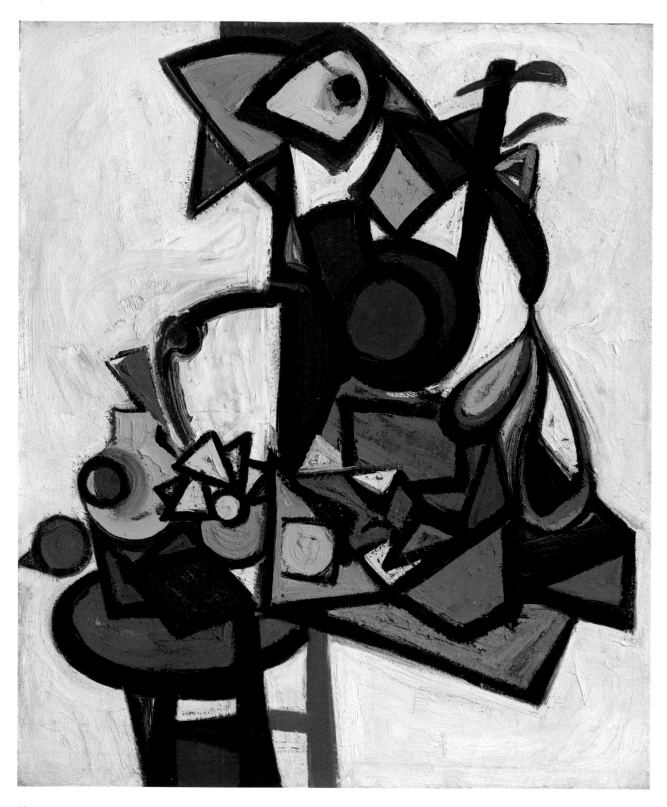

69
Lee Krasner (1908–1984)
Untitled, c. 1940
Oil on canvas
30 × 25 in. (76.2 × 63.5 cm)
Fayez Sarofim Collection

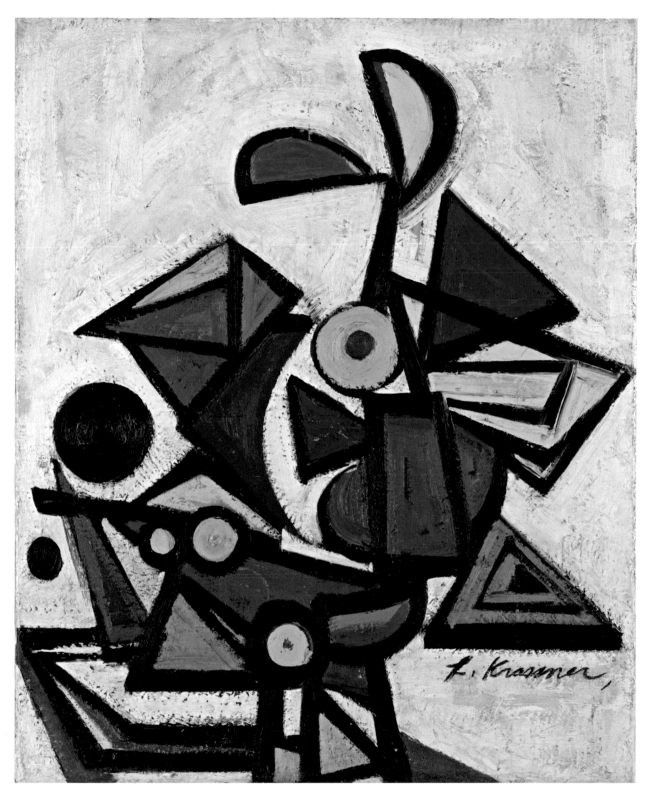

70

Lee Krasner (1908–1984)

Composition, 1943

Oil on linen

30⅛ × 24¼ in. (76.5 × 61.6 cm)

Smithsonian American Art Museum, Washington, D.C., Museum purchase
made possible by Mrs. Otto L. Spaeth, David S. Purvis, and anonymous donors
and through the Director's Discretionary Fund, 1987.33

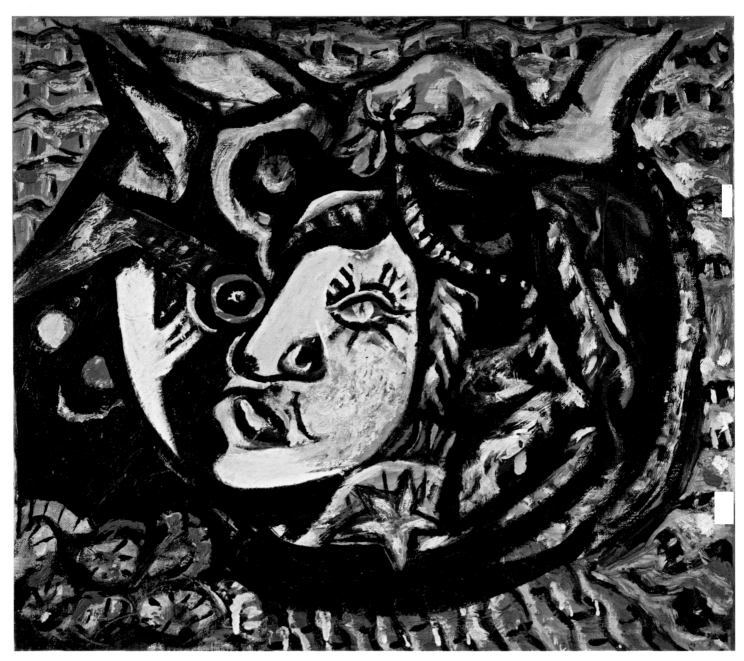

71
Jackson Pollock (1912–1956)
Mask, c. 1941
Oil on canvas
16¾ × 19 in. (42.5 × 48.3 cm)
The Museum of Modern Art, New York,
Enid A. Haupt Fund, 1980

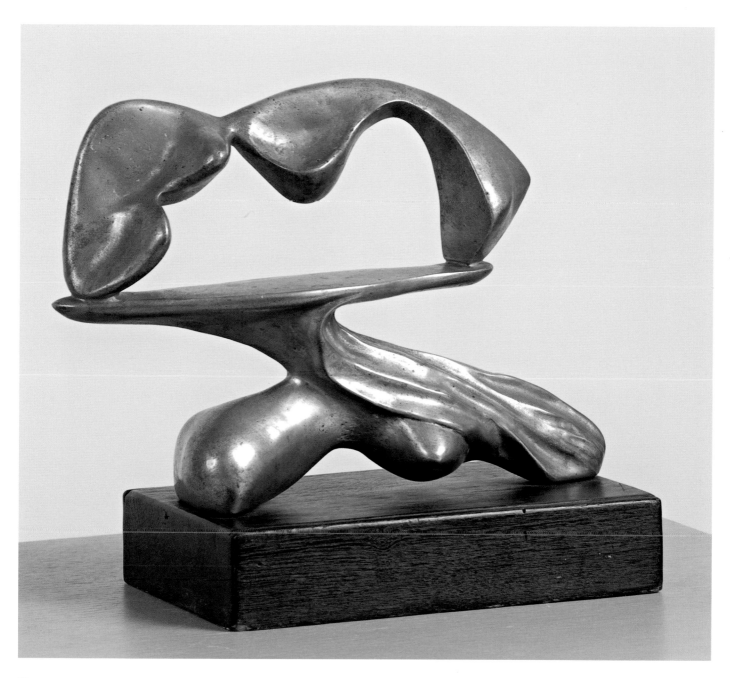

72

David Smith (1906–1965)

Head as a Still Life 1, 1942

Cast aluminum

8½ × 12 × 4½ in. (21.6 × 30.5 × 11.4 cm)

Des Moines Art Center Permanent Collection, Gift of Jesse R.

Fillman in honor of James S. Schramm, 1977.37

74
Willem de Kooning (1904–1997)
Woman, 1943
Oil on board
28¼ × 23¹⁄₁₆ in. (71.8 × 58.6 cm)
Seattle Art Museum, Gift of Mr. and Mrs. Bagley Wright

73 (*opposite*)
Willem de Kooning (1904–1997)
Seated Woman, c. 1940
Oil and charcoal on masonite
54¹⁄₁₆ × 36 in. (137.3 × 91.4 cm)
Philadelphia Museum of Art, The Albert M. Greenfield
and Elizabeth M. Greenfield Collection, 1974, 1974-178-23

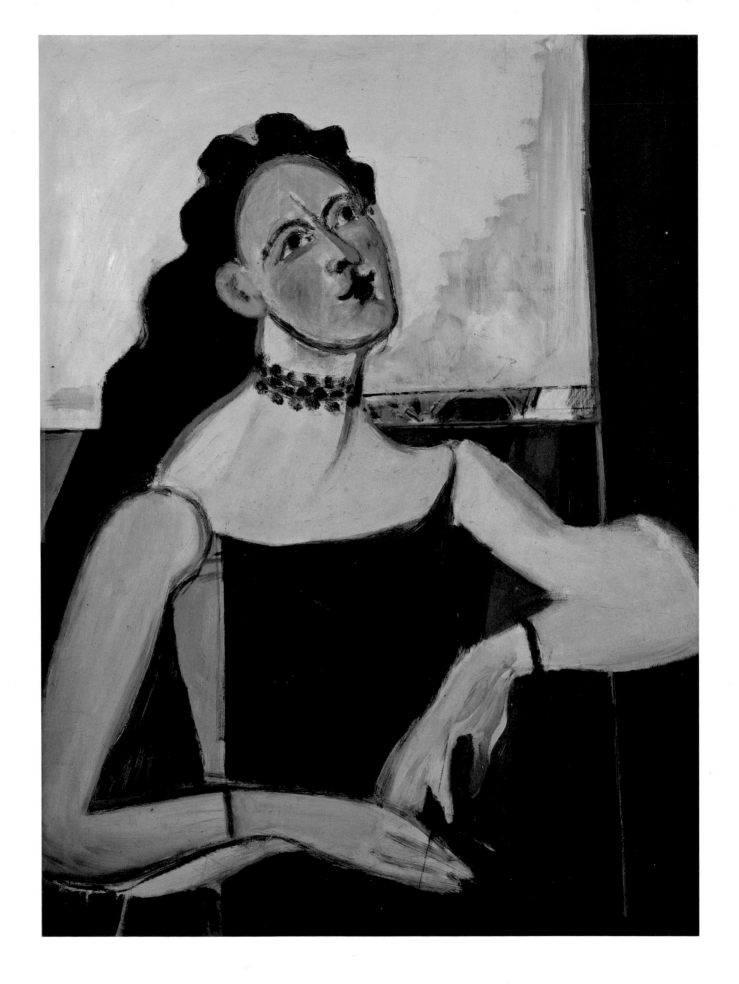

Arshile Gorky (1904–1948)
Portrait of the Artist's Wife, 1942–46
Oil on canvas mounted on masonite
31 × 22 in. (78.7 × 55.9 cm)
Private collection

75 (*opposite*)
John Graham (1887–1961)
Portrait of a Woman Seated (Seated Woman), c. 1942
Oil on canvas
48 × 35½ in. (121.9 × 90.1 cm)
Private collection, Brooklyn, New York

77
John Graham (1887–1961)
Woman, 1943
Oil on canvas
24⅜ × 20 in. (61.9 × 50.8 cm)
Collection of The Honorable and Mrs.
Joseph P. Carroll, New York

78
John Graham (1887–1961)
Poussin m'instruit, 1944
Oil on panel
60 × 48 in. (152.4 × 121.9 cm)
Anthony F. Bultman IV and Ellis J. Bultman

EXHIBITION CHECKLIST

Dorothy Dehner (1901–1994), Adolph Gottlieb (1903–1974), Esther Dick Gottlieb (1907–1988), Edgar Levy (1907–1975), Lucille Corcos Levy (1905–1973), David Smith (1906–1965)
Six Artist Etching, 1933, printed 1974
Edition 51/100
Etching on wove paper, image: 5¾ × 7¾ in. (14.6 × 19.7 cm); sheet: 9¾ in. × 10⅝ in. (24.8 × 27 cm)
Adolph and Esther Gottlieb Foundation, New York
Plate 82

David Burliuk (1882–1967)
Portrait of David Smith, c. 1930
Charcoal and crayon on paper, 11¼ × 8½ in. (28.6 × 21.6 cm)
Private collection
Plate 83

Alexander Calder (1898–1976)
Portrait of John Graham, c. 1931
Wire, 12 × 8 × 9 in. (30.5 × 20.3 × 22.9 cm)
Private collection
Plate 81

Stuart Davis (1892–1964)
Egg Beater No. 1, 1927
Oil on canvas, 29⅛ × 36 in. (74 × 91.4 cm)
Whitney Museum of American Art, New York, Gift of Gertrude Vanderbilt Whitney, 31.169
Plate 5 • Amon Carter and Addison only

Adit No. 1 (Industry), 1928
Oil on canvas mounted on masonite, 28½ × 23½ in. (72.4 × 59.7 cm)
University of Arizona Museum of Art, Tucson, Gift of C. Leonard Pfeiffer
Plate 9

Adit No. 2, 1928
Oil on canvas, 28⅞ × 23¾ in. (73.3 × 60.3 cm)
Museum of Fine Arts, Boston, Gift of the William H. Lane Foundation, 1990.394
Plate 10 • Amon Carter and Addison only

Egg Beater No. 2, 1928
Oil on canvas, 29¼ × 36¼ in. (74 × 91.4 cm)
Amon Carter Museum of American Art, Fort Worth, Texas, 1996.9
Plate 6

Egg Beater No. 3, 1928
Oil on canvas, 25⅛ × 39⅛ in. (63.8 × 99.4 cm)
Museum of Fine Arts, Boston, Gift of the William H. Lane Foundation, 1990.391
Plate 7 • Amon Carter and Addison only

Rue des Rats, No. 2, 1928
Oil and sand on canvas, 20 × 29 in. (50.8 × 73.7 cm)
Hirshhorn Museum and Sculpture Garden, Smithsonian Institution, Washington, D.C., Gift of Joseph H. Hirshhorn, 1972
Plate 8

Arch Hotel, 1929
Oil on canvas, 28¾ × 39½ in. (73 × 100.3 cm)
Sheldon Museum of Art, University of Nebraska–Lincoln, UNL–F. M. Hall Collection
Plate 15 • Amon Carter and Addison only

Radio Tubes (Still Life Radio Tube), 1931
Oil on canvas, 50 × 32¼ in. (127 × 81.9 cm)
Rose Art Museum of Brandeis University, Waltham, Massachusetts, Bequest of Louis Schapiro
Plate 28

Salt Shaker, 1931
Oil on canvas, 49⅞ × 32 in. (126.7 × 81.3 cm)
The Museum of Modern Art, New York,
Gift of Edith Gregor Halpert, 1954
Plate 29

Red Cart, 1932
Oil on canvas, 32¼ × 50 in. (81.9 × 127 cm)
Addison Gallery of American Art, Phillips Academy, Andover,
Massachusetts, Museum purchase
Plate 31

Landscape, 1932 and 1935
Oil on canvas, 32½ × 29¼ in. (82.5 × 74.3 cm)
Brooklyn Museum, Gift of Mr. and Mrs. Milton Lowenthal, 73.150
Plate 30

Gloucester Harbor, 1938
Oil on canvas, mounted on panel, 23¹¹⁄₁₆ × 30⅛ in. (58.6 × 76.5 cm)
The Museum of Fine Arts, Houston, Museum purchase with
funds provided by the Agnes Cullen Arnold Endowment Fund
Plate 50 • Amon Carter and Addison only

Shapes of Landscape Space, 1939
Oil on canvas, 36 × 28 in. (91.4 × 71.1 cm)
Neuberger Museum of Art, Purchase College,
State University of New York, Gift of Roy R. Neuberger
Plate 54 • Neuberger only

Willem de Kooning (1904–1997)
Untitled, c. 1928
Oil on canvas, 28 × 20½ in. (71.1 × 52.1 cm)
Private collection
Plate 11

Still Life with Eggs and Potato Masher, c. 1928–29
Oil and sand on canvas, 18 × 24 in. (45.7 × 61 cm)
Collection of The Honorable and Mrs. Joseph P. Carroll, New York
Plate 4

Untitled, c. 1934
Oil on canvas, 36 × 45⅛ in. (91.4 × 114.6 cm)
Private Collection, Courtesy Eykyn Maclean, LP, New York
Plate 37

Portrait of Rudy Burckhardt, 1939
Oil on canvas, 49 × 36 in. (124.5 × 91.4 cm)
Collection of Basha and Perry Lewis
Plate 57 • Amon Carter and Addison only

Untitled, 1939
Gouache on paper, 5½ × 7¾ in. (14 × 19.7 cm)
Allan Stone Collection, Courtesy of the Allan Stone Gallery,
New York
Plate 58

Seated Woman, c. 1940
Oil and charcoal on masonite, 54¹⁄₁₆ × 36 in. (137.3 × 91.4 cm)
Philadelphia Museum of Art, The Albert M. Greenfield and
Elizabeth M. Greenfield Collection, 1974, 1974-178-23
Plate 73 • Amon Carter and Addison only

Composition, 1942
Oil on masonite, 24 × 36 in. (61 × 91.4 cm)
Allan Stone Collection, Courtesy of the Allan Stone Gallery,
New York
Plate 67

Woman (Elaine), 1942
Oil on board, 21 × 14 in. (53.3 × 35.6 cm)
Allan Stone Collection, Courtesy of the Allan Stone Gallery,
New York
Plate 85

Woman, 1943
Oil on board, 28¼ × 23¹/₁₆ in. (71.8 × 58.6 cm)
Seattle Art Museum, Gift of Mr. and Mrs. Bagley Wright
Plate 74

Portrait of John Graham, c. 1948
Graphite on paper, 7 × 5 in. (17.8 × 12.7 cm)
Private collection
Plate 79

Dorothy Dehner (1901–1994)
Still Life, 1932
Oil on canvas, 20½ × 16 in. (52.1 × 40.6 cm)
Collection Zimmerli Art Museum at Rutgers University,
Gift of the artist
Plate 33

Arshile Gorky (1904–1948)
Enigma (Composition of Forms on Table), 1928–29
Oil on canvas, 33 × 44 in. (83.8 × 111.8 cm)
Collection of The Honorable and Mrs. Joseph P. Carroll,
New York
Plate 19

Still Life with Palette, c. 1929–30
Oil on canvas, 28¼ × 36¼ in. (71.8 × 92.1 cm)
Montclair Art Museum, Museum purchase, funds provided by
the Ball Committee, 1972.18
Plate 20

Still Life, c. 1930–31
Oil on canvas, 38½ × 50⅜ in. (97.8 × 127.9 cm)
Chrysler Museum of Art, Norfolk, Virginia,
Bequest of Walter P. Chrysler, Jr., 89.51
Plate 22

Organization, 1933–36
Oil on canvas, 50 × 59¹³/₁₆ in. (127 × 151.9 cm)
National Gallery of Art, Washington, D.C,
Ailsa Mellon Bruce Fund, 1979.13.3
Plate 42

Organization (Nighttime, Enigma, and Nostalgia), c. 1934–36
Oil on linen canvas mounted on masonite, 14 × 22 in.
(35.6 × 55.9 cm)
University of Arizona Museum of Art, Tucson, Gift of Edward
Joseph Gallagher, Jr.
Plate 40

Xhorkom—Summer, 1936
Oil on canvas, 36 × 48 in. (91.4 × 121.9 cm)
Albright-Knox Art Gallery, Buffalo, New York, Sarah Norton
Goodyear Fund and Partial Gift of David K. Anderson to the
Martha Jackson Collection, 1999, 1999:8
Plate 38

Portrait of Akabi, c. 1936–37
Oil on canvas board, 12 × 9⅛ in. (30.5 × 23.2 cm)
Hirshhorn Museum and Sculpture Garden, Smithsonian
Institution, Washington, D.C., Gift of Joseph H. Hirshhorn, 1966
Plate 39

Self-Portrait, c. 1937
Oil on canvas, 55½ × 23⅞ in. (141 × 60.7 cm)
Private collection, on loan to the National Gallery of Art,
Washington, D.C.
Plate 86 • Addison only

[inscribed "To John"], c. 1938
Crayon on paper, 20 × 14¼ in. (50.8 × 36.2 cm)
Collection of Basha and Perry Lewis
Plate 48 • Amon Carter and Addison only

The Pirate I, 1942–43
Oil on canvas, 30 × 36 in. (76 × 91.4 cm)
Collection of The Honorable and Mrs. Joseph P. Carroll,
New York
Plate 68

Portrait of the Artist's Wife, 1942–46
Oil on canvas mounted on masonite, 31 × 22 in. (78.7 × 55.9 cm)
Private collection
Plate 76

Adolph Gottlieb (1903–1974)
South Ferry Waiting Room, c. 1929
Oil on cotton, 36 × 45 in. (91.4 × 114.3 cm)
Adolph and Esther Gottlieb Foundation, New York
Plate 16

Untitled (Gloucester Docks), c. 1938
Oil on canvas, 19 × 23⅞ in. (48.3 × 60.6 cm)
Adolph and Esther Gottlieb Foundation, New York
Plate 49

Untitled (Still Life), 1941
Oil on canvas, 25¹³⁄₁₆ × 34 in. (65.4 × 86.3 cm)
Adolph and Esther Gottlieb Foundation, New York
Plate 64

Pictograph (Yellow and Purple), 1942
Oil on canvas, 48 × 36 in. (121.9 × 91.4 cm)
Adolph and Esther Gottlieb Foundation, New York
Plate 65

John Graham (1887–1961)
Horse and Rider (recto), *Portrait of a Woman* (verso), 1926
Oil on canvas, 22 × 16 in. (55.9 × 40.6 cm)
Collection of The Honorable and Mrs. Joseph P. Carroll, New York
Plate 1

Sailboat, 1927
Oil on canvas mounted on cardboard, 8⅞ × 15¼ in. (22.5 × 38.7 cm)
The Phillips Collection, Washington, D.C.
Plate 2

Fountain, 1929
Oil on canvas, 21¼ × 25¼ in. (54 × 64.1 cm)
The Phillips Collection, Washington, D.C.
Plate 14

Still Life with Pipe, 1929
Oil on canvas, 13¼ × 23 in. (33.7 × 58.4 cm)
The Museum of Fine Arts, Houston, Gift of
Mr. and Mrs. George R. Brown and George S. Heyer, Jr.
Plate 12 • Amon Carter and Addison only

Table Top Still Life with Bird, 1929
Oil on canvas, 32 × 39 in. (81.3 × 99.1 cm)
Tommy and Gill LiPuma, New York
Plate 3

Vigneux, 1929
Oil on canvas, 19⅝ × 25¼ in. (49.8 × 64.1 cm)
The Phillips Collection, Washington, D.C.
Plate 13

Portrait of Elinor Gibson, 1930
Oil on canvas, 28⅛ × 22 in. (71.4 × 55.9 cm)
The Phillips Collection, Washington, D.C.
Plate 80

The White Pipe, 1930
Oil on canvas mounted on board, 12¼ × 17 in. (31.1 × 43.2 cm)
Grey Art Gallery, New York University Art Collection, Gift of
Dorothy Paris, 1961
Plate 23

Untitled, 1930
Oil on canvas, 16 × 21 in. (40.6 × 53.3 cm)
Collection of Basha and Perry Lewis
Plate 24 • Amon Carter and Addison only

The Yellow Bird, c. 1930
Oil on canvas, 16⅛ × 20⅛ in. (41 × 51.1 cm)
Weatherspoon Art Museum, The University of North Carolina at
Greensboro, Museum purchase with funds from the Jefferson-
Pilot Corporation, 1970
Plate 21

Embrace, 1932
Oil on canvas, 30 × 36 in. (76.2 × 91.4 cm)
The Phillips Collection, Washington, D.C., Bequest of
Dorothy Dehner Mann, 1995
Plate 32

Untitled, c. 1933
Pen and ink on paper, 8⅝ × 11⅞ in. (21.9 × 30.2 cm)
Allan Stone Collection, Courtesy of the Allan Stone Gallery,
New York
Plate 43

Europa and Bull, 1936–37
Pen and ink on paper, 8⅝ × 11⅞ in. (21.9 × 30.5 cm)
Allan Stone Collection, Courtesy of the Allan Stone Gallery,
New York
Plate 44

Interior, 1939–40
Oil on canvas, 30 × 20 in. (76.2 × 50.8 cm)
Rose Art Museum, Brandeis University, Waltham,
Massachusetts, Bequest of Louis Schapiro, Boston
Plate 61

New York, 1940
Oil on canvas, 25 × 20 in. (63.5 × 50.8 cm)
Allan Stone Collection, Courtesy of the Allan Stone Gallery,
New York
Plate 63

Sun and Bird, c. 1941–42
Oil on canvas, 21 × 18 in. (53.3 × 45.7 cm)
Allan Stone Collection, Courtesy of the Allan Stone Gallery,
New York
Plate 62

Untitled, 1942
Gouache on paper, 24 × 18 in. (61 × 45.7 cm)
Allan Stone Collection, Courtesy of the Allan Stone Gallery,
New York
Plate 66

Portrait of a Woman Seated (Seated Woman), c. 1942
Oil on canvas, 48 × 35½ in. (121.9 × 90.1 cm)
Private collection, Brooklyn, New York
Plate 75

Woman, 1943
Oil on canvas, 24⅜ × 20 in. (61.9 × 50.8 cm)
Collection of The Honorable and Mrs. Joseph P. Carroll,
New York
Plate 77

Poussin m'instruit, 1944
Oil on panel, 60 × 48 in. (152.4 × 121.9 cm)
Anthony F. Bultman IV and Ellis J. Bultman
Plate 78

Lee Krasner (1908–1984)
Untitled, c. 1940
Oil on canvas, 30 × 25 in. (76.2 × 63.5 cm)
Fayez Sarofim Collection
Plate 69

Composition, 1943
Oil on canvas, 30⅛ × 24¼ in. (76.5 × 61.6 cm)
Smithsonian American Art Museum, Washington, D.C., Museum
purchase made possible by Mrs. Otto L. Spaeth, David S. Purvis,
and anonymous donors and through the Director's Discretionary
Fund, 1987.33
Plate 70

Edgar Levy (1907–1975)
Portrait of David Smith (David Smith), c. 1930
Oil on linen, 24¾ × 16 in. (62.9 × 40.6 cm)
The Metropolitan Museum of Art, New York, Purchase, Mrs.
Derald Ruttenberg Gift, 1999 (1999.205)
Plate 84 • Addison only

Figure in Yellow Window, 1938
Oil on canvas, 60 × 48 in. (152.4 × 121.9 cm)
Private collection
Plate 51

Still Life, Figure, Self-Portrait, 1938
Oil on canvas, 60 × 48 in. (152.4 × 121.9 cm)
Courtesy Babcock Galleries, New York
Plate 52

Jan Matulka (1890–1972)
Arrangement with Phonograph, 1929
Oil on canvas, 30 × 40 in. (76.2 × 101.6 cm)
Whitney Museum of American Art, New York, Gift of
Gertrude Vanderbilt Whitney, 31.298
Plate 17

Still Life with Lamp, Pitcher, Pipe, and Shells, 1929–30
Oil on canvas, 30 × 36 in. (76.2 × 91.4 cm)
The Museum of Fine Arts, Houston, Museum purchase
Plate 18 • Amon Carter and Addison only

Still Life with Horse Head and Phonograph, 1930
Oil and sand on canvas, 24 × 40¼ in. (61 × 102.2 cm)
The Art Students League of New York, Permanent Collection
Plate 25

Composition, c. 1930
Oil on canvas, 30 × 40 in. (76.2 × 101.6 cm)
Collection of Bunty and Tom Armstrong
Plate 27

Jackson Pollock (1912–1956)
Bird, c. 1938–41
Oil and sand on canvas, 27¾ × 24¼ in. (70.5 × 61.6 cm)
The Museum of Modern Art, New York, Gift of Lee Krasner in
memory of Jackson Pollock, 1980
Plate 59

Masqued Image, c. 1938–41
Oil on canvas, 40 × 24 in. (101.6 × 61 cm)
Modern Art Museum of Fort Worth, Museum purchase made
possible by a grant from the Burnett Foundation, acquired in 1985
Plate 60 • Amon Carter only

Mask, c. 1941
Oil on canvas, 16¾ × 19 in. (42.5 × 48.3 cm)
The Museum of Modern Art, New York, Enid A. Haupt Fund, 1980
Plate 71

David Smith (1906–1965)
Untitled (Table Top Still Life), c. 1930
Oil on canvas, 18 × 12 in. (45.7 × 30.5 cm)
The Estate of David Smith, Courtesy Gagosian Gallery, New York
Plate 26

Head, 1932
Wood on artist's base, painted, 23 × 8⅜ × 5⅜ in.
(58.4 × 21.2 × 13.6 cm)
The Estate of David Smith, Courtesy Gagosian Gallery, New York
Plate 34

Chain Head, 1933
Iron, 19 × 10 × 7 in. (48.3 × 25.4 × 17.8 cm)
The Estate of David Smith, Courtesy Gagosian Gallery, New York
Plate 35

Untitled (Untitled [Head, Blue and White]), 1934
Oil on canvas, 14 × 24 in. (35.6 × 61 cm)
The Estate of David Smith, Courtesy Joan Washburn Gallery,
New York
Plate 36

Dancer, 1935
Patinated iron, 21 × 9½ × 8 in. (53.3 × 24.1 × 20.3 cm)
Collection of Peter Blum, New York
Plate 46

Construction on a Fulcrum, 1936
Bronze and iron, 14 × 17 × 3 in. (35.6 × 43.9 × 7.6 cm)
Private collection
Plate 41

Untitled (Billiards), 1936
Oil on canvas, 11¾ × 16 in. (29.8 × 40.6 cm)
The Estate of David Smith, New York
Plate 45

Interior, 1937
Welded steel with cast iron balls, 15⅝ × 26 × 6 in.
(39.7 × 66 × 15.2 cm)
Weatherspoon Art Museum, The University of North Carolina
at Greensboro, Museum purchase with funds from anonymous
donors, 1979 (1979.2668)
Plate 47 • Addison only

Amusement Park, 1938
Welded steel, 20 × 34 × 4 in. (50.8 × 86.4 × 10.2 cm)
New Orleans Museum of Art, Louisiana, Gift of Mr. and Mrs.
Walter Davis, Jr., in honor of the museum's seventy-fifth
anniversary, 85.105
Plate 53

Leda, 1938
Painted steel, 28⅝ × 15½ × 13½ in. (72.7 × 39.4 × 34.3 cm)
The Museum of Fine Arts, Houston, Gift of
Mr. and Mrs. W. D. Hawkins
Plate 55 • Amon Carter and Addison only

Structure of Arches, 1939
Steel with zinc and copper plating, 39⁵⁄₁₆ × 48 × 30¼ in.
(99.8 × 121.9 × 78.8 cm)
Addison Gallery of American Art, Phillips Academy, Andover,
Massachusetts, Purchased as the Gift of
Mr. and Mrs. R. Crosby Kemper (PA 1945)
Plate 56

Head as a Still Life 1, 1942
Cast aluminum, 8½ × 12 × 4½ in. (21.6 × 30.5 × 11.4 cm)
Des Moines Art Center Permanent Collection,
Gift of Jesse R. Fillman in honor of James S. Schramm, 1977.37
Plate 72

CHRONOLOGIES

John Graham

Prepared by Alicia Longwell

1920 **November:** John D. Graham (then known as Jan Dabrowski, a Polish variant of his name) sails for the United States on the S.S. *Kroonland* with his twenty-year-old second wife, Vera Alexandrovna Sokolova, and newborn infant son in tow. They have spent the better part of the previous two years trying to escape the upheaval of the Bolshevik Revolution (Graham was born Ivan Gratianovich Dombrowski in 1887 in Kiev, then Russia, to a family belonging to the hereditary Polish nobility; he has in fact abandoned his first wife and two small children in Moscow in the melee). Vera begged Graham to book first-class passage, so horrified was she by stories of immigrating through Ellis Island. He uses most of their meager savings to secure the best accommodations on the creaky vessel. The *Kroonland* docks in New York on November 24—the eve of Thanksgiving Day.

1921 Graham, trained in the law and the military, and Vera, versed in music and languages, take odd jobs to pay the rent on their apartment in Upper Manhattan. She plays the piano afternoons in an ice cream parlor; he seeks a permanent position by petitioning the Committee for Russian Relief, recommending himself as a loyal anti-Bolshevik. Seeking a more stable situation, they begin to work for the family of Samuel Thorne, Sr., in Rye, New York, Graham as riding instructor to the sons and Vera teaching music and French to the boys and a younger sister.

1922 Graham grows disenchanted with suburban life and returns to New York City. Not known to have practiced as an artist in Russia, he enrolls in courses at a commercial art school and also studies privately with Irene Weir, a noted teacher and member of the well-known family of painters.

 August: He secures a passport under the name John G. Dombrowski, issued through the Polish consulate in New York.

79
Willem de Kooning (1904–1997)
Portrait of John Graham, c. 1948
Graphite on paper
7 × 5 in. (17.8 × 12.7 cm)
Private collection

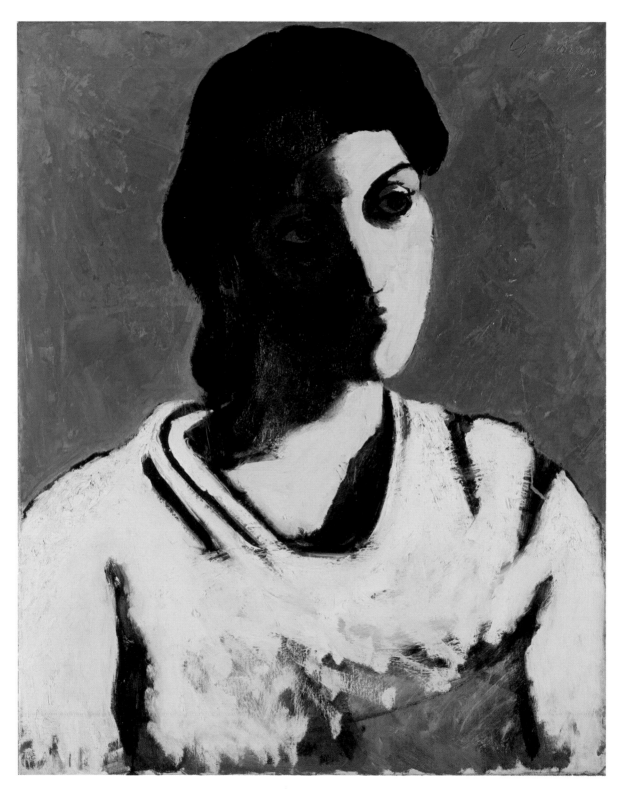

80
John Graham (1887–1961)
Portrait of Elinor Gibson, 1930
Oil on canvas
28⅛ × 22 in. (71.4 × 55.9 cm)
The Phillips Collection, Washington, D.C.

December: Graham fulfills a lifelong ambition, unthinkable in his native Russia, and registers for one month of drawing and composition at the Art Students League. (Later he wrote: "All my life from earliest childhood, I have been drawing and wanted to be an artist, but bewildered by astonishing sights of life and its mirages, entangled in bewitching passions, with no one that could advise me, nor one whose judgment I could trust, I was like a vessel without a captain.")[1]

1923 Registers in John Sloan's life painting classes at the League and also studies with Allen Tucker and Kenneth Hayes Miller. Fellow student Alexander Calder recalls: "I also went in the evening to John Sloan's class, where my best friend was the monitor John Debrowsky [*sic*]. . . . I never was conscious that he was much older than I when I knew him at the Art Students League. . . . Debrowsky first attracted my attention by drawing a nude with two pencils, one red and one black, and starting with the feet and running right up."[2] Graham is thirty-six; Calder is twenty-five. Other League students include Barnett Newman, Adolph Gottlieb, and a young artist from Baltimore named Elinor Gibson.

Graham works as social secretary at the Associated Press and attends League classes in the evenings. Renews friendship "from the old days [in Russia]" with artist David Burliuk.

February: Serves as Sloan's class monitor; Sloan fosters key connection for Graham by introducing him to Frank Crowninshield, the urbane editor of *Vanity Fair,* for whom Graham would amass a stellar collection of African art.

April–May: Two large exhibitions held in New York may have sealed his resolve to collect and deal in African sculpture: *Primitive Negro Art, Chiefly from the Belgian Congo* at the Brooklyn Museum and an exhibition of Picasso's work displayed alongside African sculpture organized by Marius de Zayas for the Whitney Studio Club galleries. Graham traces his interest in primitive sculpture back to visiting Sergei Shchukin's collection in pre-revolutionary Moscow, where he first saw Matisse and Picasso, the latter displayed with African sculpture.

August: Begins divorce proceeding in Moscow against Vera.

1924 **January:** Marries Elinor Gibson. They relocate to her native Baltimore. Gibson was the daughter of the prominent musician and composer Archer Gibson (1875–1952), the first organist in America to become a millionaire,

primarily from his recordings on Aeolian Duo-Art rolls and RCA phonograph records. For most of her career, Elinor finds employment as an art teacher; during the years she and Graham are together, she provides a steady income and, presumably, has some family financial resources to rely on.

February: Graham's arrival in Baltimore is heralded by a banner headline in the *Baltimore Sun,* "Member of Nobility Who Fled Russia Makes Home in Baltimore." He describes himself as a soldier and former jurist of the czarist regime in this first public construction of his past but omits mention of his earlier marriages and offspring. The article identifies him as John Dabrowsky Graham—the first time he has used this version of his name.

December: Graham obtains an annulment of marriage to Vera.

1925 Graham and Elinor are soon drawn into the fledgling group of modernists in Baltimore, artists and proponents alike, who call themselves the Friends of Art. The inclusion of a saw in two of Graham's tabletop still lifes from this year suggests more than a passing acquaintance with the work of Stuart Davis (who first included this motif in his 1922 composition *Landscape, Gloucester*). An often repeated anecdote from Davis's first wife has Graham knocking on their door in Manhattan saying he bicycled all the way from Baltimore to introduce himself to an artist he admires. It is more likely he met Davis through Sloan, who knew him through work on *The Masses.* Russian poet Vladimir Mayakovsky visits New York; it is likely that Graham (who will single out Mayakovsky for high praise in later writings) renews acquaintance through Burliuk.

1926 **February:** The Friends of Art hold exhibitions in the Grahams' apartment at 15 East Pleasant Street, Baltimore. Graham has a one-man exhibition there in the so-called Modernist Galleries; his excitement at exhibiting publicly is evident in the inscription on the back of one of the paintings, *Pears in Motion:* "This painting rich in potentialities, I painted for my own satisfaction in city of Baltimore, Md. / 15 E/ Pleasant St. / January 1926 A.D."[3] Through the Friends of Art, Graham and Elinor meet Etta and Claribel Cone, Baltimore sisters who are assembling one of the most important groups of modernist European art in America, including Matisse and Picasso.

June: Graham and Elinor travel to Europe in the summer. Correspondence between the Cone sisters reveals how the Grahams financed this and

subsequent trips to Europe: "Then I went to the Graham's [sic] to see their paintings and things they had bought in Africa and as she (Mrs. G.) said—'Dr. Cone we took your advice and brought a few things back with us to sell in this country'—I naturally bought a few."[4] Christian Zervos founds the magazine *Cahiers d'art* in Paris.

Fall: Graham meets Duncan Phillips (whose gallery in Washington, D.C., was founded in 1921 as the nation's first museum of modern art) when Phillips agrees to lend paintings to Friends of Art exhibition in Baltimore.

November: Sloan and Graham remain close; Sloan purchases Graham's *Still Life—Pitcher and Fruit,* 1926, which is in his collection at the time of his death. Adages heard in Sloan's classes (later compiled in *Gist of Art,* 1939) are taken to heart by Graham and would certainly have buoyed his resolve to become an artist: "Though a living cannot be made at art, art makes life worth living. It makes living, living. It makes starving, living." "Don't be afraid to borrow. The great men, the most original, borrowed from everybody. . . . Little men just borrow from one person. Assimilate all you can from tradition and then say things in your own way." Davis is introduced by Burliuk to collector and patron Katherine Dreier, who began annual exhibitions of modernist art in the early 1920s under the banner of the Société Anonyme. She includes Davis's *Super Table* in a large-scale international exhibition held at the Brooklyn Museum in November and December, drawing some 52,000 visitors, Graham doubtless among them; more than three hundred works by 106 artists from twenty countries are featured. It is likely that Graham's introduction to Dreier comes through David Burliuk as well but they do not actually meet until 1936.

1927 **March:** Phillips is so taken with one of Graham's works (*Blue Bay and Interior,* most likely painted in Europe in the summer of 1926) that he commissions Graham to develop a painting whose subject will be only the body of water visible through a window in the upper left quadrant of the painting. Phillips takes the liberty of giving Graham explicit directions on reworking a first version of the painting.

March 28: Graham becomes a naturalized U.S. citizen, his name now officially John D. Graham. Adolph Gottlieb, a friend from Art Students League days, acts as witness.

April: *Blue Bay* is included in *An Exhibition of Expressionist Painters from the Experiment Station of the Phillips Memorial Gallery,* a show of Phillips's collection on loan to the Baltimore Museum. Despite Phillips's meddling,

Graham enters into an agreement with him to receive $800 a year in quarterly installments—$200 checks in the months of January, April, July, and October.

Summer: Graham and Elinor are again in Europe.

1928 **January:** Graham secures a contract and promise of a one-man show with Dudensing Galleries in New York in March 1929. Feeling stifled by Baltimore, he writes Phillips appealing for a stipend to travel abroad again: "I cannot afford a model or a bunch of flowers to paint as Baltimore offers no inspiration."[5] Notes that he and Elinor have no income from June to October when she is not teaching; Phillips does not respond to this request.

April: Writes Phillips that he is leaving by freighter for France with plans for an extended stay abroad, claiming that his reception in America is too slow in coming. Phillips urges him to stay: "You are a portent of the new American and with your lovely American wife you must take root among us and contribute to our civilization your ancient Slavonic culture. Don't expect to be acclaimed or understood at once. It never happens."[6]

May: Graham sails on a Red Star Line freighter for France, never to return to Baltimore; writes Phillips that he plans to travel to Italy while waiting for a studio at 6 rue Huyghens, just around the corner from the intersection of the boulevards du Montparnasse and Raspail, the heart of Montparnasse.

June: Davis arrives in Paris, where he has sublet a studio from Czech-born Cubist painter and League instructor Jan Matulka at 50 rue Vercingétorix, a twenty-minute walk from Graham's studio. (Sale of two paintings to Juliana Force of the Whitney Studio Club enabled Davis to plan this sojourn abroad.) He brings two of his *Egg Beater* paintings with him to Paris.

Mid-June: Elinor joins Graham in Paris.

Summer: Both Davis and Graham work at the atelier of the brothers Edmond and Jacques Desjobert, frequented by young American artists who had few opportunities in the United States to work in lithography. Through Davis Graham meets American writer Elliot Paul, who worked for Eugene Jolas's fledgling literary journal *transition* ("An International Quarterly for Creative Experiment"). Davis later recalls that Graham took him to

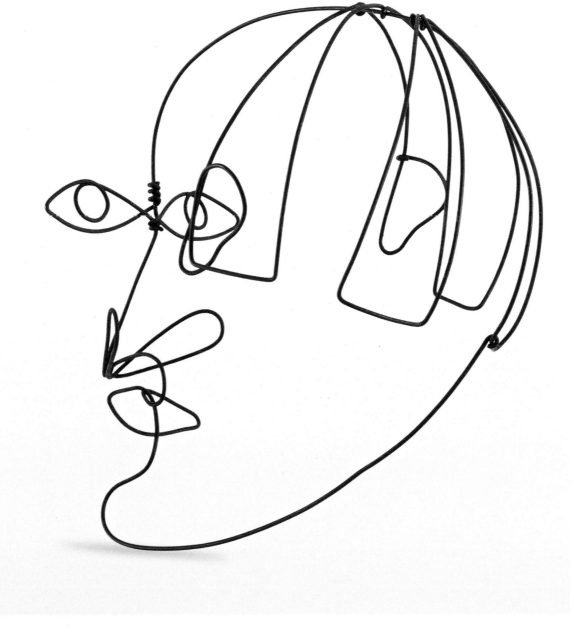

81
Alexander Calder (1898–1976)
Portrait of John Graham, c. 1931
Wire
12 × 8 × 9 in. (30.5 × 20.3 × 22.9 cm)
Private collection

Léger's studio: "John Graham was there, an artist I knew very well. He was a Russian. He spoke French and everything else."[7]

August: Graham has a one-man show at the Left Bank gallery of Leopold Zborowski, a Polish-born poet who arrived in Paris in 1913 and became one of the city's best-known dealers. His sustaining friendship with Amedeo Modigliani is by now legendary. The exhibition at Galerie Zborowski is at least partially self-subsidized. Graham writes to Phillips: "It is surprising that Paris art critics accepted my work right away while New York critics still do not recognize me. . . . People who liked my work so far are Picasso, [André] Salmon, [Paul] Guillaume, Zborowski, [Waldemar] George, [Florent] Fels and others."[8] Davis is more discriminating than Graham, turning down an offer from Zborowski for a solo exhibition for which he would have had to help pay. Despite the August opening, Graham's show draws the attention of an array of prominent Parisian critics, including André Salmon, who describes him in the September issue of *Apollo* as "a good American painter [who has] profited by his sojourns in Paris." Graham likely reconnects with Alexander Calder. Graham's line drawing *Self-Portrait* of 1928 and Calder's portrait of Graham in wire (pl. 81) show a strong affinity.

October: *transition* 14 takes as its theme "Americans in Paris" and features Davis's *Hôtel de France* on the cover with four works inside; two works by Graham illustrate the section "Why Do Americans Live in Europe?" Graham returns from Paris and he and Elinor relocate to New York City. A letter from Phillips reveals that Graham is bringing paintings back for his patron: "I am eager to see the Derain which you recommend so highly and which is so much less expensive that the ones offered by the New York dealers."[9]

December: Writes Katharine Dreier in an attempt to arrange a meeting with her and Burliuk, but it does not happen until later. It is difficult to pinpoint the date when Graham first meets Arshile Gorky (likely through Burliuk), but most sources agree they are acquainted by 1928.

1929

January: A monograph on Graham is published by Le Triangle, a small Paris press known for artist's editions; it features an essay by critic Waldemar George and Graham's line drawing *Self-Portrait* on the cover. Although still receiving quarterly payments from Phillips for the purchase of paintings, Graham once again petitions Dreier for a stipend. "To be able to live and work in Paris fifteen months I need eight hundred dollars. . . . I know that I am a great living painter, perhaps one of the greatest. I am

neither proud nor ashamed of it—it is a fact, like being blond or brunette. And many great men whose opinion you respect believe in my greatness, and if you would see my paintings I am sure you would agree."[10] Dreier responds that she is sorry but she is helping a "small group" which she cannot extend.

March: Exhibits twenty-two paintings at Dudensing Galleries, New York; the catalogue features contributions by the French critic André Salmon, Ben Hecht, a playwright and later screenwriter, and David Burliuk. Willem de Kooning, on a routine weekend round of galleries, happens on the opening and it is likely that de Kooning meets Gorky there too. Exhibition *American Art of Tomorrow* opens at Morton Galleries, New York, organized by Burliuk and sponsored by Dreier and Dr. Christian Brinton, an art critic and tireless promoter of modernism, especially that of Eastern European artists. As Graham prepares for a solo exhibition at Phillips's gallery, his patron advises him: "It is because I am so much interested in you and your new pictures that I do want you to cultivate moderation and subtlety and not to surprise and shock every time. . . . It is up to you to decide whether you will be yourself and perhaps a great master in your own right or just another of the minor men in the Post-Cubist movement, in the Picasso following which is slowly passing, if it is not already out of sight."[11]

March 6–31: Graham shows sixteen paintings in a solo exhibition at the Phillips Memorial Gallery, Washington, D.C.

April: A negative review of the Dudensing show by Lloyd Goodrich appears in *New York Times*. "Mr. Graham's painting, in spite of a good color sense and a certain bumptious vigor, resembles rather crude reminiscences of Picasso, Braque, Gris and the Matisse of about 1908."

May: Graham returns to Paris, despite Elinor's advanced pregnancy (their son John David Graham is born June 14, 1929). "In Paris I have a better chance to develop a personal way of painting since the French style of painting is too obvious there and one has no desire to paint that way. To fight off French influence one has to go and live among [the] French."

Summer: Dorothy Dehner and David Smith, young artists studying at the League whom Graham has met and taken under his wing, spend their first summer at Bolton Landing, a village in upstate New York on Lake George, as guests of the artist (Wilhelmina) Weber Furlong, an administrator at the League, and her husband, Tomas; Smith and Dehner later buy an eighty-six-acre farm there.

September: Davis, just back from Paris, meets Gorky through Graham.

October 1–15: Graham shows fourteen paintings at Galerie Zborowski, positively reviewed in *Cahiers d'art*. Davis includes his lithographs in the exhibition *Americans Abroad* at the Downtown Gallery.

November: Phillips writes that he wants to "settle up" with Graham. "I was not satisfied with the rather pale Paris landscape which I tentatively selected for last quarter of last year . . . the January check [will] complete our contract, if such it can be called. I have no business buying so many of your pictures as I have not done that with anyone else."[12]

November 27–December 7: Davis has a solo exhibition of watercolors at the Whitney Studio Club.

December: Plans for an extended stay abroad do not materialize. Back in the United States, Graham writes Phillips about a highly favorable review of the Zborowski show in *Cahiers d'art* and bemoans his reception stateside. "Here in New York everything is a rakett [*sic*], a game, in Paris men like George, Zervos, Salmon, Raynal, Terriade, Vauxcelles, Picasso, Léger, and others like my paintings. The Whitney Club intrigue seems to make my effort here . . . hopeless."[13] The December issue of *Vanity Fair* reviews Calder's work in Paris, calling the pieces "wire sculptures"; it is likely that Graham brought Calder to Crowninshield's attention.

1930 **January:** Graham exhibits two paintings in the 125th Annual Exhibition of Paintings and Sculpture at the Pennsylvania Academy of the Fine Arts. Exhibits with Stuart Davis, David Burliuk, and Jan Matulka and others at Romany Marie's, a tearoom and gallery in Greenwich Village. The exhibition *African Sculpture from the Collection of Frank Crowninshield and John Graham* is at the Dudensing Galleries.

February: Graham strongly advocates for Davis's work with Phillips: "There is an interesting show of Stuart Davis on now [at the Downtown Gallery], fine paintings, and I believe you ought to have an example of his work in your collection. Beautiful things."[14] Phillips purchases a work, *Blue Café* from 1928. Graham is in a group show at the Mural Galleries in New York together with Adolph Gottlieb, Stuart Davis, and others. Graham writes Phillips looking for a patron who will guarantee $800 annually in exchange for "16 or 20 paintings per year; alternately an outright loan of $3000 payable in three yearly installments, returning the money in ten years with interest of five paintings per year. By the way, as a security for

the loan I would offer my negro sculpture collection, which is worth more than the sum I am asking."[15] Phillips counsels Graham not to travel abroad and to cease "keeping one eye on Picasso. . . . It wouldn't do you any harm to stay in this country with your wife and child as I hear when you go to Paris you get too much Bohemia. . . . You are one of the best painters in America and you stand out more over here than you do in Paris where they have so many like you. Think it over."[16] Graham brings Smith and Dehner to Gorky's studio. Gorky's response: "They don't look like artists to me. They look like college kids."

Summer: While Graham is in Paris, Elinor stays in Bolton Landing with their friends the Furlongs.

Fall: One-person exhibition opens at the Galerie Van Leer in Paris; a reviewer for *Cahiers d'art* notes, "among the American painters who have been seen in Paris in the post-war period, Graham is unquestionably one of the best, if not the best."[17]

September: Graham is hired by Nicholas Roerich (1874–1947), a Russian-born artist and philosopher, to teach painting and drawing at the Master Institute of the Roerich Museum on Manhattan's Upper West Side; he teaches there intermittently over the next five years. Also hired as instructor in art at Wells College, a small, liberal arts women's school in Aurora, New York (Duncan Phillips has written a letter of recommendation).

December 28: Graham opens the *New York Times* to read Samuel Putnam's "Art Comment from Paris," a review of the Galerie Van Leer exhibition that doubtless strengthens his resolve to persevere as an American painter. "There is a peculiarly American quality in his work, his modernism, and it is as an American that most of us instinctively think of him. . . . Mr. Graham's esthetic product, indeed, might be regarded as an American commentary on Picasso—rather than as an American departure from Picasso."[18] Seizing upon this idea, he immediately writes Phillips in an effort to refute the nagging notion that his painting is too influenced by his sojourns in Paris and the sway of Picasso: "It is not the subject matter that makes painting American or French, but the quality, certain quality which makes painting assume one or the other nationality."[19]

1931 **Summer:** Elinor buys a house in Bolton Landing near the Smiths. According to Dehner, the summers of 1931–33 were relatively happy ones for the Grahams and their young son.

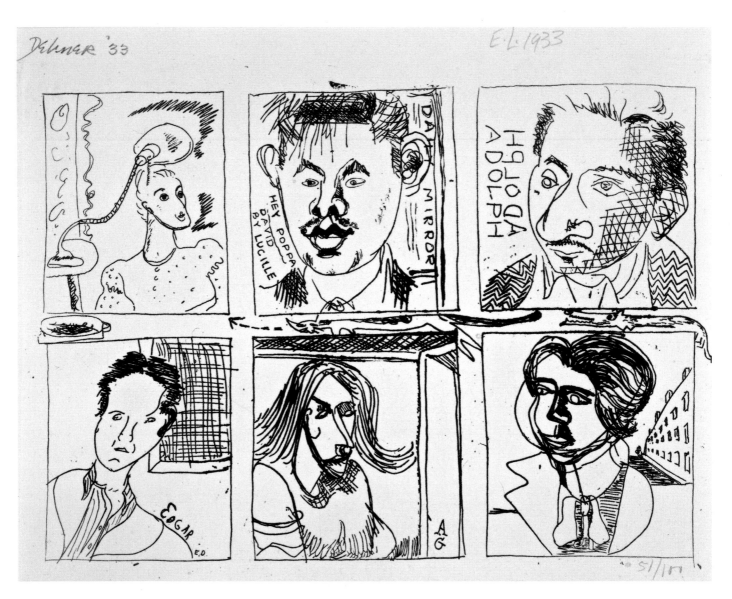

82

Dorothy Dehner (1901–1994), Adolph Gottlieb (1903–1974),
Esther Dick Gottlieb (1907–1988), Edgar Levy (1907–1975),
Lucille Corcos Levy (1905–1973), David Smith (1906–1965)
Six Artist Etching, 1933, printed 1974
Edition 51/100
Etching on wove paper
image: 5¾ × 7¾ in. (14.6 × 19.7 cm);
sheet: 9¾ in. × 10⅝ in. (24.8 × 27 cm)
Adolph and Esther Gottlieb Foundation, New York

September: The Grahams move to Summit, N.J., where Elinor has a teaching position; Graham is now associate professor at Wells; his studio courses included lectures in the theory of design. In an article for the September issue of the critic Henry McBride's *Creative Life,* Davis reflects on his sojourn in Paris: "It enabled me to spike the disheartening rumor that there were hundreds of talented young modern artists in Paris who completely outclassed their American equivalents. It demonstrated to me that work being done here was comparable in every way with the best of the work over there by contemporary artists. It proved to me that one might go on working in New York without laboring under an impossible artistic handicap."[20]

Fall: Graham begins to paint a series of murals at Wells, decorations for a smoking room in the basement of the main building, using largely abstracted planes of color with the inclusion of recognizable imagery such as playing cards, a guitar, lettered packaging, and profiles and heads.

1932 **January:** The cultural climate in France had become less welcoming to foreign artists as the 1920s drew to a close. Journals like Waldemar George's nationalistic *Formes,* published for four years beginning in December 1929, stirred up discourse on the subject. (The author of the 1929 monograph on Graham, George had railed against foreign-born artists in the summer 1931 issue of his journal.) In the January 1932 English edition of the magazine, the lead article asks "Is there an American Art?" and opines that Europeans would always deny its existence. Asked to respond in those pages to the charge that "American painting lacks originality," Duncan Phillips submits an essay, "Original American Painting of Today," in which he finds inheritors of American originals like Albert Pinkham Ryder, Augustus Vincent Tack, and John La Farge in the contemporary artists John Marin, Georgia O'Keeffe, Arthur G. Dove, Rockwell Kent, Walt Kuhn, and Charles Burchfield, among others. Phillips also notes the arrival of artists born abroad now living in America: "Painters like John D. Graham (born Dabrowski) bring to us alien points of view and exotic manners of expression, but they, too, make up a part of the New America. They have much to give us of ancient culture and Old World temperament. If they are wise they will try to absorb from our earlier native character and tradition the stimulus to a fresh start, and perhaps a new art."[21] Graham's *Study for Ikon of the Modern Age* (1930) from Brinton's collection is included in *Exhibition of Russian Painting and Sculpture: Realism to Surrealism* at the Wilmington [Delaware] Society of the Fine Arts, a 1932 presentation organized by Brinton.

March: Graham invites Gorky and art historian Frank Jewett Mather, Jr., professor at Princeton, to speak at Wells; they deliver a joint lecture and debate, "Two Views on Modern Art."

November: Participates in the First Biennial Exhibition of Contemporary American Painting at the Whitney Museum of American Art.

Although writing, teaching, and business dealings in Paris occupy much of his time, Graham continues to exhibit and, as for most artists, the 1930s are difficult years. He sells very few works of art, but dealing in African art provides a reliable source of income. His painting production during this period diminishes.

1933 **January:** One-man exhibition at Eighth Street Gallery includes twelve paintings and a series of drawings. Critical reception reveals growing insularity of the times; the conservative tone of Edward Alden Jewell's review in the *New York Times* hints at xenophobia, explaining that the artist, upon marrying an American, "changed his name—a very long and difficult one, it is said—to John Graham. . . . But art . . . does not necessarily concern itself with citizenship papers. Certain enthusiasts, it is true, assert that in Mr. Graham's paintings we may find an apotheosis of modern America."[22] Dehner remembers seeing Gorky at an Artists' Union meeting to which she and Smith had been brought by Graham.

March: Graham recommends to Crowninshield that he hire Smith to fabricate bases for a large number of his African objects. Dehner later recalls: "Crowninshield complimented 'David Boy,' as he called him, on the ingenious mounting of his collection."[23]

Summer: Graham and Elinor in Bolton Landing where Smith and Dehner are neighbors.

Fall: Graham returns from a trip to Paris and discovers that Elinor has left him (Dehner later recalls Graham's infatuation with a student at Wells, the daughter of a trustee). He does not return to teach at Wells.

November: In a letter to Phillips, Graham states that he has finished his book (*System and Dialectics of Art*), saying it is currently in a "short form. Is there any publisher I could show it to?"[24]

December: Writes Phillips that he has not been able to register with the Public Works of Art Project (PWAP; Phillips is an adviser). "I am very

anxious to paint murals in a conservative style. If you would mention to Mrs. Force [chairwoman of the New York Regional Committee of the Public Works of Art Project] that I give up abstract painting, it may help. Things certainly are gloomy."[25]

1934 **February:** Smith recalls the influence of Graham in this period. "Being far away, depending upon *Cahiers d'art* and the return of patriots, often left us trying for the details instead of the whole. I remember watching a painter, Gorky, work over an edge probably a hundred times to reach an infinite without changing the rest of the picture, based on Graham's recount of the import put in Paris on the 'edge' of paint."

 Summer: Spends time in Bolton Landing and gives Smith a Julio González sculpture most likely obtained in Paris.

 August: Divorce from Elinor is finalized; he is ordered to pay twenty-five dollars per month in child support.

 October: Writes Phillips that he is "coming to my senses after the shock of the last year. . . . I have worked a good deal on my book on art and it is nearly finished. I will send you a copy as soon as I can have it typed."[26] Graham secures help with vetting the manuscript when, during a visit to Frank Crowninshield's Condé Nast offices, he meets Constance Wellman, a twenty-one-year-old socialite working as a receptionist.

 December: By the end of 1934, Davis and Gorky's friendship comes to an end because of what Davis feels is a lack of political activism by Gorky. Artist Balcomb Greene recalled that Gorky "attended Union meetings, served on committees, and spoke with much feeling on many issues. He considered it his mission to instill into the rank and file of the organization a respect for art and a suspicion of the political adventurer. He would gain the floor on the most inauspicious occasions and declaim about the contours of Ingres."[27]

1935 **February:** The Whitney Museum of American Art organizes *Abstract Painting in America*. Davis (cited in the catalogue as "one of the most brilliant exponents of the movement") is asked to write an introduction and strikes an elegiac tone in describing the fragile nature of abstract art in mid-1930s America. Noting that the years 1915 to 1927 marked the period of greatest activity, he writes: "Abstract art in America as shown in this exhibition, although actively participated in by relatively few artists, has been a vital factor in the sharpening of issues. Its objective and real contributions

will not be lost."[28] The exhibition features 134 works by sixty-five artists—Davis, Gorky, and Graham among them.

An abbreviated version of *System and Dialectics of Art* (fourteen pages long, containing fifty-nine questions) is published in *Methods of Teaching the Fine Arts* (1935) by William Sener Rusk, an educator and the chairman of the Wells College Art Department. The title of Graham's article, "The Dialectics of Art," suggests that he has yet to articulate the idea of a "system."

March: Six objects from Crowninshield's collection are included in the *African Negro Art* exhibition at the Museum of Modern Art in New York; curator James Johnson Sweeney writes in the catalogue: "It is not the tribal characteristics of Negro art nor its strangeness that are interesting. It is its plastic qualities." Gottlieb, among many other artists, knows Graham's collection of African art; Gottlieb secures an introduction to Parisian dealers in African art from Graham and purchases five sculptures.

Summer: Graham is in Paris, largely engaged in buying African art. Dehner and Smith visit him there.

1936 **January:** Graham marries Constance Wellman, and her intelligence and estimable editorial skills prove invaluable to him over the next several years. He organizes *Sculptures of Old African Civilizations* exhibition for the Jacques Seligmann Gallery, New York, a prestigious venue known for exhibitions of Picasso. American Abstract Artists is founded to counter perceived lack of respect for modernist artists.

April: Graham gives the manuscript of *System and Dialectics of Art* to Alma Reed, known for promoting Mexican artists like Orozco and Rivera and pre-Columbian art through her New York gallery and publishing house, Delphic Studios. Reed seeks advice on the project from Katherine Dreier, and Graham finally meets Dreier for the first time, forming an important relationship.

June: Graham and Constance are in Paris completing work on the manuscript for *System and Dialectics of Art* (the preface states that the book has been written in New York and Paris, 1926–36). Graham added that his background in the law had provided him with the rigorous training necessary to approach a subject from all sides before forming opinions. "My legal training has helped me to formulate postulates clearly and to the point. In law, any specific crime or obligation is recognized as such

only when that particular crime or obligation satisfies all characteristics of that particular legal definition. I am sure no one has ever defined: art; work of art; purpose of art; painting; etc."[29] A letter from Paris to Dreier signed "Our best to you/Affectionately/ John & Co[nstance]" indicates that they have become fast friends. "If anyone would ask me to characterize Katherine S. Dreier in one word, I would say: 'Fearless' with all that the word implies."[30]

July: In a letter to Paris, Dreier responds with advice on the manuscript, although she fears it may be too late in the process: "I would not give any examples—but let your definition stand and sink in—planting it like a seed. . . . In my judgment it will strengthen your book."[31]

Summer: Graham arranges for the publication of *System and Dialectics of Art* in France with Jacques Povolozky at his Imprimerie Crozatier in Paris. Povolozky, a Russian émigré, was active in art publishing and in translations of Russian material.

Fall: Davis founds the American Artists' Congress in reaction to Communist Party influence over the Artists' Union, with Graham listed as a member. Gorky avoids this group and he and Davis part ways. Back in New York, the Grahams are living in Brooklyn Heights where they are neighbors with Gottlieb and his wife, Esther Dick, Smith and Dehner, and Edgar Levy and his wife Lucille Corcos.

November: Influential exhibition *George de la Tour and the Brothers Le Nain* opens at Knoedler Gallery, organized by Louis Carré, a Parisian dealer known to Graham; Crowninshield's name appears on a list of supporters. Smith and Dehner are in Moscow and visit Graham's first wife and children.

1937 **February:** *System and Dialectics of Art* is published in Paris and New York.

March: The exhibition *African Negro Art from the Collection of Frank Crowninshield* opens at the Brooklyn Museum of Art.

April: Graham's seminal article "Primitive Art and Picasso" appears in the *Magazine of Art,* realizing his ambition of bringing to an American periodical the kind of informed discourse found in European publications such as *Cahiers d'art.* "No artist ever had greater vision or insight into the origins of plastic forms and their ultimate logical destination than Picasso. . . . All Picasso's work from 1927 on discloses the most profound

insight into the problems of space and matter, into the origins of forms and their ultimate, logical destination."[32] The article is influential and widely read, especially by younger artists, Jackson Pollock among them. Pollock had a copy among his books in Springs; he may have looked Graham up after reading the article. Pollock's friend Nicholas Carone recalled what he had heard of the meeting: "Jackson told me, 'I went to see Graham because I thought he knew something about art and I had to know him. I knocked on his door, told him I had read his article and that he knew. He looked at me a long time, then just said, Come in.'"[33]

May: Graham auctions a large group of his African sculpture at a public sale, "African Sculpture of Gaboun, Cameroun, and Belgian Congo, The Collection of John D. Graham, New York City." Many of the sixty-four lots had annotated provenance, among them the prominent Parisian collectors and dealers Moris, Ratton, Fénéon, and Tzara.

October: Critical response to *Systems and Dialectics of Art* is meager. Philip McMahon in *Parnassus,* admitting that the author evinces a "deep and sincere enthusiasm for the subject," finds the text "abrupt" and "dogmatic." Among artists (Graham's avowed audience) the book gains cult status, establishing a lexicon for speaking and writing about art.

1938　　**March:** Graham and Constance are employed by Hilla Rebay as she prepares for catalogue and opening installation of the Museum of Non-Objective Art.

June: Graham's son Nicholas, age eighteen, is adopted by his stepfather, Samuel Thorne, Jr.

Summer: Graham and Constance travel to Mexico, where they meet Josef and Anni Albers.

Fall: In a letter to the John Simon Guggenheim Foundation, in support of Graham's 1938 fellowship application, Crowninshield wrote: "He is, I think, the most honest man I have ever known. He is an excellent painter of the modern French abstract school and an art critic of the first order. . . . In the department of African and Oceanic art, I think his knowledge and appreciation is second to that of no other in America. . . . He is one of my closest friends and has been a great influence in shaping my taste and knowledge."[34] Graham affiliates with "The Ten," a loose confederation of artists including Ilya Bolotowsky, Adolph Gottlieb, and Marcus Rothkowitz (Mark Rothko). The group, already in existence for several years, protests the Whitney selection committee's bias toward non-abstract art; they

exhibit in *The Ten: Whitney Dissenters* at the Mercury Galleries (on Eighth Street two doors down from the object of their dissension), November 2–26.

1939 **January:** Rebay pushes her small staff to the limit; Graham writes to Dreier bemoaning the atmosphere of "nervous tension . . . in humoring up a sick person."

May: Graham writes Dreier that they have "taken [her] advice and quit their jobs." They return to Mexico where Graham is occupied with writing an extensive history of art and working on a revision of *Systems and Dialectics of Art*.

October: Back in New York, they move to 54 Greenwich Avenue. The apartment shares a fire escape with Pollock's friends Nene and Bernie Schardt, and this may be how Graham and Pollock met.

1940 **March:** Gorky and Graham, accompanied by the younger artist Jacob Kainen, visit a Poussin exhibition at Durlacher Gallery especially to see Poussin's *Triumph of Bacchus*. Kainen recalled: "Graham and Gorky took that painting apart in detail. This sort of analysis was a revelation to me; it included color sequences and shifts, back and forward movements, pulls and pulsations." Graham continues to influence younger artists. Philip Pavia (1912–2005), a sculptor and founder of the "The Club," recalls that Graham "attracted all the young artists, Bill de Kooning, Jackson Pollock, Elaine de Kooning, Lee Krasner, Theodoros Stamos, myself and others."[35] According to Pavia, Graham would recount his exploits as a cavalryman in the Russian military, suggesting that young artists expand their visual acuity and sense of perspective by pivoting their heads in a 180-degree sweep: "Graham had another theory which was very visual and which greatly heightened my sensibility of art space. It was that the space projected out from one's eyes. . . . It was a peripheral art space that one sees in the work of Pollock, de Kooning and Gorky. The idea was born in Graham when he was an officer in the Russian Cavalry . . . in the wilds of Siberia. This is how he got his clue: 'Early in the morning, we would get up. Wash ourselves in ice water, do our toiletries and as a last gesture, we would dash vinegar on our genitals. . . . As we cantered our horses we would scan the horizon, our heads turning in a semi-circle, from one side to the other, thereby changing our perspective points on the horizon."[36]

September: Opens the Primitive Arts Gallery at 54 Greenwich Avenue, his home address at the time, showing work from his own and Crowninshield's collection of African sculpture plus some of Graham's own work.

1941 Graham seeks out and supports younger artists and receives enormous energy from these contacts.

January: With Pollock, attends the exhibition *Indian Art of the United States* at the Museum of Modern Art, where they watch as Navajo artists execute sand paintings on the gallery floor. A postcard from Graham to a young Lee Krasner mentions the exhibition he is planning:

> Dear Lenore:
>
> I am arranging at an uptown gallery a show of French and American paintings with excellent publicity etc. I have Braque, Picasso, Derain, Segonzac, S. Davis and others. I want to have your last large painting. I will stop at your place Friday afternoon with the manager of the gallery. Telephone me if you can. Ever, Graham.[37]

1942 **January:** Exhibition of *French and American Paintings* opens at McMillen, Inc., a decorating firm located on the Upper East Side that holds exhibitions as well (a connection made through Crowninshield). The exhibition brings about the meeting of Krasner and Pollock for the first time. In a later interview, Krasner verified that it was Graham who first really acknowledged Pollock. "John Graham was the first to mention Jackson Pollock as one of the greatest painters America has produced, and he called it at a time when the name of Jackson Pollock was barely known. [Graham] fully acknowledged him. And said so to anyone who cared to listen."[38] When de Kooning was asked some years later about the exhibition, he had vivid memories. "It was a very little show—not outstanding. The critics liked it and were sympathetic so it was written up nicely. The Americans looked very good."[39] When asked if he thought Graham discovered Pollock, de Kooning responded emphatically: "Of course he did. Who the hell picked him out? The other critics came later—much later. Graham was a painter as well as a critic. It was hard for other artists to see what Pollock was doing—their work was so different from his."[40] Graham did not include Gorky in the exhibition; by this time the friendship seems to have ended. Graham included Davis in a list of "Young outstanding American painters" in *System and Dialectics of Art*. Yet even greater recognition was given to Gorky, who is mentioned in the section devoted to those who have refined taste: "To find a perfect . . . painting, or figure, or a living being, or a situation, requires a nature of high tension and capacity for stupendous effort. Example of highly developed taste: . . . A. Gorky."[41]

American Vanguards and Their Circle: 1920–1942

Prepared by Emily Schuchardt Navratil[42]

David Davidovich Burliuk (b. Kharkiv, Ukraine, July 1882)

John Graham [Ivan Gratianovich Dombrowski] (b. Kiev, Ukraine, 1887)

Jan Matulka (b. Vlachovo Březí, Bohemia, November 7, 1890)

Stuart Davis (b. Philadelphia, Pennsylvania, December 7, 1892)

Alexander Calder (b. Lawnton, Pennsylvania, July 22, 1898)

Dorothy Dehner (b. Cleveland, Ohio, December 23, 1901)

Adolph Gottlieb (b. New York, New York, March 14, 1903)

Arshile Gorky [Vosdanig Adoian] (b. Dzov, Turkish Armenia, April 15, 1904)

Willem de Kooning (b. Rotterdam, April 24, 1904)

David Smith (b. Decatur, Indiana, March 9, 1906)

Edgar Levy (b. New York, New York, September 26, 1907)

Lee Krasner (b. New York, New York, October 27, 1908)

Jackson Pollock (b. Cody, Wyoming, January 28, 1912)

1920	**February 26:** Vosdanig Adoian, later known as Arshile Gorky, and his sister Vartoosh arrive at Ellis Island.
	March 1: They are admitted into the United States and are taken to the family home on Coolidge Hill Avenue in Watertown, Massachusetts. Gorky later goes to Providence, Rhode Island, to stay with his father.
	June: Jan Matulka, a former student of Hans Hofmann, exhibits abstract paintings at Katherine Dreier's Société Anonyme.
	Late June: Matulka and his wife Lida sail to Germany, traveling to Paris, then Prague. Lida returns to the States in October and Matulka remains in Paris, where he associates with Georges Rouault and Czech artists in France.
	November 24: Ivan Dombrowski, later known as John Graham, and his wife arrive in New York.
1921	Adolph Gottlieb, age seventeen, works his passage to Europe. He attends sketch classes at the Académie de la Grande Chaumiere, Paris, and travels to Berlin and Munich.
	January–June: Gorky attends Samuel W. Bridgham Junior High School in Providence.

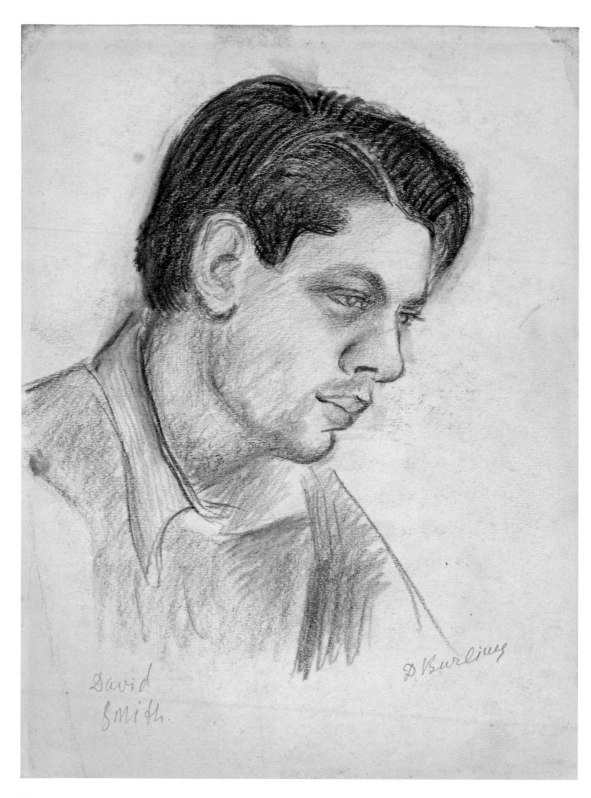

83
David Burliuk (1882–1967)
Portrait of David Smith, c. 1930
Charcoal and crayon on paper
11¼ × 8½ in. (28.6 × 21.6 cm)
Private collection

February: Stuart Davis's article about the writer Floyd Dell, accompanied by his illustration, is published in the *New York Herald.* Davis paints the *Tobacco Still Life* series using cigarette packages of various brands as source material.

April: Davis exhibits fifteen works, including the *Tobacco Still Life* series, in the *Exhibition of Paintings by Stuart Davis and J. Torres-Garcia and Sculptures by Stanislaw Szukalski* at the Whitney Studio Club, 147 West Fourth Street, New York. He paints a group of Cubist landscapes the compositions of which will serve as the source material for a series of works in the 1940s. He paints his first mural for his artist friend Gar Sparks's Nut House in Newark, New Jersey, a multicolored painting done on all four walls in typographically diverse lettering of the items on the menu, prefiguring his later incorporation of words as compositional elements.

Summer: Gorky works at the Hood Rubber Company, Watertown, Massachusetts, for two months before being fired for drawing on shipping frames. Matulka and Lida summer in Czechoslovakia. Matulka winters in Paris again.

Fall: Gorky attends the Technical High School, Providence, where he takes some art classes in addition to the regular curriculum.

1921–24: David Smith and his family move to Paulding, Ohio. Smith attends the city high school. In 1923, he enrolls in a correspondence course in cartooning from the Cleveland Art School. He is chosen to illustrate the high school yearbook.

1922 Jackson Pollock, age ten, and living at home in Orland, California, receives his first exposure to modern art from copies of *The Dial,* a monthly periodical containing fiction, poetry, book reviews, and black-and-white reproductions of fine art, sent by his older art student brother, Charles.

David Burliuk moves to New York from Russia.

Winter 1922–23: Gorky attends the New School of Design and Illustration in Boston.

Davis, living with his parents at 356 West Twenty-second Street in New York, meets and becomes a close friend of the painter Niles Spencer. Davis paints a series of large Cubist still lifes that demonstrate his confident assimilation of Cubist principles.

April: Davis joins the Modern Artists of America and exhibits with Thomas Hart Benton, Paul Burlin, e. e. cummings, Yasuo Kuniyoshi, Joseph Stella, and others at the Joseph Brummer Galleries (Brummer Gallery) in New York.

Spring: Lenore Krassner, later Lee Krasner, graduates from high school.

Summer: Matulka and Lida summer in Czechoslovakia and spend the winter together in Paris.

June: Davis is elected a director of the Society of Independent Artists with John Sloan as president. In Gloucester, Massachusetts, he paints small abstract landscapes.

September: Davis holds an exhibition of his paintings at his studio in Gloucester, at 4 Eastern Point Road. Following a dispute regarding the juried exhibitions held at Gallery-on-the-Moors, Davis helps organize the Gloucester Society of Artists, an association modeled after the no-jury exhibition policy of the Society of Independent Artists.

1922–23: Dorothy Dehner is a drama major at the University of California, Los Angeles.

1923 Gottlieb returns to New York, finishes high school, and studies at Parsons School of Design, the Art Students League, Cooper Union, and the Education Alliance Art School. Graham is among his fellow students at the League.

April: Matulka and Lida return to New York, moving into 48 East Seventy-ninth Street. They spend the summer in Gloucester.

June: Davis travels to Santa Fe, New Mexico, with his brother, Wyatt, and visits John and Dolly Sloan there. Through arrangements made by Sloan, he works in a studio at the Palace of the Governors. He finds the landscape too picturesque but paints a series of landscapes and still lifes, including a painting of what he calls "tin cans in a more or less naturalistic way—that was a gesture against the romantic idea of natural beauty."

August: Davis's article "A Painter of City Streets: An Analysis of the Work of Glenn Coleman" is published in *Shadowland*.

Fall: Matulka returns to Paris.

September: Three recent paintings by Davis are exhibited at the Museum of New Mexico, in Santa Fe. He returns to New York from New Mexico in late autumn.

October–December: Alexander Calder begins classes at the Art Students League, where he meets Graham.

Dehner moves to New York City to study at the American Academy of Dramatic Arts.

1924 Dehner travels to Europe, visiting Italy, Switzerland, and France.

Smith begins studying at Ohio University in Athens. He leaves after one year, frustrated by the way art is taught.

Davis paints a series of still lifes of lightbulbs and mouthwash bottles that demonstrate his early interest in commercial products as subject matter, and are later discussed as anticipating the imagery of the Pop artists by forty years.

Matulka exhibits in the *Salon des indépendants* and *Exhibition of American Art* organized by Marie Sterner.

January–April: Calder enrolls again at the Art Students League of New York, where he continues to study through 1925.

Spring: Gorky is assistant instructor of life-drawing class at the New School of Design, his first teaching position. He paints his earliest known painting, *Park Street Church,* signed "Gorky, Arshele," the first appearance of his pseudonym, which has variant spellings until 1932, when he begins to consistently use "Arshile Gorky."

July: Davis participates in the exhibition of the Gloucester Society of Artists with Milton Avery, Theresa Bernstein, William Meyerowitz, Alice Beach Winter, and others. He will continue to exhibit annually with this society through 1926.

Fall: Dehner enrolls at the Art Students League. Matulka returns to New York, where he has a two-person show with James Chapin at the New Gallery. He attends classes at the Art Students League. He probably meets Calder and Graham at this time.

Late 1924: Gorky moves to New York City and accepts a teaching job at a branch of the New School. Mark Rothko is one of his students.

1925 Matulka continues at the Art Students League.

January 9: Gorky enrolls at the National Academy of Design as a day student in life-drawing class with Charles Hawthorne, but leaves the academy after a month.

February: Davis's first one-man museum exhibition, *Paintings by Stuart Davis,* is held at the Newark Museum. Nine watercolors and an oil from 1912–24 are shown. By this time, Davis meets and establishes what will become a lifelong friendship with Holger Cahill, a curator at the Newark Museum, who later served as the national director of the Works Progress Administration in Washington, D.C., in 1935.

During summer vacation, Smith works as a spot welder for the Studebaker automobile factory in South Bend, Indiana. In the fall, he enrolls at the University of Notre Dame but quits after two weeks because there are no art courses. He returns to Studebaker, working for its finance department.

October: Gorky enrolls at the Grand Central School of Art. He is quickly made instructor of an evening sketch class.

November: Davis's *Early American Landscape,* 1925, is exhibited in *Paintings in Oil by American and European Artists* at the Brooklyn Museum.

November–December: Matulka's first one-man show is presented at the Artist's Gallery.

Late 1920s: Edgar Levy attends the Art Students League.

1926 Davis has five illustrations published in the *New Masses,* a magazine founded by John Sloan, Hugo Gellert, and Maurice Becker. He fills a small sketchbook with drawings of New York scenes, a practice he will continue in New York, Paris, and Gloucester through the 1930s, later mining them as source material for paintings. Davis lives at the Chelsea Hotel, 222 West Twenty-third Street, New York.

January: Matulka has a one-man show at the Whitney Studio Club.

April: Katherine Dreier organizes a show of Matulka's work at the Art Center.

Spring: Pollock graduates from Grant Elementary School in Riverside.

Summer: Dehner is in California.

August 15: De Kooning immigrates illegally to the United States with friend Leo Cohan by working in the engine room of the S.S. *Shelley*. He arrives in Newport News, Virginia. From there he goes to Boston on a coaler, working as a stoker, then to Rhode Island by train; to South Street, New York, by boat, and finally to Hoboken, New Jersey, by ferry. He stays at the Dutch Seaman's Home while he supports himself as a house painter.

Fall: Pollock enrolls in Manual Training School, Riverside. Dehner studies oil painting and drawing at the League.

September: Gorky becomes a full member of the faculty at the Grand Central School of Art, where he remains on the faculty until 1931. His biography printed in the school catalogue is almost entirely fabricated.

By October: Davis's parents acquire a house at 51 Mount Pleasant Avenue in Gloucester, where he sets up and maintains a summer–fall studio. His mother, Helen Davis, a sculptor, continues her own artistic pursuits there. In November, he exhibits in the *International Exhibition of Modern Art* assembled by the Société Anonyme for the Brooklyn Museum.

November: Gorky's poem "Thirst" is published in *Grand Central School of Art Quarterly*. A traveling exhibition of art by the faculty includes a portrait and still life by Gorky. Matulka begins contributing illustrations to the *New Masses*.

December: A retrospective exhibition of Davis's paintings is held at the Whitney Studio Club, 14 West Eighth Street, New York. He exhibits forty-three works, five of which are sold from the show. Following the exhibition, Gertrude Vanderbilt Whitney, through Juliana Force, begins providing a monthly stipend of $125 to Davis for one year.

Winter 1926–Spring 1928: Krasner attends the Women's Art School of the Cooper Union.

Smith moves to Washington, D.C., where he works at Morris Plan Bank while taking art and literature classes at night at George Washington University. At the end of the year, he leaves for New York to work for Industrial Acceptance Corporation, a Morris Plan Bank subsidiary.

He moves into an apartment near Columbia University, at 417 West 118th Street. His neighbor Dehner advises him to take a course with her at the Art Students League.

1927 De Kooning moves to a studio apartment on West Forty-second Street. His work consists of commercial art jobs, department store displays, sign painting, and carpentry until 1935.

January: De Kooning sees the Matisse exhibition at Dudensing Gallery.

Davis begins the *Egg Beater* paintings, setting up a still life by nailing an eggbeater, a rubber glove, and an electric fan to a table in his studio as a personal challenge to use the same subject matter for a year. They are his most abstract works to date. Davis lives and works at 67 Seventh Avenue, New York. He makes a series of portrait drawings of Bessie Chosak, who will later become his first wife.

March: Matulka's work is included in an exhibition at Frank K. M. Rehn Gallery in New York, which becomes his primary gallery during his lifetime.

April: Davis exhibits work at Edith Gregor Halpert's Downtown Gallery, 113 West Thirteenth Street, New York.

Starting in the fall, and continuing until 1932, Smith attends the Art Students League full-time, where he studies with John Sloan and later with Matulka.

November: Davis's first one-man exhibition is held at the Downtown Gallery, beginning a professional relationship that will continue for most of the next thirty-seven years.

December 24: Smith and Dehner marry. They move to 15 Abingdon Square in Greenwich Village.

Gorky rents a studio at 47a Sullivan Street on Washington Square South. He is within walking distance of A. E. Gallatin's Collection of Living Art, which has a profound impact on him.

1928 **March:** After months of academic and emotional struggle, Pollock withdraws from Riverside High School.

April: Davis and Glenn O. Coleman have a show at the Valentine Gallery, New York, accompanied by an artist's statement by Davis. The four *Egg Beater* paintings are shown.

May: Juliana Force of the Whitney Studio Club, acting on behalf of Gertrude Vanderbilt Whitney, purchases two of Davis's paintings, thus enabling him to travel to Paris. Davis departs New York for Paris with Bessie Chosak, and brings two of his *Egg Beater* paintings with him.

Summer: De Kooning spends the summer in an artists' colony in Woodstock, New York.

Smith, while still studying at the Art Students League and painting in his free time, takes random jobs. Smith and Dehner spend the summer in California. In the fall they move to Brooklyn.

June: Davis and Bessie Chosak arrive in Le Havre by ship and travel by train to Paris. He rents Matulka's former apartment at 50 rue Vercingétorix in Montparnasse, where he completes a sketchbook, paints, and makes a series of lithographs. He socializes primarily with friends from America who are in Paris, including the painters Niles Spencer and John Graham, the poet Robert Carlton Brown from *The Masses* staff, as well as Elliot Paul, a friend from Gloucester acting as the editor of the magazine *transition*. Paul arranges for Davis to visit Gertrude Stein, where he sees her collection of Cubist paintings. Through Graham, he exchanges studio visits with Fernand Léger.

Fall: Gorky meets Graham.

September 11: Pollock enrolls at Manual Arts High School, where he concentrates on art and is introduced by the head of the art department to abstract art and to the writings of mystical thinkers such as Krishnamurti and Rudolph Steiner, the founder of theosophy.

October: Three of Davis's works are exhibited in *Paris by Americans* at the Downtown Gallery, New York. In the fall, a feature article on Davis by Elliot Paul appears in *transition*, and *Hôtel de France* is reproduced on the cover.

December: De Kooning moves to 64 West Forty-sixth Street through April 1930.

Late 1920s: Gorky paints Synthetic Cubist still lifes after Braque and Picasso.

1928–32: Krasner takes a drawing course at the Art Students League, and then studies at the National Academy of Design in New York until spring 1932. She begins a close friendship with Russian émigré Igor Pantuhoff, a friend of Graham.

1929 Gottlieb is awarded a joint prize in the Dudensing National Competition.

March: Pollock is expelled from Manual Arts High School.

April: De Kooning meets Graham at the opening of his exhibition at Dudensing Gallery.

Summer: Smith and Dehner go to Bolton Landing, near Lake George in the Adirondacks in upstate New York. They stay with Tomas and Weber Furlong, both painters and, respectively, the treasurer and executive secretary of the Art Students League. Smith buys Old Fox Farm. He and Dehner go upstate in the summer and fall until 1940, when they move permanently to Bolton Landing.

G. L. Van Roosbroeck arranges a showing of thirty-three paintings by Matulka at Columbia University, the largest solo exhibit during Matulka's life. Van Roosbroeck also publishes *Grotesques* with illustrations by Matulka. Matulka has another one-man show at the Rehn Gallery. He wins a teaching job at the League, his first salaried position. Matulka encourages Smith to attach found objects made of wood and other materials to painted surfaces. He introduces him to the work of Wassily Kandinsky, Piet Mondrian, Pablo Picasso, and the Russian Constructivists.

June 29: Davis marries Bessie Chosak in Paris.

August: Davis and Bessie return to New York. Davis travels to Gloucester and paints a series of gouaches, applying the spatial concepts developed in his Parisian street scenes to Gloucester subject matter. In New York, they live in an apartment at Fourteenth Street and Seventh Avenue. Davis is introduced to Gorky, probably by Graham; the close friendship of these three artists gives them the nickname "the Three Musketeers."

Fall: Pollock is readmitted to Manual Arts High School. He subscribes to the magazine *Creative Art* and is particularly impressed by an article on the Mexican muralist Diego Rivera.

November: Davis has a one-man exhibition of recent watercolors at the Whitney Studio Galleries, 10 West Eighth Street, New York.

1930 During the 1930s de Kooning works as an assistant painter at American Music Hall Night Club.

Burliuk establishes the journal *Color and Rhyme*.

Gottlieb is included in a two-person exhibition at Dudensing Galleries, New York.

Through Tomas Furlong, Smith meets Graham. Graham introduces Smith to Davis, Jean Xceron, Gorky, and de Kooning. These artists are avid for the new ideas coming out of Europe. Graham, who travels frequently between Paris and New York, informs them about the latest artistic developments in France. At Graham's home, Smith sees reproductions of welded metal sculptures by Julio González and Pablo Picasso in *Cahiers d'art.* Smith also befriends Gottlieb, Edgar Levy, and Milton Avery during this time.

January: Davis has a one-man exhibition of his Paris paintings, *Stuart Davis: Hotels and Cafés,* at the Downtown Gallery.

February 3: Davis and Bessie move to 8 St. Luke's Place, New York. Davis writes a response, in *Creative Art,* to a review by Henry McBride of his 1929 one-man exhibition of watercolors at the Whitney that refers to his style as French. While acknowledging the influence of Aubrey Beardsley, Toulouse-Lautrec, Fernand Léger, and Picasso, he defends his position as an American painter.

March 1–15: Burliuk exhibits a group of wood carvings, watercolors, and paintings at Macy Galleries in New York.

Spring: Pollock attends Manual Arts on a part-time basis.

April: Matulka has another one-man show at the Rehn Gallery. He and his wife travel to Europe.

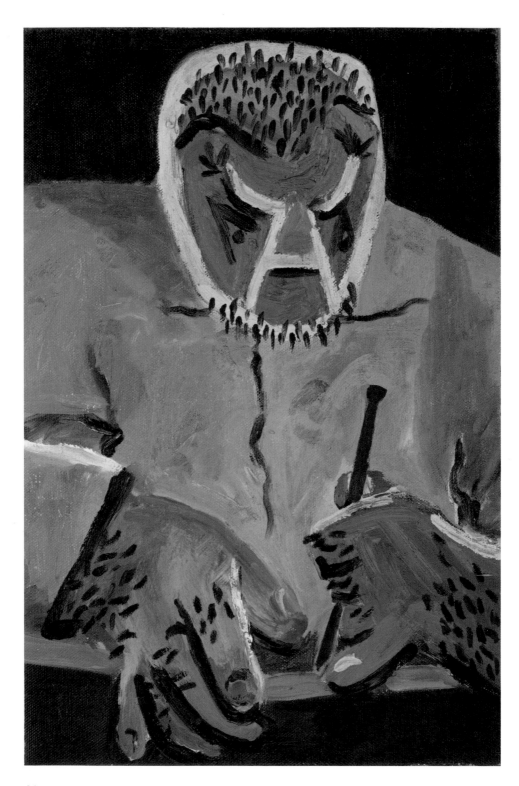

84

Edgar Levy (1907–1975)

Portrait of David Smith (David Smith), c. 1930

Oil on linen

24¾ × 16 in. (62.9 × 40.6 cm)

The Metropolitan Museum of Art, New York, Purchase,

Mrs. Derald Ruttenberg Gift, 1999 (1999.205)

April 11–26: Three still lifes by Gorky are included in the Museum of Modern Art's *An Exhibition of Works by 46 Painters and Sculptors Under 35 Years of Age*. His biography in the catalogue reads: "Archele Gorki Born 1903, Nizhu-Novgorod Studied there and in Tiflis and three months under Kandinsky in 1920. To America 1922 . . ."

June: Pollock sees José Clemente Orozco's *Prometheus* fresco in the recently completed Fray Hall of Pomona College in Claremont, California.

September: Pollock follows his brothers Charles and Frank to New York City, where he enrolls in Thomas Hart Benton's class at the Art Students League.

December: Three paintings by Davis are included in the exhibition *Painting and Sculpture by Living Americans* at the recently opened Museum of Modern Art, in the Heckscher Building at Fifth Avenue and Fifty-seventh Street, New York.

1930–31: De Kooning meets Gorky at Misha Reznikoff's studio. De Kooning meets dealer Sidney Janis through Gorky. De Kooning and Gorky become close friends, visiting museums and galleries together.

Gorky moves to a new studio at 36 Union Square which he keeps for the remainder of his life.

1931 Matulka's classes at the Art Students League end. Smith, Dehner, and others study with him privately until 1932 when the class disbands, but he still accepts individual students. Matulka and his wife move to 439 East Eighty-ninth Street, their residence until 1969.

Over the course of the year, Gorky sends a group of works to the Downtown Gallery.

Davis paints the *New York–Paris* series, juxtaposing scenes of New York, Paris, and Gloucester, and makes a series of lithographs.

January 1–February 1: Gorky shows *Improvisation* at the Société Anonyme in an exhibition celebrating the new building for the New School for Social Research.

March: Davis has a one-man exhibition at the Downtown Gallery, in which the *New York–Paris* paintings are shown.

April: Abby Aldrich Rockefeller purchases Gorky's Cézannesque still life *Fruit,* circa 1928–29, from the Downtown Gallery.

June 2–22: Gorky shows *Still Life* at the Downtown Gallery in *Paintings, Watercolors, Drawings, Sculptures by Leading Contemporary American Artists.*

September: Davis's "Self-Interview" is published in *Creative Art* magazine in which he writes about the significance of his stay in Paris. Davis begins teaching a semiweekly evening class at the Art Students League. At Davis's request, Gorky writes a critical appraisal of his work titled "Stuart Davis," published in *Creative Art.*

October 5–25: Gorky shows in *Artists' Models: Figure Paintings by Leading Contemporary American Artists* at the Downtown Gallery.

October 1931–Summer 1932: Smith and Dehner are in the Virgin Islands.

Fall: Gorky starts a sketchbook of neoclassical figures similar to Picasso's figures of 1920s. He meets Dorothy Miller and Holger Cahill, who study painting with him briefly. He primarily lectures from books on David, Ingres, and Copley.

December 7–31: Gorky shows three lithographs in *American Print Makers: Fifth Annual Exhibition* at the Downtown Gallery.

Sometime between 1931 and 1932 Davis arranges a showing of his work at the Art Students League along with Matulka, Graham, and Gorky.

Circa 1931–32: Gorky begins *Nighttime, Enigma, and Nostalgia* drawings, influenced by de Chirico, Picasso, and Uccello.

1932 De Kooning lives at 348 East Fifty-fifth Street.

Gottlieb marries Esther Dick.

Winter: Gorky urges Julien Levy to see Graham's work; Graham in turn suggests that Levy look at Gorky's drawings.

Stuart and Bessie live at 166 Second Avenue. He completes three major paintings of Gloucester, including *Red Cart.*

March: Davis has a one-man exhibition of new work, *Stuart Davis: American Scene,* at the Downtown Gallery. The title issues a challenge to the regionalist American Scene school of Grant Wood, Thomas Hart Benton, John Steuart Curry, and others.

March 3: Gorky and Frank Jewett Mather, Jr., the Marquand Professor of Art at Princeton University, debate "Two Views on Modern Art" at Wells College in Aurora, New York, after being invited by Graham, who was teaching there.

May: Davis completes a triptych including an image of the recently completed Empire State Building for the exhibition *Murals by American Painters and Photographers* at the Museum of Modern Art. Davis becomes a founding member of ACA ("American Contemporary Art") Galleries, 1269 Madison Avenue at Ninety-first Street. Under the direction of Herman Baron, ACA Galleries is later instrumental in raising funds to support the American Artists' Congress beginning in 1936.

June: Davis's teaching position at the Art Students League ends.

June 15: Davis's wife, Bessie Chosak Davis, dies from complications following an abortion. After her death, Stuart Davis travels to Gloucester. He is commissioned to paint a mural for the men's lounge in Radio City Music Hall, New York. Known as *Men Without Women,* the mural is completed in November.

During the summer, Smith installs a forge and anvil in his studio in Bolton Landing and begins to make constructions out of wood, wire, stone, aluminum rod, soldered metal, and other materials.

November 22–January 1933: Davis's *American Painting,* 1932, is exhibited in the *First Biennial of Contemporary American Painting* at the Whitney Museum of American Art.

Gorky's *Objects,* 1932, is illustrated in no. 3 of *Abstraction-Creation Art Non-Figuratif,* the magazine of the international artists' association of the same name founded in Paris in 1931.

Gorky shows two works at the Wilmington Society of Fine Arts' *Exhibition of Russian Painting and Sculpture.*

1933 Davis rents two rooms on the top floor of 236 West Fourteenth Street, and teaches a private art class in modern composition there.

Levy attends dissections at Harlem Hospital.

January: Pollock enrolls in John Sloan's "Life Drawing, Painting, and Composition" class at the Art Students League.

February–March: Matulka has a one-man exhibition at the Rehn Gallery.

April: Pollock watches Diego Rivera paint his controversial mural in the RCA Building at Rockefeller Center.

Summer: Matulka makes his final trip to Europe.

Fall: Smith, stimulated by reproductions of Picasso's and González's sculpture, buys a welding suit and an oxyacetylene torch and begins welding metal heads, almost certainly the first welded metal sculptures made in the United States.

Matulka joins the Public Works of Art Project (PWAP), a government relief agency that employs artists to make public art.

December 20: Gorky joins the PWAP. He submits a written proposal for a mural.

December 25: Davis moves into a room above Romany Marie's restaurant at Eighth and MacDougall Streets, a local gathering place for artists, writers, and Greenwich Village bohemians.

December 26: Davis enrolls in the PWAP.

1934 Graham gives Smith a González sculpture, *Head,* circa 1927. Smith sees Pablo Gargallo's welded metal sculptures at the Brummer Gallery, New York.

De Kooning joins the Artists' Union along with Gorky, Graham, Davis, and Rothko.

Davis shares the top floor of a building near Fourteenth Street and Eighth Avenue with his brother, Wyatt, Wyatt's wife, Mariam, and their young daughter, Joan. Stuart joins the Artists' Committee of Action, and

participates in a demonstration, organized by the artist Hugo Gellert, to protest the controversial destruction of Diego Rivera's mural at Rockefeller Center. Davis is an organizer and founding member of the Artists' Union, a politically nonsectarian trade union established to represent the rights of artists as legitimate members of American society.

January: Krasner joins the PWAP until March. Two of Smith's *Heads* are exhibited at the Academy of Allied Arts, New York. He also participates in a group exhibition at the Julien Levy Gallery, New York.

February 2–15: Gorky has his first one-man exhibition at the Mellon Galleries in Philadelphia, which includes thirty-seven paintings from 1926–30. The checklist includes statements by Davis, Harriet Janowitz, F. J. Kiesler, and Holger Cahill.

February 28–March 28: Gorky shows three works in the *First Municipal Art Exhibition* at the Forum, RCA Building, Rockefeller Center, New York.

March: Smith begins to supervise mural painting for the technical division of the Civil Works Administration's Public Works of Art Project and then for the Emergency Temporary Relief Administration until July 1935.

April: Davis has a one-man exhibition of recent paintings and watercolors at the Downtown Gallery.

April 28: Gorky is dropped from the PWAP roster. His mural proposal is never realized. Davis is discharged from the PWAP. He meets Roselle Springer, the estranged wife of the artist Misha Reznikoff, at the Jumble Shop, a restaurant frequented by artists.

July: Davis moves into an apartment and studio at 43 Seventh Avenue, New York, with Roselle Springer, who later becomes his second wife. They will remain at this address until 1954.

August: De Kooning lives at 40 Union Square.

Summer or fall: Gorky joins the Artists' Union but does not participate in political activism. Gorky's lack of political commitment causes the erosion of his friendship with Davis. Smith becomes politically active, participating in union activities that support artists.

November: Davis exhibits *Sail Loft,* 1933, in the group exhibition *Modern Works of Art* at the Museum of Modern Art.

1935 Gottlieb becomes a founding member of "The Ten," a group devoted to expressionist and abstract painting. He collects African sculptures.

De Kooning lives at 143 West Twenty-second Street.

PWAP ends and Matulka joins the Federal Arts Project. He creates a mural, *Synthesis of American Music and History.* Matulka, Davis, and de Kooning participate in the Williamsburg Federal Housing Project, chaired by Burgoyne Diller.

Davis, de Kooning, Gorky, Graham, Smith, Edgar Levy, and Misha Reznikoff form a group seeking to participate in the Whitney Museum of American Art's *Abstract Painting in America* under the condition that they all be invited. Some are invited and refuse, but Gorky and Davis accept. Gorky shows *Composition No. 1, Composition No. 2, Composition No. 3,* and *Organization,* claiming his work was sent without his knowledge. Smith reviews the exhibition for *Parnassus.* Shortly thereafter, Smith chooses to concentrate on sculpture.

By January: Davis serves as the editor of *Art Front,* the monthly journal of the Artists' Union. His review of Salvador Dalí's exhibition at Julien Levy Gallery, New York is published in *Art Front*'s second issue. Davis will contribute six more articles and letters to *Art Front* this year.

February: Davis exhibits six works in the group show *Abstract Painting in America* at the Whitney Museum of American Art and writes an introduction for the catalogue.

February 1–28: Pollock shows *Threshers* in the *Eighth Exhibition of Watercolors, Pastels, and Drawings by American and French Artists* at the Brooklyn Museum.

February 25: Pollock is hired as a stonecutter by the New York City Emergency Relief Bureau, restoring public monuments for $1.75 an hour.

March: Davis meets with other socially concerned artists to set up the American Artists' Congress, modeled after the European Writers' Congress, to establish a more coherent cultural role and voice for artists in

America. Davis designs the cover for the May issue of *Art Front,* and 1,700 copies of the magazine are sold at the May Day parade in New York.

April 5–24: Gorky shows *Composition,* 1932, in the exhibition *Sidney Janis Collection of Modern Paintings* at the Arts Club of Chicago.

July: Davis is nominated as vice president of the Artists' Union.

August: Krasner works for the Federal Art Project (FAP) of the Works Progress Administration. Pollock and his brother Sande enlist with the FAP as well. Sande, who has worked with David Siqueiros in Los Angeles, is assigned to the mural division. To stay close to his brother, Pollock also joins the mural division rather than the easel division. Davis, too, enrolls in the FAP, which is directed by his friend Holger Cahill. Gorky is assigned to the mural division as well, and he begins *Aviation* mural designs for Floyd Bennett Field, intended to incorporate photographs by Wyatt Davis. De Kooning also joins the mural division, working on a mural for the Williamsburg Federal Housing Project, Brooklyn. Studies exist, but the mural was never completed. After more than a year, de Kooning leaves the WPA because he is not an American citizen.

September 13: Davis speaks about the artist in society on the program "Poets of To-day" in a radio broadcast on WNEW. By this time, Davis is a member of the American Society of Painters, Sculptors, and Gravers.

September–October: Gorky has a one-man exhibition of pen and ink drawings at the Boyer Galleries, Philadelphia, and he lectures on abstract painting at the galleries in conjunction with the exhibition.

October: Gorky participates in a group exhibition at the Guild Art Gallery, New York. Smith and Dehner travel to Europe for the first time. Graham introduces them to artists in Paris. Smith visits Jacques Lipchitz's studio and sees the latest works by Picasso. They spend the winter in Greece, where Smith tries bronze casting and takes color samples of antique sculptures. They visit Crete, Naples, Malta, Marseilles, and then London. From there they board a steamer for a twenty-one-day tour of the Soviet Union. In Moscow they discover the Museum of Modern Western Art. Back in London, they study Egyptian and Sumerian seals at the British Museum.

November 12: Gorky signs a three-year contract with the Guild Art Gallery.

November 24: Gorky delivers a lecture titled "Methods, Purposes, and Significance of Abstract Art" at the Guild Art Gallery.

December 16, 1935–January 5, 1936: *Abstract Drawings by Arshile Gorky* opens at the Guild Art Gallery, his first solo show in New York.

1935–36: Gorky works on *Khorkom* paintings. He corresponds about artistic philosophy with his cousin Ado Adoian, a member of the Armenian Communist Party in Yerevan.

De Kooning moves to a loft at 156 West Twenty-second Street, where he remains until 1940. He befriends his neighbors Rudy Burckhardt and Edwin Denby, who would become the earliest collectors of de Kooning in the United States. He also meets musician-composers Virgil Thomson and Aaron Copland.

1936 Davis continues painting under the auspices of the WPA. Gottlieb is employed as an easel painter with the FAP. Pollock, working for the FAP, submits a proposal early in the year for a mural but fails to secure a commission.

January: De Kooning joins a discussion at Ibram Lassaw's studio that leads to the formation of American Abstract Artists. He works with Fernand Léger on the French Line Pier Project, which was never executed, and he begins painting full-time.

February 14: As the elected executive secretary of the American Artists' Congress, Davis delivers the opening speech at its inaugural convention at Town Hall in New York. In it, he outlines the aims of the congress and its intention to be a permanent national organization.

February 24–March 17: Burliuk has a one-man show at the Boyer Galleries in Philadelphia.

March 16–April 4: The exhibition *Drawings, Small Sculpture, Watercolors* at the Guild Art Gallery includes Gorky, Boris Aronson, Ahron Ben-Shmuel, Lloyd Ney, Anna Walinska, and others.

April: Siqueiros establishes a "Laboratory of Modern Techniques in Art" in his loft at 5 West Fourteenth Street. Pollock and his brother Sande participate. Siqueiros experiments with nontraditional materials such as enamel paints, and with unconventional techniques of paint application:

dripping, pouring, and airbrushing, materials and techniques that Pollock will adopt.

Spring: Gorky castigates the Social Realists and condemns propagandistic illustrations as "poor art for poor people" in his speech at the Artists' Union.

May 7: Davis attends the District Convention of the Artists' Unions at the Hotel New Yorker and speaks on "Artists' Organizations and Culture." With Henry Glintenkamp, Davis resigns from the staff of *Art Front* due to his increased involvement in the activities of the Artists' Congress. In debates in the pages of *Art Front* and in the Artists' Union he defends abstract art, articulating its radical social importance as distinct from the extremes of the American Scene painters on the right and the Social Realists on the left.

May–September: Alfred H. Barr, Jr., chooses Gorky's WPA mural *Aviation* for Newark Airport from two proposals submitted to him. Subsequently, the idea of using photographs is dropped and the mural is reassigned to the airport's administration building.

June: Gorky is included in the Boyer Galleries, New York, show *Modern American Paintings.*

June 22: Davis travels to Philadelphia to speak on the "Purpose and Function of the American Arts" at the Philadelphia League of Allied Artists. He joins with other artists who have become increasingly critical of the gallery and private patronage system, and he participates in developing and attempting to implement such alternative practices as collector museum rentals of artists' works, as well as government sponsorship. After a dispute with Edith Halpert, he terminates his relationship with the Downtown Gallery, although it will be reestablished in later years.

July 4: Smith and Dehner return to the United States. They move to 57 Poplar Street in Brooklyn Heights, where they are neighbors with the Grahams, the Gottliebs, and Edgar Levy and his wife Lucille Corcos.

Late summer: Pollock, Sande, Phillip Goldstein (later Guston), and two other friends visit Dartmouth College, in Hanover, New Hampshire, to see Orozco's mural *The Epic of American Civilization* in the Baker Library.

September: The New York City Art Commission approves Gorky's mural *Aviation,* for the Newark Airport administration building.

September 14–October 12: The Museum of Modern Art presents *New Horizons in American Art,* a survey of works done under the FAP. Gorky, Davis, de Kooning, and Matulka are all included. Gorky exhibits one of his Newark panels.

De Kooning exhibits a study for the Williamsburg Federal Housing Project.

November 10–December 10: Gorky, Davis, and Graham are included in the Whitney's *Third Biennial Exhibition of Contemporary American Painting.*

December: Krasner meets Pollock at an Artists' Union loft party. They will not meet again until 1942.

December 18: Frederick Kiesler's article "Murals Without Walls: Relating to Gorky's Newark Project" is published in *Art Front,* vol. 2. This is the first magazine article on Gorky.

1937 Gottlieb moves to the desert, near Tucson, Arizona, through June 1938.

Krasner receives a scholarship to study at Hans Hofmann's School of Fine Arts in Greenwich Village, at 52 West Eighth Street. She takes part in protests organized by the Artists' Union.

Through Burgoyne Diller, de Kooning is commissioned to design a ninety-foot section of a three-part mural called *Medicine* for the Hall of Pharmacy at the New York World's Fair of 1939–40. Professional mural painters execute the mural in 1939. Michael Loew and Stuyvesant van Veen contribute the remaining two-thirds of the mural design.

De Kooning meets Max Margulis, vocal coach and writer, and artists Philip Guston and Barnett Newman. He also meets art student Elaine Fried, who begins studying with him and later becomes his wife.

Davis begins work on the mural *Swing Landscape* under the auspices of the WPA.

February: Smith is assigned to the sculpture division of the WPA's Federal Art Project, where he will work until August 1939. A photograph of Gorky working on the Newark murals is published in Kiesler's "The Architect

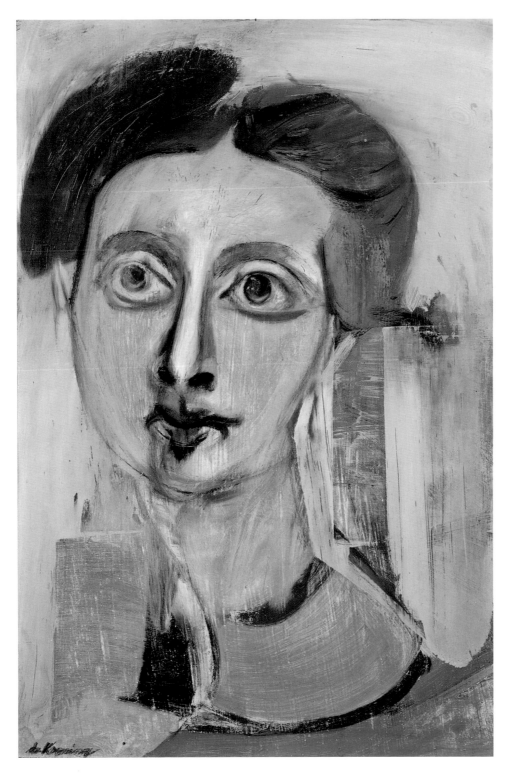

85
Willem de Kooning (1904–1997)
Woman (Elaine), 1942
Oil on board
21 × 14 in. (53.3 × 35.6 cm)
Allan Stone Collection, Courtesy of
the Allan Stone Gallery, New York

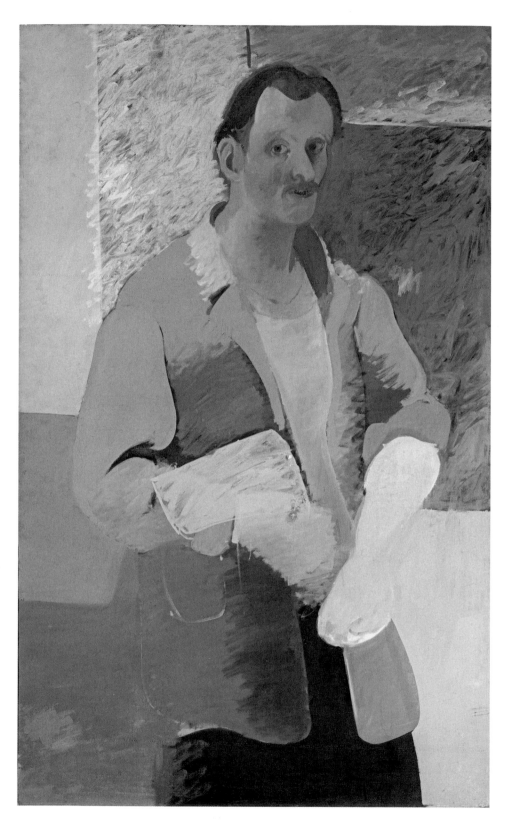

86
Arshile Gorky (1904–1948)
Self-Portrait, c. 1937
Oil on canvas
55½ × 23⅞ in. (141 × 60.7 cm)
Private collection, on loan to the National Gallery of Art,
Washington, D.C.

in Search of . . . ," an article published in the *Architectural Record* about works created through the Federal Art Project.

February 3–21: Pollock exhibits *Cotton Pickers* at the Temporary Galleries of the Municipal Art Committee, 62 West Fifty-third Street.

February 18–March 6: *Art Here,* an exhibition at the Syracuse Museum, includes work by Gorky.

April: Davis is included in the first annual membership exhibition of the American Artists' Congress; he will continue to participate in its exhibitions through 1938.

May 12: Gorky probably speaks before the American Federation of Artists in Washington, D.C.

Summer: Davis's article "The Artist and the War: Twenty Years After" is published in the *American Artists' News Bulletin.*

June 9: Gorky's Newark Airport murals are unveiled at the administration building.

June 12–October 31: Gorky shows *Organization No. 2* in *Greater Pan American Exhibition: Art of the Americas, Pre-Columbian and Contemporary* at the Dallas Museum of Fine Arts.

Summer: Gorky is permitted to easel paint in his studio while employed by the mural division of the FAP. He continues to do so until summer 1941. Around this time he begins paintings based on Picasso's studio interiors.

July 19–31: Krasner's work is included in an exhibition challenging periodic WPA firings and rehirings, entitled *Pink Slips Over Culture,* held at the ACA Galleries. Davis incorporates a fragment of a clipping with the words "art of the people/get pink slips" in a gouache.

August: Gorky begins studies for murals for the Marine and Aviation Buildings in the New York World's Fair of 1939–40. Sometime in 1938 his study is rejected in favor of work by Lyonel Feininger.

October: Pollock exhibits a watercolor in the first exhibition at the new WPA Federal Art Gallery, at 225 West Fifty-seventh Street.

November 10–December 12: Gorky shows *Painting,* 1936–37, in the Whitney Museum of American Art's *Annual Exhibition of Contemporary American Painting.* The Whitney buys *Painting,* Gorky's first museum purchase.

Gorky and de Kooning attend the first meeting of American Abstract Artists; neither joins.

December: The American Artists' Congress holds its second large conference and Davis is elected national chairman.

Smith begins planning a series of fifteen bronze medals, the *Medals for Dishonor* (1938–40), an antiwar statement provoked by events in Europe—the rise of fascism and the Spanish Civil War—and drawing inspiration from the Sumerian seals and German World War I medals that he saw at the British Museum in London, among many other sources.

Smith sells his first sculpture to Herman Shumlin for eight dollars at an auction raising money for Spanish Republican forces.

Marian Willard, who opened the East River Gallery on Fifty-seventh Street in Manhattan in 1936, visits Smith in his Terminal Iron Works studio and offers him a solo show. He continues to show with Willard until 1956.

1938 De Kooning begins his first *Woman* series.

January: Smith's first solo show opens at the East River Gallery in New York in January, which includes seventeen welded iron sculptures dating from 1935 to 1938, as well as drawings.

January 1–27: Gorky is included in the *Exhibition of Contemporary American Painting,* which opens at the Gallery of the Architecture Building, University of Illinois, Urbana-Champaign, and travels to the University Gallery, University of Minnesota, Minneapolis, as *Third Annual Exhibition of Contemporary American Painting at the University of Minnesota,* February 4–23.

February 25: Stuart Davis marries Roselle Springer (recently divorced from Misha Reznikoff) in Elkton, Maryland, en route to Washington, D.C.

February 28: Davis testifies before a congressional committee in favor of a permanent federal art bill. Other witnesses for the bill include Lillian Gish, Orson Welles, and Theodore Dreiser.

March 6: Davis speaks on WYNC radio about the federal art bill.

March 8: Davis discusses "Art in the Subway" on WEVD.

May: Davis completes the mural *Swing Landscape.* Initially commissioned for the Williamsburg Housing Project, Brooklyn, New York, the mural is never installed there. Davis designs the book jacket for *Concert Pitch,* a novel by Elliot Paul published by Random House.

Smith participates in the *Second Annual Membership Exhibition of the American Artists' Congress* in New York. He begins to work more extensively with steel and produces a series of drawings based on Barbara Morgan's photographs of Martha Graham performing *Lamentation* (1930).

May–July: Gorky shows *Painting,* 1936–37, in *Trois siecles d'art aux Etats-Unis* at the Musée du Jeu de Paume, Paris, in collaboration with the Museum of Modern Art.

June 9: Pollock's employment with the Federal Art Project is terminated due to "continued absence."

November: Gorky has a one-man exhibition at the Boyer Galleries and is included in James Johnson Sweeney's article "L'art contemporain aux Etats-Unis," in *Cahiers d'art* with a reproduction of *Painting.* Pollock is reassigned to the easel division of the WPA project.

December 12: Davis participates in a radio broadcast on WEVD titled "Shall the Artist Go Back to the Breadlines."

1939 Gottlieb wins a nationwide mural competition sponsored by the U.S. Treasury and is commissioned to paint a mural for the post office in Yerrington, Nevada.

Krasner is appointed to the executive board of the Artists' Union and becomes embroiled in debates regarding Stalinist versus Trotskyist politics. She joins the American Abstract Artists and is included in AAA's annual exhibitions from 1940 to 1943.

Smith makes his first arc-welded sculptures.

Matulka's affiliation with the Federal Art Project ends.

January 16: Gorky leaves the FAP to complete murals for the World's Fair Aviation Building.

February: Davis has a one-man exhibition of paintings at the Katharine Kuh Gallery in Chicago. He is commissioned to design the mural *History of Communication* for the Hall of Communications at the New York World's Fair. The work is destroyed at the end of the fair. He is commissioned by *Harper's Bazaar* to paint *Impression of the New York World's Fair,* which is published in the February issue.

March: Smith participates in a WPA exhibition at the Federal Art Gallery, New York, as well as in several other group shows, notably *Exhibition of Contemporary American Art at the New York World's Fair.*

March 5: Under the sponsorship of the WPA, Davis completes *Mural for Studio B, WNYC, Municipal Broadcasting Company* for the New York City radio station. He shares studio space with Philip Guston while working on this mural.

March 29–April 13: The Phillips Memorial Gallery shows *An Exhibition of Paintings by David Burliuk, Russian-American Expressionist.*

April 3–22: Burliuk has a one-man show, *Burliuk: Paintings, 1929–1939,* at the Boyer Galleries in New York.

April 29: Davis writes a review of the World's Fair art show titled "Exhibition of American Art Is Democratic in Scope" in the *New York Post.*

April 30: The New York World's Fair opens in Queens. Gorky's mural *Man's Conquest of the Air* is installed in the Aviation Building.

May: Picasso's *Guernica* and preparatory sketches made for the work are on view at the Valentine Gallery on Fifty-seventh Street, where it is exhibited by the Artists' Congress to help raise funds for refugees from the Spanish Civil War, and where it is studied carefully by New York artists including Gorky, Davis, Pollock, and others.

May 5–27: Gorky, Leo Katz, and Walter Pach hold a panel discussion in conjunction with the exhibition of *Guernica.* Davis will later participate in a symposium on the painting at the Museum of Modern Art in 1947.

May 20: Gorky becomes a naturalized United States citizen.

June 9: Gorky is reinstated in the FAP.

August 2: Davis participates in a radio broadcast on WYNC on the dedication of the studio murals of the Federal Art Project.

August 4: Smith's father dies and he produces a model for a bronze memorial plaque.

August 18: Davis is disenrolled from the FAP because of rules restricting the length of employment, and leaves the WPA.

Smith is commissioned by the Museum of Modern Art to make fireplace accessories for the museum's penthouse apartment.

1939–40: De Kooning meets Franz Kline at Conrad Marca-Relli's studio, 148 West Fourth Street.

1940 Gorky begins the *Garden in Sochi* series.

January 5: Davis is interviewed for a *New York Reporter at Large* article on the lively history of McSorley's Ale House.

January 10–February 18: Gorky shows *Head Composition* in the Whitney's *Annual Exhibition of Contemporary American Painting*.

February: At a forum of the United American Artists, in which Davis and Irene Rice Pereira also participate, Smith speaks in support of abstract art and against the more fashionable Social Realism in a talk titled "On Abstract Art."

February 7: Davis delivers the speech "Is American Art Menaced by Alien Trends?" at the Museum of Modern Art under the auspices of the American Artists' Congress.

February 15: Davis delivers a speech on "Abstract Art" at the Labor Stage for the United American Artists and later that day participates in a radio broadcast on NBC from Town Hall, New York, "Is There a Revolution in the Arts?" He comments on the effect that social and scientific changes have on the arts.

March: De Kooning's fashion illustrations appear in *Harper's Bazaar*. He is commissioned through Edwin and Grace Denby to design sets and

costumes for Nini Theilade's ballet *Les nuages,* set to music by Claude Debussy, performed by the Ballet Russe de Monte Carlo at the Metropolitan Opera House on April 9. Smith's solo show at the Neuman-Willard Gallery, New York, is favorably reviewed by Clement Greenberg in *The Nation.*

April 5: Davis resigns from the American Artists' Congress, ending his involvement in radical politics. He begins teaching at the New School for Social Research, New York, where he remains a member of the faculty through 1951. He sells *Summer Landscape,* 1930, formerly owned by Samuel M. Kootz, to the Museum of Modern Art—the first Davis painting to enter the museum's collection.

Spring: Smith and Dehner move permanently to Bolton Landing.

June: Pollock watches Orozco at work at the Museum of Modern Art, where the Mexican artist has been commissioned to paint a portable mural in conjunction with the exhibition *Twenty Centuries of Mexican Art.*

November: Smith shows his *Medals for Dishonor* at the Willard Gallery. Upon Smith's request, the novelist Christina Stead and her husband, the writer William Blake, each write an essay for the catalogue.

November 27–January 8, 1941: Gorky shows *Oil Painting,* 1938, at the Whitney's *Annual Exhibition of Contemporary American Painting.*

Early 1940s: Gorky teaches a camouflage course at Grand Central School of Art.

1941 Burgoyne Diller, head of the WPA mural division in New York City, commissions Krasner to create a proposal for an abstract mural for radio station WNYC, which already has murals by Davis, Byron Browne, and John von Wicht; due to the United States' entry into World War II, the mural is never executed.

Gottlieb begins to develop *Pictographs.*

De Kooning is commissioned by the U.S. Maritime Commission to paint a four-panel mural entitled *Legend and Fact* (National Gallery of Art, Washington, D.C.) for the library of the S.S. *President Jackson* of American President Lines.

Smith's work is included in two traveling exhibitions organized by the Museum of Modern Art—*Fifteen American Sculptors* and *Twentieth Century Sculptures and Constructions*—and in the Whitney Museum Annual.

January: Gorky meets the woman who will become his second wife, Agnes Magruder, through Elaine Fried (later de Kooning). He nicknames her Mougouch, an Armenian term of endearment.

January 16: The Museum of Modern Art acquires Gorky's *Argula,* 1938, gift of Bernard Davis, friend and early collector, and *Objects,* 1932, purchased from the artist.

January 22–April 27: The exhibition *Indian Art of the United States* is on view at the Museum of Modern Art. Pollock attends the exhibition and watches Navajo artists execute sand paintings on the gallery floor.

February: Davis breaks a bone in his ankle and is hospitalized for three days. Graham teaches Davis's class at the New School until the cast is removed in May.

March: Davis's article "Abstract Art in the American Scene" is published in *Parnassus.*

April 19–27: Gorky shows *Argula,* 1938, in *A Special Exhibition of Contemporary Painting in the United States* at the Metropolitan Museum of Art.

May 11–24: Burliuk has a one-man show at the ACA Gallery, New York.

May 22: Davis meets Piet Mondrian in New York through the artist Charmion Von Weigand. Their shared love of jazz provides common ground.

Davis's wife, Roselle, works as an assistant librarian at the Museum of Modern Art. He reestablishes a formal relationship with the Downtown Gallery, now at 43 East Fifty-first Street, New York.

August: Gorky's mural for Ben Marden's Riviera nightclub in Fort Lee, New Jersey, is installed. Gorky is quoted in Malcolm Johnson's article "Café Life in New York" in the *New York Sun,* August 22, "I call these murals non-objective art . . . but if labels are needed this art may be termed surrealistic."

August 9–24: The exhibition *Arshile Gorky* opens at the San Francisco Museum of Art and includes approximately twenty paintings. It is his first solo exhibition in a museum. Jeanne Reynal lends *Enigmatic Combat,* 1937, to the show and then gives the painting to the museum.

Fall: Graham invites Krasner to participate in a group exhibition, *French and American Painting,* to be held in 1942. Included among the Americans are Davis, Graham, de Kooning, and Pollock. Soon after receiving an invitation to participate in this exhibition, Krasner (who did not realize that she had met Pollock several years earlier) visits him and introduces herself. She and Pollock begin sharing a studio about this time.

September 15: Gorky marries Agnes Magruder in Virginia City, Nevada.

October: Davis has a retrospective exhibition with Marsden Hartley at the Cincinnati Modern Art Society. Davis's essay "Art in Painting" is included in the catalogue.

November: Smith has a solo show of his *Medals for Dishonor* at the Walker Art Center in Minneapolis.

November 12–December 30: Gorky shows *Painting,* 1936–37, in *Paintings by Artists Under Forty* at the Whitney Museum of American Art.

December 17: Davis gives the lecture "How to Construct a Modern Easel Picture" at the New School for Social Research.

1942 Work by Smith is included in *Artists for Victory* at the Metropolitan Museum of Art.

Smith and Dehner move temporarily (until 1944) from Bolton Landing to Schenectady, New York, where he works as a welder for the American Locomotive Company, assembling locomotives and M7 destroyer tanks, and becomes a member of the United Steelworkers of America, local 2054. Smith also works part-time at the Saratoga Funeral Monument Yard, some forty miles away, which allows him to learn techniques for working with marble. On weekends he returns to Bolton Landing, where he makes small wax molds on the theme of violence and destruction that will later be cast in bronze.

January 5–26: A group exhibition at R. H. Macy Department Store, New York, is organized by Samuel M. Kootz. It includes Gorky, Gottlieb, Graham, Carl Holty, Matulka, and Rothko.

January 20–February 6: Davis, de Kooning, Krasner, Pollock, and Walt Kuhn are selected by Graham for *French and American Paintings* at McMillen, Inc., at 148 East Fifty-fifth Street, which also includes Picasso, Henri Matisse, Georges Braque, Amedeo Modigliani, and André Derain. De Kooning's first critical notice appears in the article "Congenial Company," in *Art Digest.* Pollock, who exhibits *Birth,* circa 1941, and de Kooning meet.

January 25–February 28: Gorky shows in *American Art* at the City Art Museum, St. Louis.

February 28–March 31: Gorky exhibits in *Oil Paintings, Watercolors, and Prints Lent by the Yale University Art Gallery from the Collection of the Société Anonyme–Museum of Modern Art: 1920* at Wesleyan University.

April: Davis exhibits in *Masters of Abstract Art,* a benefit exhibition for the American Red Cross at Helena Rubinstein's New Art Center, New York, and contributes the essay "Art of the City" for the catalogue. Among the artists included are Josef Albers, Mondrian, Léger, and Picasso.

Spring: Herbert Matter, a member of Hans Hofmann's circle, who got to know Pollock through Krasner, invites James Johnson Sweeney to visit Pollock's studio. Sweeney tells Peggy Guggenheim that Pollock is "doing interesting work" and suggests she visit the studio.

In addition to his classes at the New School, Davis teaches a graduate class in painting and composition at New Jersey State Teachers College in Newark for the spring term. He is commissioned by *Fortune* magazine to design a cover for the October issue with the theme of scrap metal. The experimental gouache, *Ana,* is considered too advanced for the readers and the cover is never used.

May: Gottlieb's first *Pictograph* is exhibited in the second annual exhibition of the Federation of Modern Painters and Sculptors at Wildenstein Galleries.

Summer: Under the auspices of the war services division of the FAP, Krasner directs a project designing department-store window displays

announcing war-related training courses at local schools and colleges. She makes Pollock an assistant on the project.

June 30–August 9: Gorky shows the rug *Bull in Sun,* 1942, executed by V'Soske, two preliminary studies, and a design in gouache in *New Rugs by American Artists* at the Museum of Modern Art. Gorky writes to Dorothy Miller on June 26: "The design on the rug is the skin of a water buffalo stretched in the sunny wheatfield. If it looks like something else then it is even better."

July 1: The Museum of Modern Art acquires Gorky's *Garden in Sochi,* 1941.

December: Davis's *Bass Rocks No. 1,* 1939, is exhibited in *Artists for Victory* at the Metropolitan Museum of Art. His wife, Roselle, begins working for the Office of War Information.

December 7, 1942–January 22, 1943: Pollock exhibits *The Flame,* circa 1934–48, in *Artists for Victory,* an exhibition at the Metropolitan Museum of Art.

December 9–January 24, 1943: Gorky shows *My Sister, Ahko,* 1917, in *Twentieth Century American Portraits* at the Museum of Modern Art.

December 28: Gottlieb's first solo exhibition of his *Pictographs,* titled *Adolph Gottlieb: Paintings,* opens at Artists Gallery.

Notes
1. John D. Graham, Baltimore, to Duncan Phillips, Washington, D.C., April 2, 1928, John D. Graham records, Archives of American Art (AAA), Microfilm reel 1935, frame 245.
2. Alexander Calder, *Calder: An Autobiography with Pictures* (New York: Pantheon, 1966), 61.
3. John D. Graham artist file, Phillips Collection, photocopied cataloguer's notes. On the reverse is the head of a woman, most likely Elinor Graham.
4. Dr. Claribel Cone to Miss Etta Cone, January 12, 1927, Dr. Claribel and Miss Etta Cone Papers, Manuscript Collection, Baltimore Museum of Art.
5. John Graham, Baltimore, to Duncan Phillips, Washington, D.C., January 19, 1928, John D. Graham records, AAA, Microfilm reel 1935, frame 212.
6. Duncan Phillips, Washington, D.C., to John Graham, Baltimore, April 20, 1928, Phillips Collection records, AAA, John D. Graham records, Microfilm reel 1935, frame 73.
7. Interview with Stuart Davis, in Harlan B. Phillips, *Stuart Davis Reminisces: As Recorded in Talks with Dr. Harlan B. Phillips* (New York: Archives of American Art, Brandeis University, 1962), 158.

8. John Graham, Paris, to Duncan Phillips, Washington, D.C., July 19, 1928, Phillips Collection records, AAA, Microfilm reel 1938, frame 253.

9. Duncan Phillips, Washington, D.C., to John Graham, New York, October 15, 1928, Phillips Collection records, AAA, Microfilm reel 1935, frame 334.

10. John D. Graham, New York, to Katherine S. Dreier, New York, January 22, 1929, Katherine S. Dreier Papers/Société Anonyme Archive, Yale Collection of American Literature, Beinecke Rare Book and Manuscript Library, Yale University.

11. Duncan Phillips, Washington, D.C., to John Graham, New York, March 1, 1929, Phillips Collection records, AAA, Microfilm reel 1938, frame 321.

12. Duncan Phillips, Washington, D.C., to John Graham, New York, November 5, 1929, Phillips Collection records, AAA, Microfilm reel 1938, frame 501.

13. John Graham, New York, to Duncan Phillips, Washington, D.C., December 3, 1929, Phillips Collection records, AAA, Microfilm reel 1938.

14. John Graham, New York, to Duncan Phillips, Washington, D.C., February 3, 1930, Phillips Collection records, AAA, Microfilm reel 1935, frame 74. Phillips did acquire a work from the exhibition, *Blue Café* (1928, fig. 3.11) in 1930.

15. John Graham to Duncan Phillips, February 3, 1930, Phillips Collection records, AAA, Microfilm reel 1938, frame 245.

16. Duncan Phillips, Washington, D.C., to John Graham, New York, March 14, 1930, Phillips Collection records, AAA, Microfilm reel 1938.

17. *Cahiers d'art,* no. 7 (1930): 387. Two works by Graham are reproduced with the review.

18. Samuel Putnam, "Art Comment from Paris," *New York Times,* December 28, 1930, p. X13.

19. John Graham, New York, to Duncan Phillips, Washington, D.C., December 28, 1930, Phillips Collection Archives, Washington, D.C.

20. Stuart Davis, "Self-Interview," *Creative Art* 9 (September 1931): 211.

21. Waldemar George, "Americanism and Universality," *Formes* 21 (January 1932): 196, 197; Duncan Phillips, "Original American Painting of Today," *Formes* 21 (January 1932): 201.

22. Edward Alden Jewell, "Art in Review," *New York Times,* January 26, 1933, 15.

23. John Graham, *System and Dialectic of Art,* ed. Marcia Epstein Allentuck (Baltimore: Johns Hopkins Press, 1971), 7.

24. John Graham, New York, to Duncan Phillips, Washington, D.C., November 27, 1933, Phillips Collection records, AAA, Microfilm reel 1944, frame 201.

25. John Graham, New York, to Duncan Phillips, Washington, D.C., December 29, 1933, Phillips Collection records, AAA, Microfilm reel 1944, frame 290.

26. John Graham, New York, to Duncan Phillips, Washington, D.C., October 24, 1934, Phillips Collection records, AAA, Microfilm reel 1944, frame 300.

27. Balcomb Greene, "Memories of Arshile Gorky," *Arts Magazine* 50 (March 1976): 110.

28. *Abstract Painting in America,* exhibition catalogue (New York: Whitney Museum of American Art, 1935), n.p.

29. John D. Graham, New York, to Duncan Phillips, Washington, D.C., May 23, 1931, Phillips Collection records, AAA, Microfilm reel 1941, frame 29.

30. John Graham, Paris, to Katherine S. Dreier, New York, June 6, 1936, Katherine S. Dreier Papers/Société Anonyme Archive, Box 15, Folder 423, Yale Collection

of American Literature, Beinecke Rare Book and Manuscript Library, Yale University.

31. Katherine S. Dreier, New York, to John Graham, Paris, July 7, 1936, Katherine S. Dreier Papers, ibid.

32. John Graham, "Primitive Art and Picasso," *Magazine of Art* (April 1937): 239, 260.

33. Jeffrey Potter, *To a Violent Grave: An Oral Biography of Jackson Pollock* (New York: Pushcart, 1985), 56.

34. John Graham, Guggenheim Fellowship application, 1936, John Simon Guggenheim Memorial Foundation Archives, New York.

35. Unpublished manuscript chronicling the 1940s through the 1960s in New York City, courtesy Natalie Edgar Pavia, New York. The excerpt is from chapter 3, "Gulf Stream," Pavia's expression for the fervency that flowed through New York's Greenwich Village in the 1940s.

36. Ibid.

37. John Graham, postcard to "Lenore Krassner [*sic*]," The Pollock-Krasner Foundation, New York.

38. Lee Krasner, interview by Barbara Rose for AAA, July 31, 1966, www.aaa.si.edu/collections/oral histories/transcripts/krasner66.htm, accessed August 12, 2006.

39. James T. Valliere, "De Kooning on Pollock: An Interview with James T. Valliere," *Partisan Review* (Fall 1967): 603.

40. Ibid.

41. Graham, *System and Dialectics of Art,* 128.

42. This chronology draws on the following sources: Ani Boyajian and Mark Rutkoski, eds., *Stuart Davis: A Catalogue Raisonné* (New Haven: Yale University Press, 2007); The Calder Foundation, 2007, www.calder.org; Carmen Giménez, *David Smith: A Centennial* (New York: Guggenheim Museum, 2006); The Adolph and Esther Gottlieb Foundation, 2009, www.gottliebfoundation.org; Eleanor Green, *John Graham: Artist and Avatar* (Washington, D.C.: Phillips Collection, 1987); Robert Carleton Hobbs, *Lee Krasner* (New York: Independent Curators International, in association with H. N. Abrams, 1999); Melissa Kerr, "Chronology," in *Arshile Gorky: A Retrospective,* ed. Michael R. Taylor (Philadelphia: Philadelphia Museum of Art, 2009); Joan Marter, *Dorothy Dehner and David Smith: Their Decades of Search and Fulfillment* (New Brunswick, N.J.: Zimmerli Art Museum, 1984); Harry Rand, *John Graham: Sum Qui Sum* (New York: Allan Stone Gallery, 2005); Patterson Sims and Whitney Rugg, *Jan Matulka: The Global Modernist* (Chicago: TMG Projects, 2004); Kirk Varnedoe, *Jackson Pollock* (New York: Museum of Modern Art, 1998); Diane Waldman, *Arshile Gorky* (New York: Guggenheim Museum, 1981); Judith Zilczer, *Willem de Kooning: From the Hirshhorn Museum Collection* (Washington, D.C.: Hirshhorn Museum and Sculpture Garden, Smithsonian Institution, 1993); Oxford Art Online.

PHOTOGRAPHY CREDITS

Unless listed below, photographs were taken or supplied by lending institutions, organizations, or individuals credited in the picture caption. Individual photographer names are provided when available. Every effort has been made to obtain rights from image rights holders. Any information on unlocated rights holders forwarded to the museum will be acted upon for future editions.

Art by Alexander Calder © 2010 Calder Foundation, New York/Artists
 Rights Society (ARS), New York
All art by Stuart Davis © Estate of Stuart Davis/Licensed by VAGA,
 New York
All art by Willem de Kooning © 2010 The Willem de Kooning Foundation/
 Artists Rights Society (ARS), New York
All art by Arshile Gorky © 2010 The Arshile Gorky Foundation/Artists
 Rights Society (ARS), New York
All art by Adolph Gottlieb © Adolph and Esther Gottlieb Foundation, Inc./
 Licensed by VAGA, New York
All art by Lee Krasner © 2010 The Pollock-Krasner Foundation/Artists
 Rights Society (ARS), New York
All art by Jan Matulka © Estate of Jan Matulka
All art by Pablo Picasso © 2010 Estate of Pablo Picasso/Artists Rights
 Society (ARS), New York
All art by Jackson Pollock © 2010 The Pollock-Krasner Foundation/Artists
 Rights Society (ARS), New York
All art by David Smith © Estate of David Smith/Licensed by VAGA, New York
© Addison Gallery of American Art, Phillips Academy, Andover,
 Massachusetts, museum purchase, Pls. 31, 56, Fig. 24
Courtesy of the Allan Stone Gallery, New York, Figs. 27, 20
Photography © The Art Institute of Chicago, Fig. 25
Courtesy of Babcock Galleries, New York, Fig. 30
G. Braziller, New York, Fig. 34
Photograph © 2010 reproduced with the Permission of The Barnes
 Foundation, Figs. 13, 14

Bridgeman Art Library International, Fig. 28
Estate of David Burliuk © 1968, Photo: Courtesy The Estate of David Smith, Pl. 83
Geoffrey Clements, Fig. 38
Sheldon C. Collins, Fig. 41
Artwork © 2010 The Willem de Kooning Foundation/Artists Rights Society (ARS), New York, Fig. 34
Courtesy The Willem de Kooning Foundation, Figs. 34, 35, 36
Thomas Dubrock, Pl. 69
William V. Ganis, Fig. 32
Courtesy Galerie Gmurzynska, Pl. 34
Courtesy The Arshile Gorky Foundation, Fig. 3
Courtesy Guggenheim Museum, Pl. 46
David Heald, Pl. 46
Hickey-Robertson, Houston, Fig. 33
Courtesy L&M Arts, New York, Fig. 40
John Lamberton, Fig. 40
Erich Lessing/Art Resource, New York, Fig. 26
Paul Macapia, Pl. 74
© 2010 Succession H. Matisse, Paris/Artists Rights Society (ARS), New York, Fig. 25
Image copyright © The Metropolitan Museum of Art/Art Resource, New York, Pl. 84, Fig. 8
© 2011 Successió Miró/Artists Rights Society (ARS), New York/ADAGP, Paris, Fig. 33
Photograph © Museum of Fine Arts, Boston, Pls. 7, 10
Digital image © The Museum of Modern Art/Licensed by SCALA/Art Resource, New York, Pls. 29, 59, Figs. 4, 10, 15, 16, 18, 23
Musée Zervos, Vézelay, France, Fig. 31
Image courtesy of the Board of Trustees, National Gallery of Art, Washington, Pls. 42, 86, Fig. 42
Joshua Nefsky, Pl. 27, Fig. 11
R. G. Ojeda, Fig. 22
Courtesy Philadelphia Museum of Art, Fig. 17
Courtesy, Réunion des Musées Nationaux/Art Resource, New York, Fig. 22
Richard Sanders, Des Moines, Pl. 72
Courtesy of Sotheby's, New York, Fig. 21
Lee Stalsworth, Pl. 8, Figs. 43, 44, 46
Image © Tate, London 2010, Fig. 12
Jerry L. Thompson, Pl. 17
Ellen Page Wilson, Pl. 35
Courtesy Joan Washburn Gallery, New York, Pls. 36, 45

INDEX

Note: *Italic* page numbers refer to figures and plates

82, 92n31, 187, 189, 209, 210–11, 212, 213, 217, 218–19, 221, 222; and Public Works of Art Project, 208; and realism, 82–83; and Sloan, 44, 61n29, 124, 176, 196; and Surrealism, 47, 81; and textures, 125; and Three Musketeers, 3, 43–47, 75–76, 81, 90; and Zborowski, 180

 works of: *Adit No. 1 (Industry), 16; Adit No. 2, 17,* 45; *American Painting,* 44, *45,* 207; *Ana,* 225; *Arch Hotel, 22,* 56; *Autumn Landscape,* 56, *57; Bass Rocks No. 1,* 226; *Blue Café,* 182; *Deuce, 51–52, 51; Early American Landscape,* 45, *46,* 198; *Egg Beater No. 1, 12,* 49; *Egg Beater No. 2, 13,* 49; *Egg Beater No. 3, 14,* 49; *Egg Beater* series, 3, 49, 53, 178, 200, 201; *Flags,* 50; *Gloucester Harbor,* 47, *105; History of Communication,* 220; *Hôtel de France,* 180, 201; *Landscape, 66,* 143; *Landscape, Gloucester,* 176; *Men Without Women* mural, 207; *New York Mural,* 83, *83; New York–Paris* series, 205; *Percolator,* 53, *53; Radio Tubes (Still Life Radio Tube),* 46, 50, *64; Red Cart, 2,* 47, *67,* 206; *Rue des Rats, No. 2, 15,* 45; *Sail Loft,* 210; *Salt Shaker,* 46, *65; Shapes of Landscape Space,* 47, *109; Summer Landscape,* 222; *Super Table,* 177; *Swing Landscape,* 2, 83, 214, 219; *Tobacco Still Life* series, 195

Davis, Wyatt, 50, 61n29, 196, 208–9, 211

Degas, Edgar, 119

Dehner, Dorothy: and Art Students League, 42, 60n24, 197, 199, 200; background of, 37, 196, 199; and Bolton Landing property, 55–56, 60n24, 181, 186, 202, 222, 224; European trips of, 41, 188, 197, 211; and Gorky, 48, 183, 186; the Gottliebs' relationship with, 43; and Graham, 38, 41, 49, 60n15, 60n24, 77, 130, 183, 186, 188, 189; and Graham circle, 3, 36, 40, 42, 60n24, 181; on Levy, 43; Matulka as influence on, 59n3, 76, 205; and Smith's bases for African sculptures, 42, 186

 works of: *Six Artist Etching,* 43, *184; Still Life,* 37, *69*

de Kooning, Elaine (Elaine Fried), 191, 214, 223

de Kooning, Willem: and Abstract Expressionism, 35, 89, 90, 132; and American Abstract Artists, 84, 85, 89, 212, 218; on art of 1930s, 4, 75; background of, 37, 142, 199, 200, 201, 203; and biomorphic abstraction, 52; and classicism, 122, 141–43, 144n24; and Cubism, 89, 90, 132, 141; and eggs, 125, 128, 130, 132, 134–35; and exhibitions, 4, 84, 210, 214, 224, 225; and Federal Art Project, 211; and figurative work, 52, 53, 54, 87, 89, 117, 118, 119, 120, 123, 134, 135, 141, 142–43; and Gorky, 52–53, 54, 139, 141, 181, 205; and Graham, 181, 191, 202; and Graham circle, 42, 55, 56, 76, 125; and modernism, 1, 3, 36, 52, 117, 118, 142–43; and Picasso, 77; political activities of, 91n29, 92n30; and set and costume design, 221–22; and Smith, 203; and Surrealism, 87, 89, 132; and Three Musketeers, 3, 44, 52–54, 61n38, 75, 76, 79, 90

 works of: *Composition, 154; Death of a Man,* 132, *132; Design for World's Fair Mural for Hall of Pharmacy,* 87, *87; Legend and Fact,* 222; *Medicine* mural, 214; *Mother, Father, Sister, Brother,* 53, 134; *Orestes,* 134; *Pink Landscape, 88,* 89; *Portrait of John Graham, 173; Portrait of Rudy Burckhardt,* 53, *112,* 141; *Seated Figure (Classic Male),* 52, 56, 57, 136, *137,* 141; *Seated Woman,* 53, *160; Still Life,* 132, *133; Still Life with Eggs and Potato Masher, 11,* 53, 132; *Study for a Mural in the Williamsburg Housing Project,* 134, *134,* 211, 214; *Untitled* (c. 1928), *18,* 132; *Untitled* (c. 1934), 52, 53, *73; Untitled* (1939), *113; The Wave,* 134; *Woman,* 53, 54, *161; Woman (Elaine),* 215; *Woman* series, 218; *Women,* 54; *Zurich,* 134

Delacroix, Eugène, 124, 126

Dell, Floyd, 195

Demuth, Charles, 120, 121

Denby, Edwin, 79, 212, 221

Denby, Grace, 221

Depression. *See* Great Depression

Derain, André, 56, 135, 180, 225

Desjobert, Edmond, 178

Desjobert, Jacques, 178

De Stijl, 85, 121

Diaz, Virginia, 56

Diller, Burgoyne, 1, 76, 210, 214, 222

Donatello, 35

Dove, Arthur, 1, 185

Downtown Gallery, 200, 213, 223

Drawings, Small Sculpture, Watercolors exhibition (1936), 212

Dreier, Katherine: and Davis, 177; and Graham, 180–81, 188, 189, 191; and Matulka, 193, 198

Dreiser, Theodore, 218

Duchamp brothers, 132

Dudensing Galleries, 52, 178, 181, 182, 202

Dumas, Alexandre, 44, 52, 59

Eakins, Thomas, 117, 140

Eighth Exhibition of Watercolors, Pastels, and Drawings by American And French Artists exhibition (1935), 210

Eighth Street Gallery, 186

Éluard, Paul, 41, 55

Emerson, Ralph Waldo, 121

European vanguard, 36, 40–41, 50, 56

Exhibition of American Art (1924), 197

Exhibition of Contemporary American Painting (1938), 218

ADDISON GALLERY OF AMERICAN ART BOARD OF GOVERNORS

241

ADDISON GALLERY OF AMERICAN ART STAFF

Susannah Abbott, Director of Development

Brian T. Allen, The Mary Stripp and R. Crosby Kemper Director

Julie Bernson, Curator of Education

Brian Coleman, Preparator

Anthony F. Connors, Manager of Security

Kathy Conners, Visitor Services

Roger E. Cowley, Museum Security

Elaine Doucette, Visitor Services

Jaime L. DeSimone, Assistant Curator

Susan C. Faxon, Associate Director and Curator of Art before 1950

Anna L. Gesing, Administrative Assistant

John Jeknavorian, Museum Security

Denise J. H. Johnson, Registrar and Financial Administrator

Jamie L. Kaplowitz, Education Fellow and Museum Learning Center Specialist

Allison N. Kemmerer, Curator of Photography and Art after 1950

Richard Kiberd, Museum Security

Leslie Maloney, Chief Preparator and Building Manager

Dolores I. Mann, Visitor Services

Juliann D. McDonough, Curatorial Coordinator

Barbara O'Sullivan, Visitor Services

Caroline Pisani, Development Administrative Assistant

Gilda Rossetti, Museum Security

Jason D. Roy, Assistant Preparator

Jeffrey Schlothan, Custodian

Austin Sharpe, Head of Security

James M. Sousa, Associate Registrar for Collections and Archives

Janet I. Thoday, Visitor Services

Charlie Wilkinson, Museum Security

Katherine Ziskin, Education Fellow for School & Community Collaborations